# Cultural and Political Nostalgia in the Age of Terror

This book re-examines the role of the sublime across a range of disparate cultural texts, from architecture and art, to literature, digital technology, and film, detailing a worrying trend toward nostalgia and arguing that, although the sublime has the potential to be the most powerful uniting aesthetic force, it currently spreads fear, violence, and retrospection. In exploring contemporary culture, this book touches on the role of architecture to provoke feelings of sublimity, the role of art in the aftermath of destructive events, literature's establishment of the historical moment as a point of sublime transformation and change, and the place of nostalgia and the returning of past practices in digital culture from gaming to popular cinema.

**Matthew Leggatt** is Lecturer in English and American Literature at the University of Winchester, UK.

# Routledge Research in Cultural and Media Studies

For a full list of titles in this series, please visit www.routledge.com.

# Cultural and Political Nostalgia in the Age of Terror
The Melancholic Sublime

Matthew Leggatt

Routledge
Taylor & Francis Group

NEW YORK AND LONDON

First published 2018
by Routledge
711 Third Avenue, New York, NY 10017

and by Routledge
2 Park Square, Milton Park, Abingdon, Oxon OX14 4RN

*Routledge is an imprint of the Taylor & Francis Group,
an informa business*

© 2018 Taylor & Francis

The right of Matthew Leggatt to be identified as author of this
work has been asserted by him in accordance with sections
77 and 78 of the Copyright, Designs and Patents Act 1988.

*Library of Congress Cataloging-in-Publication Data*
CIP data has been applied for.

ISBN: 978-1-138-22099-7 (hbk)
ISBN: 978-1-315-41149-1 (pbk)

Typeset in Sabon
by codeMantra

MIX
Paper from
responsible sources
FSC
www.fsc.org   FSC® C013604

Printed and bound by CPI Group (UK) Ltd, Croydon, CR0 4YY

# Contents

# Acknowledgments

As always with a first monograph, there are so many people to thank. I'll start with my family: Pat, Roger, Chris, and Linda for their unwavering support over the years. I want to thank Laura for getting me through this and for helping me bounce so many of these ideas around. I wouldn't have made it over the line without you. Dan Varndell needs a special mention here. I've gotten so much out of talking to you about all of the issues in this book, and I'm forever grateful for the amount of your own time you've given up to help me. Thanks also to Caroline Williams for her advice. In my career to date, I've been lucky enough to have many people looking out for me, and I owe a great deal to them all. Two people in particular, Murray Pomerance and Linda Ruth Williams, need special thanks for their guidance and support over the years. Finally, a big thanks to all my friends and my colleagues at the University of Winchester for your encouragement.

I'd also like to acknowledge that some of this work, particularly sections of Chapter Three, are adapted from an article I published in 2016, and thanks goes to Interdisciplinary Literary Studies for permission to reprint in an altered form. For the original article, please see Matthew Leggatt (2016). Deflecting Absence: 9/11 Fiction and the Memorialization of Change. *Interdisciplinary Literary Studies*. 18 (2), pp. 203–221.

# Jump Number Ten

There are laws that most of us take for granted. Physical laws. Laws that, no matter how much we might want to and even at times try to break, still drag us inexorably along with them. That's all he could think about for a time. An unknown length of time. A time that seemed to collapse and fold in on itself until it became something infinitesimal, unmeasurable on any human scale. He thought about Newton and the apple, he thought about Eve and the apple. How does one measure gravity without feeling its tug on the back of your shirt?

He stared straight ahead, closed his eyes, and took a deep breath inwards. Some people, some mistaken people, called him a thrill-seeker. But this wasn't about the rush. It was an attempt at something he wasn't quite sure of. An attempt to piece together an experience he felt almost certain was unattainable for him. With eyes blinking against the sun, he stretched out his arms and then immediately wondered if that was one of the problems. His arms. Outstretched. Is that how they would have...?

The azure blue seemed to wink back at him. Perhaps it was the setting that was wrong. He needed the howl of sirens from the depths below, a sea of people, a sea of specks, looking up in wonder. Himself, right there with them. Or was this chasm the closest he would ever come to looking at the face of death?

He tried to put out of his mind that this was optional, that he had a choice and that, in fact, he'd paid money to be stood where he was at that moment, that precise moment, planned and orchestrated. It was like his life. Always playing catch-up. Spending too long planning and not enough time doing. But he had to plan because how else could the experience be total?

The wind gently fluttered his trousers as he edged himself forward, but there was a moment when it seemed to drop out entirely and the blazing heat pinpricked beads of sweat across his forehead. Would this time be any different from the last, he wondered? You never understand it until you are there in the midst of the motion, and then you don't understand it. How can you?

The push comes and suddenly everything else is replaced by that human impulse to fall.

What did he want from this? He wanted to see their faces, indistinguishable on the screen. He wanted to know if they were crying, if they were laughing, if they were horrified, or if they were smiling. He wanted to feel the heat over his shoulder, to see the lick of those furious red flames and the ugly billowing cloud that seemed to grow exponentially. Towering to where? God knows.

He wanted to see the face of God.

But what he saw, every time, was something completely different. His retinas were flooded with images, shards of light crisping through at the edges of his consciousness. Rolling fields of color strafing outwards in every direction. His eyes grew wider, trying to process, trying to assimilate these flickering images, piecing them together like a scene from a movie that had been edited beyond intelligibility.

He tried not to fight it, the fall, but then he wondered if this was also wrong. Was it wrong to fight inevitability? Can you fight something you know has already won?

The canyon yawned as he dived eagerly toward its open jaws. It was no accurate replica. That was clear. But in it he found something he thought might be familiar. It was its harshness and its overwhelming gravity. The sheerness of its expressionless faces. He spent time trying to fathom it. What was it that made this jump feel nearer somehow?

He thought about the cord. It didn't seem safe. They hadn't followed safety procedure. It didn't look tested. Something wasn't right. He began to worry. With each passing moment the worry turned to anxiety, the anxiety turned to fear, the fear turned to terror, and then he smiled. Not in some way that afforded him pleasure but almost like an automatic response, the muscles in his cheeks pulling at the corners of his mouth.

The colors continued to rush past, faster and faster. His head began to spin and he was no longer really in the conscious realm. Not of his actions at least. Not of his flailing limbs. These were things outside the moment that he could scarcely begin to interpret.

One thing he wanted to know: who were those people who jumped? Were they the kind like him who would sky dive, who would bungee jump, the thrill-seekers, the death drivers? Or were they just the closest ones to the flames; the ones without any options; the realists? He'd done some investigation. Tried to visit family members, girlfriends, friends. But most of the time he'd have the door slammed in his face. "I don't want to talk about it." "He wouldn't have jumped, he was a Christian." "Just leave us alone." He felt like maybe he needed to talk to the mistresses, to the *other* women or men in their lives, perhaps they knew the real person, but of course they were the silent ones that no one understood. Perhaps their lack of identity was the point anyway. He didn't really want to find out who they were because for him they were the experience of it all. To give that a face and a name, to find out what motivated that person, that, he thought, would probably just take him

further from the thing. So eventually he stopped. That was when the jumping started.

With the ground rushing up to meet you, you might hope for an epiphany, and maybe some get one, but not him. His falling always felt somehow out of control. He was a man who had gone through life without any sort of co-ordination, any sort of serenity. But he had made the most of what he did have. He resented those who made things look so easy, but he comforted himself with the idea that working hard for something might make it all the more pleasurable, even when it didn't. It just made him all the more tired. All those long nights at the office.

Now he was just like any other person, though. Falling.

What was that? He caught a glimpse of something swooping in fast. Must be a bird, and it was gone before he could process. Just another whoosh of light. Two lives almost in collision, moving in opposite directions. It was odd for him to think about it. A bird who spends its whole life in this alien environment. And him a man. At the mercy of quite different physical limitations. Limitations that seemed so inconsequential throughout his normal working day but now, and then too he imagined, immediate and pressing.

And time pressed on, second by second, but not at its normal rate. And he thought, if I could break down time into smaller and smaller fragments, eventually would it stop? They can do it in the movies, but what is a movie if it's not real life?

As he fell he was inventing new colors. The sparkling blue of the sky was now out of view but was left like a trace on his retinas and it mixed in a cascade, blurred into new shapes with the red of the rock out in front and the white of the shimmering heat. There was the black of the inside of his eyelids as he blinked them shut before forcing them open again, resisting the urge to hide from this terrifying new world because he needed to see what they saw.

But he knew the cord would not break, and this was his greatest disappointment. Not that it wouldn't break, but that he *knew* it wouldn't break. And so he was just like any other bungee jumper, at arm's length from the thing. The death that hung in the air that day was here replaced with something quite different. It was like he was back watching the TV again. Drawn to it, fascinated by it, that vision of sublimity, but always at one pace removed from it. Tumbling, falling, jumping, flying, what do all these words even mean? They are just verbs, loose connectors to actions. They sound so trivial. They seem to have so little weight. And yet in some circumstances, precisely the right ones, they take on new meanings. *Absorb* new connections, sucking them in through a kind of gravitational pull. That's because for them falling didn't really mean *falling*.

Falling from grace. Icarus. The sun blazing. The wind rushing.

What was he even doing here? This 48 year old man. Dressed in a suit. They asked him about the suit but he couldn't answer truthfully.

It was an office dare, he told them. Some people think his is a morbid fascination but there are far worse things. We're all fascinated by death in some way.

Watching the footage over, it felt so strange always to be on the outside. He wanted to see inside the building. Like a hidden-camera show. Maybe this was the purpose of the jumping. Forever trying to get a glimpse inside. It was that which truly separated the newsreels from the Hollywood films. The stubborn refusal of the cameras to take you where you really wanted to go. Inside the story was so very different; the calm exterior a front. The smooth surfaces, the glinting sunshine, the languid smoke, the smell of money—burning—all that was replaced by something entirely different inside. It was all just a mask for the rubble, the choking darkness, the panic, and the stench of scorched flesh.

He was nearing the bottom of the canyon now, and he was suddenly aware of the ground below. It became the focus of his attention, and all other thoughts drained away. It seemed to hurry toward him, and with each passing moment he saw it with greater clarity, the image becoming sharper and sharper. He could see the cracked earth like the cracks in his life. The image became a symbol. Maybe this was his epiphany. The jump was not their jump, it was his.

He imagined he could reach out and touch it now before his momentum began to slow, a sense of relief but also disappointment. Hanging there, suspended, a lurching feeling in his stomach as he bobbed up and down.

*The ride is over. Please make your way to the exit.*

Adrenaline still coursed through his body, but he felt different somehow. As he was winched slowly skywards, dangling there like some meaty bait on a hook, he saw the journey he'd just made but in reverse. It all seemed so slow, so sedate, so unthreatening now. A calmness had returned where just a moment ago a swirling vortex of light and sound had engulfed his senses. This is what speed does, it distorts, it changes the very nature of the object. Now only the ruffling wind through his hair disturbed the peace.

He thought he had it figured out. Not a sudden realization but a coming together, a working through of his collective thoughts on the jumps so far. It was about defiance. They were all defying something, and that's what connected them. The terrorists; they were defying America, the bloated God of global capital. The jumpers; they were defying their killers. Dying on their own terms. Sticking a middle digit up to those filled with hatred at their over-caffeinated lives. And him? He was defying gravity, defying death itself.

Of course, he would never replicate those feelings: the whirlwind of emotions that must surge through your body as you make that *choice*. To fling yourself out of a window, and know you're not coming back. It takes a certain type of person. A person he wasn't. But in those moments

when he was falling he thought of them, and they didn't seem so lost or so far away anymore. And when he stepped back onto that platform he felt just that little bit more alive.

Today is September 11, 2011.
And this is Jump Number Ten.

# Introduction
## Theorizing the Sublime

After a somewhat unconventional opening to this book, it is worth paus-
ing to draw breath, to take stock of the scene in front of us, before we
ourselves dive headfirst into the abyss of the sublime. Let us start with
the most obvious of questions: why begin in such a way? The answer
comes from the object of study itself. From the outset, the writer's job is
to define the terms of the writing, to attempt to shape and contain that
writing for the benefit of some imagined reader. In surveying the ground,
the writer must deal with the difficulties arising from the subject mat-
ter and in some way attempt to justify their own processes in order to
appease this imagined reader, perhaps even to build a bond of trust be-
tween the two. The writer immediately seeks to lay claim to the factual
ground upon which the assertions of the work are founded and in do-
ing so creates a necessary distance between the three spheres of writer,
reader, and object of study. The establishment of these three spheres
as somehow autonomous, disengaged if you like, is vital to the way in
which the reader comes to trust the veracity of the writing itself. But the
sublime demands a different approach; it resists such a segregation.

Here, with this short story, I intend to make the reader do the work of
interpretation because the sublime is not an object that can be so neatly
defined and explored without first acknowledging a necessary amount
of subjectivity, which comes to define the very essence of what makes
something sublime. This can be seen in the often personal, enigmatic,
and indulgent descriptions offered by theorists who have attempted to
articulate it, demonstrating perhaps *what* it is, but not necessarily *how*
it is, through the recreation of the very feelings of grandeur produced
by the sublime with their own personal use of language. Indeed, many
interpretations of the sublime lapse into a poetic form. Take this extract
from the psychoanalytic criticism of Julia Kristeva, for example, only a
fragment of a lengthier piece of prose describing the sublime: "for the
sublime has no object either," she writes.

> When the starry sky, a vista of open seas or a stained glass window
> shedding purple beams fascinate me, there is a cluster of meaning,
> of colors, of words, of caresses, there are light touches, scents, sighs,

cadences that arise, shroud me, carry me away, and sweep me beyond the things that I see, hear, or think.

(12)

The "caresses," "scents," and "sighs" of Kristeva's description mark this out as a psycho-sexual experience of the sublime, but there is the hint here that she retreats into this romantic and poetic form in order to escape any universal claim. For Kristeva, it is surely the beauty of her language, designed itself to elevate the reader to a heightened state, that is instrumental in the very definition of that which she seeks to define. Her reader is transported to a near-cinematic plane through which her own experience can be shared.

What is illustrated by both the short story and this example is the need to go beyond an analysis of content to consider form, since it is in its *form* that the sublime manifests its essential power. There have been theorists who have attempted to offer a structured framework to the understanding of the sublime, most notably the two 18th-century philosophers who are chiefly associated with it, Edmund Burke and Immanuel Kant: Burke with his effort to literally shape the object itself and Kant with his more scientific categorization of the sublime through the dynamic and the mathematical. However, most subsequent writers have tended to accept the ambiguous and rather personal nature of the sublime, often having been drawn to the philosophical construct for precisely these characteristics. Such are the difficulties presented by the sublime that one critic, Jane Forsey, goes as far as to suggest that a theory of the sublime is not even possible. However, the history of the *examination* of the sublime can be understood as an attempt to come to terms with a theoretical construction that seems to shift in appearance not only through time, fundamentally altered by our experience of culture and technology (as argued by David Nye), but also according to the individual. In fact, a stated objective of Philip Shaw's compendium, *The Sublime*, is not to highlight the consistencies in accounts of the sublime, an effort to bring this knowledge together to form a kind of unified understanding of the concept, but rather to expose the inconsistencies and disparities between key accounts of the sublime in theory through identifiable personnel such as "Longinus, Burnet, Burke, Kant, Lyotard, Derrida, and Žižek" (Shaw, 9). In short, as Nye suggests, "one person's sublime may be another's abomination" (xvii).

Returning to the short story with which this book begins, then, I have decided to embrace the experiential sublime rather than that which is less amorphous and more describable. Self-indulgent though the piece may be, it is also an expression of the themes of this book. Shaw uses the example of a bungee jump to articulate the proximity of terror to the sublime, stating that the jump, "mimics the suicidal descent into the abyss, providing the person who falls with a glimpse of what that descent *might*

really entail" (54). But, while the jump is indeed an interesting example that showcases the sublime experience, Shaw's subsequent assertion that "the experience of bungee jumping is pleasurable because the person who engages in this activity is reasonably certain that the elastic cord will rescue him or her from catastrophe" seems contentious (54). Surely the sublime is located not in the feeling of pleasure through safety, but in the feeling of terror through the worry that the cord *may not* rescue the jumper.

In fact, here lies an essential problem with the equation of the sublime with terror. Burke directly states that "whatever [...] is terrible, with regard to sight, is sublime too" (53), and yet it is widely accepted that being terrified alone is not enough to produce the sublime. Gene Ray, for example, argues that,

> a direct encounter with the violence or size of nature—actually to be in the landscape, that is—could precipitate a plunge into undiluted terror. But to contemplate such scenes from a position of relative safety renders the feeling of terror somehow delightful and fascinating.
>
> (*History, Sublime, Terror*, 134)

This is evident in the witnessing of a storm: to be caught directly in its path without shelter would likely lead to fear or, at the very least, some discomfort, but to witness its power from the safety of one's home can render it sublime in the classical sense. A similar experience can often be seen in response to the terror event; those who watched the scenes of the September 11 attacks unfold in 2001 through the medium of the television set were, perhaps, closer to the experience of the sublime than those trapped in the towers who would have almost certainly experienced an "undiluted terror" of the type described by Ray. It is the addition of a mediator, then, that Ray claims allows the sublime and terror to overlap, but terror unadulterated is simply terrifying. Thus, it becomes important, when weighing up the sublimity of images of terror, for example, to be aware that people view their proximity to such terror from a variety of positions. Terror, conceptually speaking, is not sublime; neither are terrorists. Rather, the images and the emotions such agents produce fill this role. Whether it is the image of a building collapsing, a man kneeling with a knife to his throat, bodies covered up after a mass shooting, or terrorist militia in far-off lands celebrating their occupation of another Syrian or Iraqi town, the circulation and reproducibility of these pictures color our perception of the world. In the West, of course, our chances of being injured or killed in a terrorist attack are extremely small, despite what the media would have us believe. Indeed, I undertake any number of daily activities that are far more likely to kill me without even the slightest sense of fear. But this flood of images is itself provocative of the

sublime, adding the real sense of fear that this could actually happen to us; that the cord, so to speak, *might* really break.

This brings me to the other central issue with which this book—and the short story that precedes it—is concerned: nostalgia. It is my contention, here, that our encounters with the 21st-century sublime, held predominantly in the form of our response to the terror of our confrontation with the global, bring about a desire to relive the past. Just as the jumper attempts to come to terms with what he has seen on the television by trying in vain to recreate the leap of certain death with which those who jumped from the towers were faced, in memoriam, today's culture is being shaped by a desire to escape into the past as a way of assimilating the horrors of the present. While I will return to this idea at some length in the closing thoughts of this book, it is worth noting that during the writing of this work a number of political events occurred in the UK and the U.S. that seemed to echo this shift. 2016 was the year in which nostalgic politics hit full-swing, or rather full-reverse, first with Brexit in the UK—the country voting in a referendum to end its 40-year membership of the European Union (originally European Economic Community)—and then, of course, the election of Donald Trump as the 45th President of the United States of America, a man whose slogan (not to mention economic, social, and foreign policies) 'Make America Great Again' fairly epitomized the nostalgic zeitgeist. Much of this book had already been written by the time these two geopolitical quakes struck, but nonetheless they seem too important not to mention here, marking, as they seemed to, the entry of a cultural nostalgia into the mainstream political arena. While the origins of this political movement can be seen as largely economic—the rhetoric's focus on American and European declinism coming as it did after a lengthy period of weak financial growth in the wake of the 2008 financial crash, alongside a more general sense that many in the so-called 'West' now feel cut off from the perceived benefits of globalization—the origins of this nostalgic culture seem to go back further. These can be traced to a moment of great optimism about the future of American power and the subsequent lack of fulfillment of this promise.

When the political think tank Project for the New American Century (PNAC) formed in 1997, its agenda was to secure American interests against the perceived dangers of the 21st century but also to exploit the potential opportunities the moment presented. In a 2000 report entitled "Rebuilding America's Defenses" the PNAC—many members of which, most notably Dick Cheney, Donald Rumsfeld, and Paul Wolfowitz, went on to occupy prominent positions in the Bush Jr. administration—stated that one of its "Key Findings" was the need for America to "fight and decisively win multiple, simultaneous major theater wars" (iv). Following this, just nine days after the September 11 terror attacks of 2001, the same think tank sent a letter to President Bush advocating regime

change in Iraq "even if evidence does not link Iraq directly to the attack." "Failure to undertake such an effort," the letter stated, "will constitute an early and perhaps decisive surrender in the war on international terrorism." The subsequent retaliations of the Bush administration indicated that the PNAC would get their way, but by the end of the first decade of the 21st century this 'New American Century' seemed to have been derailed before it had even begun. By this time, and despite no further large-scale terror attacks having been perpetrated on U.S. soil, the events of 9/11 had become of increasing cultural as well as military significance in large part due to their continued exploitation in political rhetoric and the military quagmires that developed in Afghanistan and Iraq, both products of the War on Terror initiated after September 11. In these founding moments, a cultural nostalgia was beginning to form; a desire to retreat into the late 20th century, before the revelation that this new American power had fostered hatred and created enemies around the world; a period chiefly associated with American expansionism, invincibility, and technological wizardry.

Although it has long been thought that the sublime, because of its manifestation as a sense of wonder, was concerned with novelty and futurity (indeed, a whole discourse sprang up around the sublime as a mode tailored to the science-fiction narrative most notably through Scott Bukatman's *Matters of Gravity* and his concept of the 'Artificial Infinite' (2003)), today—and as this book will seek to demonstrate—the sublime resonates far more clearly in our experience of history and pastness than with the beckoning of a shiny scientific future. Indeed, the alternative I present in this book is that this cultural and political nostalgia is experienced largely as a response to the climate of fear driven by today's divisive politics, the mediatization of terror, and the sheer scale and overwhelming complexity of the global web within which the individual feels trapped.

Kant's mathematical sublime might be of particular use to us here, since it deals explicitly with the sublime as a response to a stimulus that overwhelms *cognition* rather than merely our senses. It is concerned not with the impact of physical objects and their overwhelming size, but rather with the kinds of calculations humans must make when confronted with *ideas* and *machinations* that appear to lie beyond the realm of our comprehension. Indeed, in Kant's estimation, it is often the product of human encounters with the infinite or seemingly incalculable that provokes the experience of the mathematical sublime, a realization that the only context I can surely provide against a certain scale, my very body, becomes but a speck in the cosmos, a grain of sand on an endless beach stretching farther than the eye can see when compared with, say, human migration across the face of the Earth, or human suffering in other lands under constant bombardment, or commerce and manufacturing when we stop to consider the impact of globalization. The

applicability of the mathematical sublime to concepts rather than objects makes it more useful for a discussion of the contemporary sublime as on some level our experience of the global represents the *failure* of Kant's mathematical form seeing as it rarely produces the pleasure he associated with the triumph of reason over incalculable scale. Kant posits that in our first encounter with an object beyond aesthetic sensibilities we must use our powers of imagination in order to rationalize it and that our sense of pleasure and awe in this comes not from the size of the object itself but from the recognition of our own infinite reason and ability to process the totality of such formless things despite their enormity. Our encounters with the global, however, challenge this idea since they more frequently tend toward a feeling of paralysis rather than elation or any innate sense of achievement that the mind can bridge such a gap. Indeed, the work of Bruce Robbins, perhaps, more accurately reflects the sublime as it is referred to throughout this book and in particular its relation to contemporary geopolitics.

In his work on the 'Sweatshop sublime,' Robbins argues that in the case of the global our power of rationalization never truly conquers the apathy provoked in our initial encounter with the sublime. In his account, when confronted by the infinite complexity of this global landscape we are not empowered by a sense of human achievement or rationalization but rather rendered incapacitated. Such fleeting moments or experiences can be brought about from as simple an action as switching on the kettle in the morning or putting on our favorite T-shirt. Ultimately, our response to this action, which when considered transports us through a maze of impossibly complex methods of manufacture, transportation, and consumption, tends toward the following potential outcomes: first, we can stand up and fight against what we perceive to be the loss of the individual at the heart of the politics of globalization; we can join action groups, for instance, seeking to protest against multinationals and world bodies that exploit the poor in order to provide us with the luxuries we enjoy on a daily basis. Second, and this could be considered a similar kind of action-based response but on a lesser scale, we can appease our guilt by giving to charity. Finally, we can take the more likely potential outcome, the easy route, so to speak, whereby we put the T-shirt on or make our cup of tea and forget about the plight of those likely producers. Most often, when confronted with the sublime realization of our place in the contemporary global machine, we just move on with our day because of the rather crippling sensation that we ourselves are powerless against the global shifts and capital flows that direct us and are beyond the scope of individual control. This more common response is nostalgic because, whilst suddenly an entire world of connections has become available to us as we consider the journey from earth, through manufacture, to consumption, ultimately the resolution of these complexities comes through a retreat into the latter. Our *consumption* of the sublime,

like our consumption of goods, takes us back to that fundamental expression of life as desire. As Lacan would have it, we are humans merely drifting from meal to meal, hoping that the next will somehow nourish the soul. So, we fall back on nature and outwardly grumble about governments, corporations, and social injustice, whilst continuing to play our part in the system that supports such inequalities whilst they ultimately support *us*.

This consumption of the sublime is important since, as we have already seen in our brief foray into its historical ancestry, the sublime has been given a great number of names and forms by both contemporary and much earlier critics. The proliferation of 'sublimes' suggests both its malleability and persistence as a concept, as well as the way in which it tends to absorb the characteristics of the age. This is why I seek in this book to offer up the sublime as peculiarly applicable to today's world of alarmist cultural output, suggesting that the contemporary sublime is an emotional connection and response to the oppression of the global, which in turn provokes a desire to get back to *something*, in particular, back to a 'simpler' past life that manifests itself in a cultural and political nostalgia.

Jean-François Lyotard used the sublime with particular reference to the term nostalgia in his attempts to define *The Postmodern Condition*, identifying two modes of the sublime, which he termed the 'melancholic' and the 'novatio.' While the novatio is forward looking, since according to Dan Webb, "it celebrates the new and genuinely induces in the subject the mixture of pleasure and pain characteristic of the Kantian sublime"—this is, perhaps, the pleasure of the new and the pain of leaving something behind—in contrast, the melancholic sublime focuses on "the inadequacy of the faculty of presentation, on the nostalgia for presence experienced by the human subject and the obscure and futile will that animates it in spite of everything" (Lyotard, 13). Thus, for Webb, "the melancholic [...] alludes to a longing for what once was; a nostalgia for harmony" (520). It is this same nostalgia for harmony as the product of the confrontation with the sublime that I argue is consistent with 21$^{st}$-century culture and more recent political populism. What is particularly interesting in this, however, is that Lyotard associated the melancholic sublime with modernism and the novatio with postmodernism. As Paul Crowther elaborates,

> for Lyotard modernism in art involves an orientation towards the sublime. However, 'nostalgic' works do not fulfil their sublime potential. The fulfilment of such potential is achieved, rather, by those works of 'novatio' which make the nature of art explicitly problematic through striving to present it as a possibility of infinite (and thence unpresentable) experiment and development.

(71)

Thus, for Lyotard, nostalgia produces only a second-rate form of the sublime experience in comparison to postmodernity, which exposes us to the infinite variation of representation. This is interesting as, in this book, I argue that we experience the sublime today in reaction to the *lack* of originality in today's ideas, the infinite *im*possibility of expression and agency, even in a world that promises complete autonomy.

Taken in sum, then, Lyotard's description of the sublime leads to a revelation about the postmodern. If the nostalgic sublime is characteristic of modernism rather than postmodernism to the extent that the postmodern restricts our very capacity for ever experiencing a genuine nostalgia, then this implies that today's melancholic sublime represents a break from, or even the end of, the postmodern age. Fredric Jameson argues that the postmodern is in part defined by its "random cannibalization of all the styles of the past" but that this offers nostalgia only by way of pastiche (*Postmodernism*, 18). What I argue here, however, is that such styles have moved beyond the empty signifiers associated with postmodern nostalgia. Instead, in the 21st century, nostalgia for the past takes on key political and cultural roles, manifested in a desire to seek *answers* in the past and suggesting a violent return of the melancholic sublime. This action is an *active* desire to return to the past, predicated not just on aesthetics but on the willingness to combine the comforting nature of the old with the technologies of the new. While it might seem contradictory to suggest that the apathy created by the melancholic sublime and its resultant nostalgia is a spur to action, exactly this apathy has recently led to a seismic shift in Western politics. Disillusionment with 'traditional' politics and a loss of faith in politicians and their ability to bring about genuine change has been the driving force behind some of the more surprising political successes in the U.S. and Europe. This new brand of 'politics' has succeeded in large part because the politicians advancing it have tended to offer simple, and predominantly regressive, answers to complex problems. The powerful forces of nostalgia from which they draw their political energy were first seen primarily only in culture but have since become, somewhat belatedly, echoed in the success of candidates who threaten to 'shake up' the world order by throwing us back into the past.

Whilst *Cultural and Political Nostalgia in the Age of Terror* explores a whole range of contemporary cultural forms from architecture, art, literature, and the digital environs of film and gaming, what remains ever present is a rooted connection with the past. In each of these areas, the sublime becomes synonymous with a retrospective appeal to a time of simplicity, particularly heightened in the face of the perceived encroachments of the external forces of terror. The aim of this book, therefore, is to equip the reader not so much with another form of something old (another offshoot to add to a collection of 'sublimes') but to leave him or her with questions about contemporary culture and its discourse of

alarmism; to give the reader a tool with which to consider, examine, reorient, and rearticulate the contemporary experience.

In the opening chapter, the book explores the idea of openings themselves by considering the definitive moment of sublime terror planted at the very doorstep of the 21st century. I draw on discourse surrounding 9/11, including seminal works by Jean Baudrillard, who famously described the 9/11 attacks as elevating the Twin Towers to the eighth wonder of the world, and Slavoj Žižek, who observed that the terrorists committed the act primarily for its "spectacular" appeal (*Welcome to the Desert of the Real*, 11), to lay the foundations for an argument that sees the contemporary period as particularly evocative of the sublime, noting also the connection between the sublime and terror—the operative term in reference to post-9/11 politics. In this section, architecture is considered central to today's experience of these emotional responses to our environment, and thus, ideas around verticality, the skyscraper, and building demolition are also explored before pausing to consider the symbolism of the 9/11 memorial Reflecting Absence as an evocation of the melancholic sublime.

From this, we move to an analysis of the role of art more broadly in relation to the melancholic sublime in Chapter Two. Many commentators have noted the artistic 'qualities' of the terrorist act, most controversially Karlheinz Stockhausen and Damien Hirst, but also to a lesser extent filmmakers like Robert Altman who attacked Hollywood film as a source of inspiration for the terrorists. It seems, therefore, useful to examine the connection between the contemporary terror event and art, along with art's goal of recreating the sublime image. Here the concepts of falling and collapse are explored with a focus on the image of the Falling Man and its intertextual points of comparison. Finally, consideration is paid to contemporary terrorist actions as artistic performance with reference being drawn to attacks in the U.S. and Europe throughout the 21st century to date, ultimately arguing that the forces of terror and global responses to terror have been aligned in their orientation toward nostalgia and regression.

Chapter Three further suggests that the sublime images we see of terrorist violence are evocative of a melancholic sublime in that they draw on reference to past images of desolation and destruction as a form of remaking. This is considered in relation to the destruction of historical landmarks by terrorist groups, particularly the Islamic State in Iraq and Syria, but also through the study of 9/11 literature in order to demonstrate the attraction toward the event as a historical watershed. A host of literary responses are considered including Don DeLillo's *Falling Man*, Jonathan Safran Foer's *Extremely Loud and Incredibly Close*, Mohsin Hamid's *The Reluctant Fundamentalist*, Joseph O'Neil's *Netherland*, and others that position the moment as a sublime impasse that fundamentally reshapes the future. In doing so these texts, I argue, establish

the past as a moment of lost innocence to which their protagonists are forever seeking a return. Thus 9/11 literature *echoes* the melancholic sublime.

Having established in Part One that our experience of the sublime and terror overlaps with our experience of the image in culture, the second part explores the changes that have occurred to the very nature of such images in the post-9/11 era with particular reference to the impact of the digital on our experience of the sublime. Chapter Four opens by considering Vincent Mosco's account of what he terms the "digital sublime" and then branches out to explore the relationship between this digital sublime and a nostalgia for older forms of image and effect. Thus, the focus of this chapter will be the link between digital media and our ideas of interconnectivity and sublimity versus the powerful dystopian discourses that circulate in relation to the dangers presented by the potential that such technology will be used by forces of terror. It begins by critiquing often-made suggestions of the digital as a site for the sublime alongside the ideas of cyber-utopianism before analyzing the increasing popularity of retro video gaming as evidence that the digital sublime has provoked a nostalgia for older forms of gaming, image, and production techniques that challenge ideas around digital convergence. Thus, both the discourses of cyber-utopianism and cyber-terror draw on nostalgia as a means of confronting the sublime interconnectivity offered by digital technology.

The argument in this part culminates in an analysis of the sublime in contemporary cinema with particular attention paid to nostalgia for older types of special effects such as physical effects, animatronics, stunts, and stop-motion. Connecting this with terror and disaster narratives in particular, the final chapter deals with key critical discourses advanced by Walter Benjamin and David Nye's conception of the American Technological Sublime. Another consideration is the longevity of digital special effects and the Uncanny Valley, the idea that the closer effects get to reality the more their imperfections stand out to spectators. Some films that will be considered include *Jaws*, *Independence Day*, *Jurassic Park*, *Avatar*, and *Star Wars*, all of which show how digital technology has advanced the industry but also produces a counter-current of popular nostalgic desire for the 'authenticity' of past cinematic special effects.

Why this book now? Cornelia Klinger observes that, "the discourse of the sublime comes up in times of crisis, when major changes are impending," but she is also quick to highlight that "there is hardly any period in the course of Western history which would not qualify as a time of crisis in some way" (92). Whilst I do not wish to presume that crisis abounds, we would be forgiven for thinking, with the daily pronouncements of doom that help spread fear through 24-hour news outlets and our 'plugged-in' lifestyle saturating our senses with news of atrocities

happening around the globe, that the world we know and understand (or fail to understand) is under siege. The powerful forces of ideological radicalization appear as our greatest threat, terrorism leaking out of the Middle East and spilling blood on the streets of the U.S. and Europe, but if that doesn't get us then surely the slow and steady march of climate change will leave us in a doomsday scenario akin to its many manifestations in contemporary Hollywood disaster films from Kevin Reynold's *Waterworld* (1995) and *The Day After Tomorrow* (Roland Emmerich, 2004) to J.A. Bayona's *The Impossible* (2012). The contemporary world, then, is experienced as an intoxicating collision between technology and fear. It is, perhaps therefore, unsurprising that when faced with the seemingly insurmountable problems of global climate change we might be tempted to retreat into melancholia and nostalgia. But this is exactly where the problem lies.

Throughout this text I argue that the impact of the melancholic sublime on our culture and its subsequent infection of geopolitical thought is wholly detrimental in that it bars the way toward productive forward thinking and the social and political change needed so urgently in the 21st century. Thus, in my closing thoughts I return to the political origins of this book to consider the role of the sublime in creating political apathy, regressive and conservative political movements, in the stifling of progress, and the promotion of nostalgia and violence. Let me finish this introduction by suggesting that today *is* a time of crisis, but it is a crisis born not necessarily out of those common fears we hold, but rather out of the very nostalgia that this book delineates. So if this book is anything it is a call to action, a call to look up from the pages of history and to end our retreat from the terror of the modern world into a violent retaliatory nostalgia that only meets violence with more violence and looks backwards instead of ahead at the global challenges we face. It is a call to resist our enslavement by images of the sublime that render us powerless against the global malaise. And finally, it is a call to restart this century—which began on the wrong foot—and to return to a sublime that finds its fascination not in the infinitely overpowering complexities of the world, only serving to crush our creativity and progression, but in the wonder at human achievement and what this century can hold for us if we put aside our differences and work together toward common goals and our own betterment.

Part 1

# Sublime Terror and Violence in the 21st Century

# 1  9/11, Sublimity, Ruination, and the War over Architecture

"In every culture, height – and its architectural expression, the tower – stands for power, control, lordship, and mastery" writes Wolfgang Schivelbusch in his epilogue to *The Culture of Defeat* (292). When the World Trade Center opened in 1973, *its* towers, standing at over 415 meters, were the tallest in the world, their spectacle magnified by their doubling. Today, America is seen as the home of the great metropolis. The skyscraper in particular, generally considered to originate with the Home Insurance Building in Chicago built in 1884, was the form that came to dominate the skylines of major U.S. cities during the course of the 20th century. For over a hundred years the world's tallest building could always be found in America, and while this has changed since the late 20th century—the majority of the world's tallest buildings are now situated in China or the UAE—it is, nevertheless, this history that has enshrined the U.S. as the cultural home of both the city and the skyscraper. This was certainly not always the case, however. The Founding Fathers, most notably Thomas Jefferson, saw cities as both dangerous and morally dubious. In a letter to James Madison in 1787, Jefferson wrote that "when [the American people] get piled upon one another in large cities, as in Europe, they will become corrupt as in Europe." This was hardly surprising considering Jefferson's belief that "those who labour in the earth are the chosen people of God" and that when he became President in 1801, some 95% of Americans lived on farms compared to around 2% today. The cultural transformation that would take place over the next 200 years would involve the reworking of ideologies associated with both rural and urban spaces and would eventually come to establish cities as the most 'natural' form of capitalist expression; the privileged site for the manufacture of the American Dream. The symbol for this cultural work became the skyscraper, its verticality echoing the democratic and meritocratic social mobility possible in this new urban landscape.

Robert Bevan highlights that, "for early Modernists [...] the skyscraper was an architectural representation of the future and of confidence in the future" (66). How apt, then, that the destruction of such skyscrapers on September 11th of 2001 would prove for America, the very home of 20th-century modernity, the catalyst for nostalgia and regression.

Rewind a mere decade or so, and as the Berlin Wall, another symbolic architectural edifice, was falling, scholars (and politicians) clamored to define a new era of American world dominance. Two texts in particular emerged, demonstrating the polarized and competing views on the shape of global politics to come. Francis Fukuyama seemed to blink first with his proclamation that in 1992 *The End of History* had arrived. In the 21st century, he argued, the world's remaining dictatorships would fall at the hands of democracy; the power vacuum left by the end of the Cold War would clear away the fearful tyrants who remained, unable to resist American supremacy and the lure of new technologies that promised a more open and free world. Indeed, even today, as Mark Fisher highlights, "Fukuyama's thesis that history has climaxed with liberal capitalism may have been widely derided, but it is accepted, even assumed, at the level of the cultural unconscious" (*Capitalist Realism*, 6). Thus, its influence is assured even while its premise has been undermined by world events. It has, as an idea, become representative of a kind of utopianist nostalgia for a pre-9/11 optimism about the future of the world. At the other end of the spectrum, just one year later, came Samuel P. Huntington's now infamous article that warned that the next century would be dominated by what he described as the clash of civilizations. Fearing the spread of religious ideologies and their collisions in the increasingly multicultural global environment, Huntington cited directly the dangers of Islamic extremism. Just as Fukuyama's thesis has since been regarded as idealistic, Huntington's alternative narrative is the so-called 'realism' at the core of the politics of fear, which has been the hallmark of Western government since 9/11. Throw into this melting pot the rhetoric in academic circles surrounding the power and reach of globalization—the opportunities, as well as dangers, that came with what newly elected Democratic President Bill Clinton called the interdependency of nations—and we have some idea about the power of the competing discourses at the time, all of which were seeking to offer coherent visions of the future.

It was hardly surprising, then, that In 2000 Anna Tsing challenged the naïve optimism of academic discourse on globalization, which she cited as offering "globalist wishes and fantasies" rather than objective reality (51). Such a statement might seem alien to us today given the number of pages since 2001 that have been dedicated to critiques of Americanization, globalization, cultural imperialism, and the recent swing of popular politics toward right-wing antiglobalist groups in the U.S. and Europe. The debate seemed settled when on September 11, 2001, American Airlines Flight 11 and United Airlines Flight 175 were flown into the financial center of this globalist fantasy: New York's World Trade Center. What seemed clear in this instance was that Huntington's pessimism rather than Fukuyama's optimism had won the argument. What had determined this prevailing vision of the future, then—one tainted by terror, in which nothing was safe and anyone could be

instantly made a target—was in fact a rearrangement of American ideas around its own architecture.

Bevan relates that Mohammed Atta, one of the leaders of the terrorists involved in hijacking and flying American Airlines Flight 11 into the North Tower of the WTC, was an architectural scholar with a particular interest in Islamic style and history. According to Bevan, the Egyptian Atta

> was horrified [...] at the way Western skyscrapers and modernist development intruded upon and overshadowed the old quarters of Aleppo, Syria, which he had studied for his doctorate, and at Egyptian government plans to regenerate an historic neighbourhood of Cairo as an 'Islamic Disneyland' for Western tourists.
>
> (65)

At the center of the attacks, then, was a young man who understood the power of architecture to both dominate a landscape and to act as a symbolic focal point for ideas about cultural identity and history. One might also note that the WTC buildings themselves were at least partly influenced by Islamic architecture and that their designer, Minoru Yamasaki, was known for his fusion of modernist and Islamic styles. For Atta, then, we could speculate that the Twin Towers were symbolic of a cultural appropriation by the West of a style he himself revered. They were also, of course, a symbol of American economic and cultural power that, with carefully orchestrated intervention, could be turned into a site of humiliation. Thus, when Atta's plane flew into the WTC building it would become a literalization of Huntington's clash or conflict between not just two ideologies, but two world orders that are defined by the very architectural foundations upon which they are built.

For Schivelbusch, "with the towers' collapse, two other dimensions were made visible: the sheer violence of their physical mass, evident in the wreckage, and the extent of the hatred that had chosen them as symbols to be destroyed" (Schivelbusch, 292). The terrorists had managed to replace the powerful sense of wonder experienced by those who encounter objects of great architectural ambition and achievement with an equally powerful fear of such objects. If the skyscraper is the quintessence of late capitalism, with its emphasis on power, luxury, excess, vertical stratification, and a concurrent tendency toward efficiency—the maximization and optimization of space in overcrowded commercial hubs—the terrorists were determined to prove its ideological vacuity and emptiness through ruination. The towers' subsequent absence from the skyline, they hoped, would always offer a reminder of the absence at the very heart of the ideology for which those same towers stood.

A quick excursion through Percy Bysshe Shelley's famous 1818 poem "Ozymandias" hints at a way we might read this attempt at humiliation

through ruination. Shelley's poem about the ruined statue of an Egyptian King whose head lies "half sunken" in the desert sands next to a pair of enormous legs was written in competition with his contemporary Horace Smith whose lesser known poem of the same name opens with an image of "a gigantic leg, which far off throws/The only shadow that the Desert knows." What is particularly relevant here is that in Smith's poem, the ruin still has value and power. By choosing to focus on the creation of a shadow, Smith shows how even after its near complete destruction, the statue has an impact on the land around it and is able to speak of a power now passed. Thus, by the end of Smith's poem a future character "stops to guess/What powerful but unrecorded race/Once dwelt in that annihilated place," emphasizing a power that still speaks through the ages. Smith's poem, then, can be seen as less a commentary on the ruination of power and its ephemerality and more an acknowledgment that even the ruin can give command and legacy.

In Shelley's version a "traveller from an antique land" describes a scene witnessed in the desert of the ruined statue of this same Egyptian King. The "colossal wreck" also speaks through the ages, but only via a second-hand verbalized account. Shelley's narrative viewpoint therefore suggests a certain mythicality to the traveler's description. What is more, Shelley includes details of an inscription on the statue's pedestal, which reads: "My name is Ozymandias, king of kings:/Look on my works, ye Mighty, and despair!" While it is certainly an intimidating message, its strength only serves to emphasize the impotence of the now-ruined force disappearing beneath the sands. The arrogance of the king, his self-proclaimed might and appeals to terror, his "sneer of cold command" are all ironized through the statue's ruination and the agony of the slow-sinking decapitated head piece. While Smith uses "forgotten" to refer to the greatness of the civilization and the King that produced such a statue, Shelley refers instead to its "decay." For Smith, the ruin produces a sense of wonder, whereas for Shelley the destruction of the statue undermines the very might professed to by the king. Thus, Shelley's poem shows how through ruination history can be rewritten, the 'mighty' challenged, and narratives changed. Indeed, Robert Young recognizes the revolutionary potential of Shelley's "Ozymandias," arguing that the poem "demonstrates that meaning, like power, is not stable or fixed, and that even power cannot guarantee a tyranny of meaning" (238). Shelley, known for his radical politics, seems to suggest that in creating a ruin, one might be able to highlight the fragility of power and undermine its hold over the imagination. It is, perhaps, in this context that we can read Atta and the other terrorists' attempts to humiliate and *reduce* American power. While far from being revolutionaries, the terrorists did seek to use the power of ruination to highlight the impotence of an empire they viewed as tyrannical.

It may seem somewhat odd to refer to the World Trade Center as a ruin, given that so little of it was left standing after the attacks and that

it has been—in a notably lengthy process—now replaced as a structure both symbolically by the 9/11 memorial and functionally by the new WTC complex of buildings. However, in the 21st century the old WTC still occupies the *imaginary* space of the ruin. Indeed, it can be imagined as such not just because its destruction left a yawning chasm in the center of Lower Manhattan for almost a decade, but because in our mediated world the images of its destruction have been preserved forever and replayed so often they have come to override any image of the towers as they were before the moment of impact. Faced with images of its ruination, the twisted skeletal steel structure silhouetted hauntingly against a backdrop of dust, we are left with only a resonant fear of the violence that transformed such mighty towers into this wreckage or a retreat into nostalgia for the buildings as they were. Thus, what is recognized in both Shelley's poem and in the lasting image of the vanquished WTC towers is that images of destruction and defeat appear more powerful and durable in the social unconscious than those of triumph or defiance.

## The Violence of Sublime Architecture

Throughout the 1970s, 1980s, and 1990s, the WTC buildings were architecturally derided. As Harriet Senie describes, "over time, as postmodernism replaced modernism as the architectural style and mode of thinking, the towers seemed less objectionable but they never achieved the visually iconic status of the Empire State or Chrysler buildings" (3–4). Nevertheless, the towers did, during this period, feature in hundreds of movies and television shows, and this certainly had a significant impact on their reconfiguration after destruction as the nostalgic and romantic heart of New York City—their continued appearance in reruns of the 1990s hit sitcom *Friends* (1994–2004), for example, acting as a constant reminder of their absence long into the 21st century.

The sense of nostalgia the buildings now invoke is also induced by James Marsh's arresting documentary *Man on Wire* (2008), which recounts Philippe Petit's wire walk between the buildings in 1974. Offering what Bryan Appleyard has called "a mood of anticipatory sadness and nostalgia for a pre-9/11 world" (quoted in Martin Randall, 88), Marsh's rather beautiful film highlights the towers' sublimity as monuments to the power of not just architectural ambition and achievement but to the very concept of what David Nye has termed "the American Technological Sublime." In the film, Petit, himself, rather theatrically describes his fascination, even obsession, with the towers, his inexplicable compulsion to conquer them. As the crowds gather below in astonishment, the performer's elation at traversing the 200 feet between the two buildings is written on his face. Indeed, the Frenchman appears entirely fearless as he dances, smiling from ear to ear and even taking the time to lie down on his wire all the while taunting the New York cops who watch

helplessly—and rather comically—from the adjoining rooftops. Referred to by the documentary's narrator as "the most sublime and transcendent episode in the entire history of the World Trade Center"—a statement that reads as part tragedy—Petit's stunt is positioned as a key moment in the buildings' transformation from lifeless and commercialized objects of ridicule to a romanticized focal point.

*Man on Wire* closes its account of the walk with a reference to Petit signing his name in "indelible ink" on a steel beam overlooking the chasm across which he performed. It is a particularly vivid example of the way in which the text aims to capture something of the towers that can never be demolished. By refusing to reference the events of 2001, *Man on Wire* enshrines the Twin Towers as monolithic objects of nostalgia that cannot be wiped from memory. Writing for *The Telegraph* on the more recent dramatized version of the film, Robert Zemeckis' *The Walk* (2015), Robbie Collin argues that the film "takes two buildings that have become emblematic of everything that's frightening and uncertain about 21st century life in the West and redeems them" (2). Indeed Zemeckis aestheticizes Petit's story in a startling way—his use of 3D, for example, reportedly caused some moviegoers to experience vertigo-induced vomiting in the cinema auditorium. What is, perhaps, most interesting about the recent film, however, is the underlying desire to revisit Petit's story again some fourteen years after the destruction of the towers, which seems to attest to a cultural longing to somehow resurrect, or at least pay homage to, the World Trade Center.

While Petit initially refers to the South Tower as "monster" and "beast"—not unlike Baudrillard who, in *The Spirit of Terrorism*, describes the towers as "architectural monsters" (41)—eventually the wire walker comes to see them as his "friends," another "ally" in his caper. This sentimentality toward the WTC buildings is further echoed in Baudrillard's articulation of the significance of the buildings' destruction as part of the shifting narrative of the New York skyline. Prior to the building of the WTC towers, he notes,

> all Manhattan's tall buildings had been content to confront each other in a competitive verticality, and the product of this was an architectural panorama reflecting the capitalist system itself – a pyramidal jungle, whose famous image stretched out before you as you arrived from the sea.
>
> (38)

For Baudrillard, it was the WTC that changed this:

> the effigy of the system was no longer the obelisk and the pyramid, but the punch card and the statistical graph. This architectural graphism is the embodiment of a system that is no longer competitive,

but digital and countable, and from which competition has disappeared in favour of networks and monopoly.

(39)

What, then, can be made of Daniel Libeskind's designs for the new WTC complex? These new towers—resembling not punch cards or bar charts but rather an obsession with the fragment, a concentration on surface and reflection—withdraw into the sky echoing the absence and loss of the originals.

This sentiment is repeated through the symbolism of Reflecting Absence, the memorial located at the feet of the new WTC towers in the hollowed footprints of their predecessors. The two pools of water that form its centerpiece are described by their designer as "large voids, open and visible reminders of the absence" (Arad, 1). David Simpson explains that, "the very title of the project, "Reflecting Absence," mimics and pays homage to Lutyen's great memorial at Thiepval, also composed of names where no bodies could be found, also evocative of an emptiness both physical and metaphysical, an "embodiment of nothingness"" [Jay Winter's phrase in *Sites of Memory, Sites of Mourning*] (*Culture of Commemoration*, 78–79). In its aesthetic, however, a more worthwhile comparison might be Maya Lin's hugely successful Vietnam memorial that opened in Washington DC in 1982, which also displays names engraved on a reflective black granite that recedes from view. The central difference, perhaps, is that whereas Lin's memorial commemorates actions that took place much further afield, and therefore maintains a 'reflective' distance, the 9/11 memorial is—while admittedly located on a prime piece of real estate at the heart of Lower Manhattan—a haunted space, the space where the victims actually perished.

In architect Michael Arad's proposal for Reflecting Absence, he claims that the memorial is designed to articulate the sense that the destruction of 9/11, and the deep outpouring of emotion that followed, is somehow unattainable; it cannot be assimilated into consciousness. In his short description of the experience the memorial would offer, Arad writes that, "at the bottom of their descent," future visitors would,

> find themselves behind a thin curtain of water, staring out at an enormous pool. Surrounding this pool is a continuous ribbon of names. The enormity of this space and the multitude of names that form this endless ribbon underscore the vast scope of the destruction. Standing there at the water's edge, looking at a pool of water that is flowing away into an abyss, a visitor to the site can sense that what is beyond this curtain of water and ribbon of names is inaccessible.

(Arad, 3)

Note how the "enormity of this space' as much as the names on the walls signifies the "scope of the destruction." The focus on the space itself, directly representative of the size of the towers, seems a fair admission that the spectacle of destruction overwhelmed the sense of grief for the victims. Arad's description clearly evokes a sense of nostalgia for an unattainable past; the moment before this absence, underlined by his reference to the thing 'beyond' the names. Thus, for all the beauty and peace of the place, Reflecting Absence, in both name and design, evokes the feeling of an unfillable void: as Marita Sturken argues,

> although [it] is not minimalist with a radical intent, it is imbued with a modernist aesthetic of emptiness. While it is designed as a memorial to the people who died, its aesthetic of absence also seems [...] an evocation of the towers.
>
> (266–267)

In its very name, Reflecting Absence speaks less of mourning than it does of a demand that we are somehow indebted to loss: "a monument to violence," as Simpson puts it, the centrality of which ensures that 9/11 will remain an unanswerable presence at the core of the American imagination for many years to come (quoted in Senie, 49).

Reflecting Absence's memorial pools represent the second major attempt to memorialize the towers at the heart of Manhattan. In the immediate aftermath of September 11, and before an official memorial could be built, six designers worked together, creating a $500,000 tribute to the World Trade Center. This temporary memorial consisted of 88 searchlights pointed skyward to create the illusion of two "phantom towers" looming over the Manhattan skyline (Winston Dixon, *Visions of the Apocalypse*, 37). The memorial proved so popular that when it was finally removed, many complained having "become accustomed to the phantom towers, as if they represented an actual structure" (37). These towers of light, mourning the loss of what was in effect a very cinematic monument, nostalgically recalled the image of the movie projector and with it the glory days of the Hollywood film industry. Their impact was dramatic, considerably more dramatic than their long-term replacements, and sublime. In William Gibson's 2003 novel *Pattern Recognition*, protagonist Cayce Pollard is described

> [looking up to see] borealis-faint but sharp edged and tall as heaven, twin towers of light. As her head goes back to find their tops a vertigo seizes her: They narrow up into nothing at all, a vanishing point, like railway tracks up into the desert of sky.
>
> (227)

Condensed in this description is both the physical presence and impact the towers of light had on New Yorkers and their reflection of the

absence at their core. Indeed, Sturken claims that it is this very desire to reimagine the towers that betrays the horrific reality of September 11:

> It is to disavow the most harrowing images of that day, that of people falling and jumping to their deaths because they were trapped by the buildings themselves. The mourning of the loss of the buildings thus acts to screen out the deaths of those who died there.
>
> (242–243)

To this extent, the vacuity of buildings composed entirely of light seems rather appropriate.

Returning to Reflecting Absence, its inversion of space, the locating of the pools in recesses where the towers previously stood, leads Senie to suggest that the memorial places, "absence at its center" (52). Here the landscape itself appears to shadow the loss of the towers, leaving two quite literal abysses. The endless grief this signifies is concurrent with the principles of the War on Terror, which began during the Bush regime: just as the war could have no end, since terror itself is an abstract concept and therefore not a force to be defeated, neither can the absence be made into presence since attempts to do this meet with reflection. Both the continual cycle of the waterfalls and the "endless" ribbon of names continue the theme of an unanswerable absence, and so Reflecting Absence evokes this same nostalgia for the days before the towers' destruction, echoed in other cultural forums that made absence the key to memorialization. Here we could cite Art Spiegelman's cover for *The New Yorker*—also replicated in his own comic, *In the Shadow of No Towers*—which carries the image of blacked-out towers. Or we might note the absence of the towers from many Hollywood films in the immediate aftermath. Shots of the WTC were removed at the behest of Hollywood Studios in *Zoolander, Serendipity, Spider-Man, Men in Black II* and *People I Know,* since it was believed that they had the power to "offend viewers or pull them out of the imaginary world of the story with a visual reminder of unpleasant reality" (Prince, 79). Senie, as a further example, describes how Hans Haacke, in commemoration of the six-month anniversary of the 9/11 attacks, "created stark white sheets with cutouts of the silhouettes of the two buildings that were then pasted over billboards at various locations, where the negative spaces in the cutouts were filled with an array of advertising images. This," she argues, "evoked both the commercial identity of the WTC and the ways some people tried to fill the anxiety-provoking void left by the attack: by following instructions from elected officials to return to normalcy through shopping" (15).

According to Schivelbusch, "all Western languages use the verb *to fall* to distinguish a heroic warrior's death from ordinary dying. And the monuments erected to those who have fallen in battle are an attempt to lift them back up" (292). This, however, does not seem to be the case in

relation to the 9/11 memorial, which, with its hollowed-out foundations and dramatic water effects, maintains its focus on the fall rather than the subsequent revival. Schivelbusch cites "the ancient idea, common to all the world's great cultures, that war, death, and rebirth are cyclically linked" (2), but this was only truly evident in America's immediate response to the attacks. For example, the favoring of images of valor over those of direct victims of the attacks was just one way in which the myth of 9/11 was being willfully constructed in the aftermath. It is understandable since there was, perhaps, something comforting in the towers of light and the images of heroic firemen standing amid the rubble, a sense of that indestructibility that was lost the day the towers, in their corporeal form, collapsed. As Jean Baudrillard poetically describes, the collapse of the towers was not the end for them, but rather part of their transformation: "although the two towers have disappeared," he wrote "they have not been annihilated." For Baudrillard,

> even in their pulverized state, they have left behind an intense awareness of their presence. [For] no one who knew them can cease imagining them and the imprint they made on the skyline from all points of the city. Their end in material space has borne them off into a definitive imaginary space.
>
> (*The Spirit of Terrorism*, 48)

In considering the role the image played in the elevation of these iconic buildings into mythos, a worthwhile historical comparison could be drawn with the fall of the Berlin Wall, the symbolic date of which is of course November 9, 1989, but the deconstruction of which was not fully completed until 1992. The fact that the wall took many months to be dismantled has become, perhaps always was, somewhat irrelevant, a historical footnote. The first image of the hammer (rather ineffectively) hitting the concrete was enough. As Baudrillard famously pointed out, it was not enough that the World Trade Center was hit; it was necessary that the towers also came down. But unlike the fall of the Berlin Wall, which seemed to involve an act of creation along with its destruction (the opening up of a space) therefore fostering a way of looking forward, the violent act of demolition highlighted in the case of the World Trade Center seems to have closed space, cluttering it and creating only regression. The spontaneity of the dismantling of the Wall, something Sunil Manghani refers to as a moment of "instant history," that is, "a form of history that would seem to take place all of a sudden, instantly relayed to a wide audience, becoming instantly recognizable, instantly historicized" (42), represented a desire to break free from history rather than to remain indebted to it. This concept is still in evidence in Berlin today. Whilst it might appear that the Wall haunts the German capital, its presence forever visible, marked by a bronze line that runs along pavements

and roads where it once stood, Berliners have embraced the Wall not as symbolic of a dark chapter in the history of the city, but rather as a space for change. This is evidenced by the wonderfully expressive art that adorns what remains of the Wall today.

Manghani highlights that "the Berlin Wall was never simply a concrete edifice, but actually a panoply of symbols, myths and images" (36). Ultimately, this did not change with its demolition as, in rendering visible the splitting of history, the image of the Wall, in the consciousness of those who lived alongside it, was transformed into a beacon of hope rather than of oppression. In comparison, Reflecting Absence serves only to memorialize the *absence* of the buildings, the destruction seeming to have instigated a retrospectivity further emphasized by the recently completed building of the new World Trade Center One, which offers a kitschy gesture of defiance with its height of 1776 feet—a date etched in American history. Thus, destruction of *this* kind, and in contrast to the demolition of the Wall, far from offers the opportunity to rebuild and reorient, instead allowing the past to haunt the present and encouraging reflection rather than projection.

But what is truly memorialized in Reflecting Absence is the end of excess. Murray Pomerance suggests that "the WTC constituted what we can already comprehend as excess; reflected the excess of the culture that built it, the excess of capitalism, the excess of ethnocentric superiority." This is an excess both symbolic, as highlighted here, and literal/physical, seen in subsequent filmic renditions of the towers in Oliver Stone's 2006 *World Trade Center* in which the buildings are shown from ground level and come to dominate the screen in a grotesque way that seems to foreshadow their imminent destruction and Zemeckis' *The Walk* with its own excess of verticality. For Pomerance,

> it is this guilt about excess that is relieved and re-relieved as we watch the edifices turn to dust and ruin in videotape replay. But immediately, as the tape loop circles, we have the buildings whole again, presto!, and we can taste triumph and power, the recipe for disaster.
>
> *(The Shadow of the World Trade Center*, 56)

Thus, the intensity of the absence in Lower Manhattan had to do with the absence of an excess, and the destruction of the towers has created in its wake an excess of history that draws people to relive that destruction over and over.

In W. G. Sebald's novel *Austerlitz*, the eponymous character remarks that "outsize buildings cast the shadow of their own destruction before them, and are designed from the first with an eye to their later existence as ruins" (23–24). In doing so, Austerlitz draws attention to the sublimity of feats of architecture that can not only awe and impress us by virtue

of their size and power, but also fascinate in allowing the spectator to imagine the potential ruination of the power they so readily symbolize. To some extent at least, then, architecture stands as a provocation to destruction. Don DeLillo's Martin Ridnour offers a similar idea in direct relation to the Twin Towers in *Falling Man*:

> But that's why you built the towers isn't it? Weren't the towers built as fantasies of wealth and power that would one day become fantasies of destruction? You build a thing like that so you can see it come down. The provocation is obvious. What other reason would there be to go so high and then double it, do it twice? It's a fantasy, so why not do it twice? You are saying, Here it is, bring it down.
>
> (116)

But, while Austerlitz suggests that sizeable buildings foreshadow their own ruination, the destruction of the Twin Towers pushed this logic to its breaking point, showcasing the violent potential of such ruination. This was not the quiet passing of a building into history, a controlled demolition at a point at which people were ready to move on (although many conspiracy theorists offered this as an explanation for the towers' collapse). Rather, the towers, and nearly all those left within, met their end suddenly. This was not a return to destruction as much as it was a return to an abrupt violence, a violence that induced a nostalgia for the seeming invincibility of 1990s America showcased in the very disaster movies in which such buildings were blown up as a spectacular dénouement demonstrating the very *im*probability of such a violence, existing as it did only in Hollywood fantasy.

"There is no architecture without violence," writes Bernard Tschumi in his provocation that opens his piece "Violence of Architecture" (229). Architecture, so Tschumi claims, exerts a "symbolic or physical violence" on users (230) and recalling the impact of the World Trade Center's sheer surfaces and imposing presence, or the vertigo produced when gazing up from ground level at any building as tall and intimidating, this certainly seems to be the case. The towers came, in this regard, to represent an excess of verticality; the manifestation of a sublime infinite that could root one to the spot in fear as much as in admiration. On some level, the responses of critics to the collapse of the Twin Towers are to be understood as reactions to this horrific verticality. It was this that helped to create the dramatic visual impact of the event—Baudrillard famously called it the "'mother' of all events" (*The Spirit of Terrorism*, 4)—showcasing its unrepeatability even as the endlessly replayed video footage attested to its infinite reproducibility as image. Taking into account the history of the towers, what they stood for in the New York skyline and in the history of the development of the city, the previous failed attempt to bring the towers down, and even the towers' own status as monuments

to spectacular disaster enshrined in Hollywood films such as *King Kong* (1977), *Independence Day* (1996), *Armageddon* (1998), and *Deep Impact* (1998), this particular terrorist attack condensed a global grand narrative. As a city steeped in symbolism, New York brought a distinctive cultural dimension to the political statement being made by Mohammed Atta and the other 9/11 terrorists. Its spectacular landmarks and status as the cultural capital of liberty and democracy amplified the message being broadcast, and the cameras trained on the New York skyline received it loud and clear. The terrorists' actions would alter one of the most iconic images of the American screen.

As Steven Schneider rather nostalgically lamented a few years later in his personal and reflective piece, "whether I see the twin towers in movies or not, one thing is a given: I will never be able to view my city's skyline, on-screen or in person, the same way again" (41). Even for a New Yorker like Schneider, separating the physical New York from its image is a difficult task and one made all the more challenging after 9/11. To understand the continuing impact of the event on both politics and culture, we need only turn to the substantial number of cultural critics, such as Baudrillard, Winston Dixon, Žižek, and Spark, who, in the aftermath of the attacks placed the image at the heart of its power. This would include Žižek's oft-cited statement that "the 'terrorists' themselves did not do it primarily to provoke real material damage but for the spectacular effect of it" (*Welcome to the Desert of the Real*, 11), and Baudrillard's assertion that 9/11 elevated the Twin Towers to the status of the eighth wonder of the world (*The Spirit of Terrorism*, 48). We could also cite the controversial statements by British artist Damien Hirst and German Composer Karlheinz Stockhausen, both of whom referred to the attacks as a work of art. Thus, more than just leaving a physical impression on the famous New York skyline, the attacks brought about an exceptionalism that Sturken suggests defined the attitude toward the events of 9/11 and was evident in the very term used to describe New York, and more specifically Lower Manhattan, after the attacks: Ground Zero. For Sturken this term ascribes to New York its position as a point of origin (which notably all but erases the attack on the Pentagon and the crash of Flight 93 in Shanksville from the cultural memory of 9/11) (167). And so it is the image and the consequential rhetoric that serve to obscure any sense of objective reality in relation to September 11. New York's cinematic quality, even in its moment of spectacular defeat, was fundamental in the manufacture of a coherent narrative of an event that otherwise raised difficult questions about the vulnerability of the U.S. and perceptions of the nation abroad.

Schneider, "view[s the towers] as retrospectively – that is to say, in their absence – enabling U.S. citizens to recall a post-Cold War fantasy in which not even the Other possesses the motives, means, or methods to cause [them] serious harm" (35). As evidence, he refers to the

almost instantaneous appearance of sellers offering memorabilia of the still-standing towers on the streets of New York after the attacks, stating that, "in one sense, the twin towers have *already* been rebuilt as communal, if only virtual, objects of nostalgic sentiment, signaling America's former confidence and self-assurance" (35). This is an important point. It seems that *Washington Post* columnist George Will's famous assertion the day after the attacks—that America's "Holiday from History" was now over—was premature. It is not that Americans since 9/11 have yet to adjust to their new reality. The wars in Iraq and Afghanistan made the attacks impossible to forget, and the Homeland security boom meant that, for many, just leaving one's home entailed an encounter with a new architectural environment built of bollards, barriers, and private security for hire. Rather, the problem is that the memorialization of the Twin Towers attests to a desire to retreat into the past. September 11 did not create a new dawn, a new American responsibility, but rather birthed a cultural nostalgia that was embodied in the image of those ruined buildings.

## A Terrifying Nostalgia

In the dénouement of David Fincher's somewhat prophetic 1999 cult hit *Fight Club*, an adaptation of Chuck Palahniuk's earlier 1996 novel, home-grown terrorists, led by anarchist and alter-ego of the unnamed narrator, Tyler Durden (Brad Pitt), succeed in their attempt to destroy half the fictionalized city. In the final scene we see the narrator (Edward Norton) and his girlfriend Marla (Helena Bonham Carter) watching on as the surrounding skyscrapers collapse, leaving two towers dead center of the frame. In a post-9/11 world, the collapse of these final towers is uncanny, but despite the "eerie reminiscence" noted by Omar Lizardo in his work "*Fight Club*, or the Cultural Contradictions of Late Capitalism," the likeness between these and the Twin Towers is "superficial" since, "while 'Project Mayhem' [Tyler's army of anarcho-'space monkeys'] can be technically classified as 'terrorists,' they still possess hope that through their act this world (that of the rich post-industrial societies) will be redeemed" (240–241). Tyler's effort to simultaneously blow up the headquarters of all the major credit card companies in the U.S. in order to wipe out the debt record is predicated on the idea that "we'll all go back to zero." His aim, therefore, is not to cause mass casualties, hence his insistence that the buildings are empty of people before they are destroyed, nor is it even to create spectacle. Rather than destroy, Tyler instead wishes to 'reset' capitalism. Indeed, for all its anticonsumerist rhetoric, the real gripe that *Fight Club* seems to have with capitalism is that life is not all that it's advertised to be. In one of his most-quoted speeches, Tyler preaches that: "we've all been raised on television to believe that one day we'd all be millionaires, and movie

gods, and rock stars. But we won't. And we're slowly learning that fact. And we're very, very pissed off," a statement made all the more sardonic by the casting of Brad Pitt as Durden. For Tyler, capitalism needs to be perfected rather than destroyed, hence his own entrepreneurial venture, The Paper Street Soap Company, for which he steals waste human fat from liposuction clinics and turns it into soap, is an attempt at a kind of zero-sum capitalism—a profitable company built on recycled waste materials that undermines the boundaries of class: "It was beautiful" Tyler enthuses: "we were selling rich women their own fat asses back to them."

In a post-9/11 age, Tyler's ambitions seem to anticipate the same forces of nostalgia, anticapitalism, patriarchy, and violence, brought together through the symbolic destruction of architecture, witnessed in the attacks. The logic of his act, as Lizardo puts it, is "destroy the credit system, and consumer capitalism (along with its contradictions) will also fall" (240), but Tyler's idealism is, of course, ill-judged. Even at the turn of the century, the idea that destroying the buildings of credit card companies would mean the erasure of debt is naïve in the extreme, and today it is laughable. In the 21st century, information hangs like precipitation, suspended in the very clouds above us. It is ubiquitous and inescapable and cannot be damaged or altered through the destruction of a mere building. In contrast, for Lizardo,

> the 9/11 hijackers [...], had already given up on this (Western, corrupt) world as patently unredeemable, and their attack was meant as an act of symbolic communication aimed at those "back home" in the "other" world of global capitalism, still comparatively untouched by the internal contradictions of this very same system.
>
> (241)

Thus, for these terrorists, the destruction of the World Trade Center was hardly an attempt to 'reset' 'world trade', or even destroy it, as much as it was a provocation for two quite different audiences. The spectacular destruction of architecture in this case functioned as a call-to-arms to reject the spread of American capitalism and its concomitant ideologies.

There is no doubting that, in the years since September 11, spectacle has been managed in a rather different way by terrorist groups such as Al-Qaeda, Boko Haram, and so-called 'Islamic State.' Whilst the Islamic State group recruits abroad through social media and makes videos of executions on the latest iPads, it was the contrast in technologies that was one of the defining features of the 9/11 attacks. As Chanda and Talbott highlight: "they dispatched the hijackers, armed with the most low-tech weapons imaginable (box cutters), to ride one of the emblematic technologies of the modern world, the passenger jet, from the periphery – that is, those lands where many feel like globalization's losers – to the center,

where the winners were beginning another workday" (xiii). But it would be a mistake to see more recent terrorist attacks as offering any dramatic shift in rationale. The attack that brought down the towers was an example of the way in which terror has often sought to co-opt the technology of its enemies, and while a more complex example—since many members of Islamic State have been active participants in Western society and have grown up surrounded by such technology—the use of today's digital tech to spread Islamic State's regressive message is predicated on this same co-option. Similarly, the use of vehicles, knives, and homemade explosive devices that have been the hallmark of attacks across Europe in the last few years are striking because they offer this same stark contrast between the sophistication of armed responders and surveillance technology and the weaponry used by the terrorists. In June 2017, just days after several large-scale attacks in the UK, for example, a French policeman shot and wounded a terrorist outside Notre Dame Cathedral when the attacker assaulted the officer's colleague with a hammer.

In Will Self's provocatively titled piece "We are Passive Consumers of the Pornography of Violence," he considers our role in the consumption of such violent spectacles. Opening his piece creatively with a fictionalized first-person account of an Islamic State beheading, the author/commentator fixates on the victim's sense of anticipation in the moment before the knife is deployed. Somewhat like the opening of this book, Self turns to fiction when confronted with an emotional impasse, in the process articulating that what we might be missing in our hyper-analysis of the terror event is the subjective and the personal. As the piece turns toward a more formal discourse, however, he writes that, "If there's one thing the liberal consensus in our society abhors it's censorship of any kind." This is because, as Self goes on to highlight, "we have a compelling need to see ourselves as completely free," a statement borne out, it would seem, by the media reaction to the Charlie Hebdo attacks of early 2015 (8).

When the Kouachi brothers attacked the office of French cartoon magazine Charlie Hebdo, in the process killing twelve people, the gunmen were reported to have told an unwitting intruder that, "we don't kill civilians." Understandably, many in the media questioned the logic of this statement, but what it makes clear is that the terrorists *did not see* the cartoonists as mere civilians. While in France the Hebdo massacre was widely decried as an attack on freedom of speech, this repackaging shows a distinct lack of understanding of the terrorists' motives. Instead, seeing the attack as another battle in an ongoing cultural war between extremists and Western ideologies highlights that rather than attacking freedom as such, the response "we don't kill civilians" most aptly demonstrates the Hebdo terrorists' belief that today our culture itself is militant. For the brothers a cartoonist was as much a soldier as a drone pilot, a police officer, or indeed a journalist (also targeted by Islamic State terrorists).

It is important that we 'read' terrorist attacks in an objective light. Too often they are misconstrued as attacks on 'freedom.' The terrorists, we are continually told, hate us for our freedom. But if we are serious about tackling terrorism, then we cannot simply dismiss such attacks as the actions of evil, or mindless, deluded individuals. Our adversaries are people who reject and want to disrupt our way of life; of course, they are vulnerable individuals who have been brainwashed by a violent and extreme ideology, but it is unlikely to be our 'freedom' to which they object. Beyond this, such a freedom seems, itself, to be a mirage; little more than another of Baudrillard's simulations. Seen in a certain light, the terrorists' attack on our 'freedom' serves to present such freedom as 'real' and tangible. Baudrillard asserted that our sense of 'reality' is propped up by its very inverse, notably using Disneyland as an example of how the fantasy it presents serves to mask the fact that all of surrounding LA is no longer 'real.' "It is always a question of proving the real by the imaginary; proving truth by scandal; proving the law by transgression; proving work by the strike; proving the system by crisis and capital by revolution," he argues. "Everything is metamorphosed into its inverse in order to be perpetuated in its purged form. Every form of power, every situation speaks of itself by denial, in order to attempt to escape, by simulation of death, its real agony" (*Simulacra and Simulations*, 176–177). Self also reads acts of terrorism by way of Baudrillard, but his reference to these acts as "hyperreal" is problematic, not because they do not display all the hallmarks of the hyperreal but because they are, in fact, a desperate attempt to negate all that *is* hyperreal: to return to a time before Baudrillard's age of simulation. Terrorism is an attempt to turn back the clock on history, a desperate search for authenticity of experience. It is a dangerous force, nostalgic for the 'real' and with a zealous belief that this 'real' can somehow be reclaimed through violence.

The reduction of buildings to rubble is a kind of reverse-engineering through violence of society as it is today. In a passage of his 2016 novel, *Zero K*, Don DeLillo writes: "Terror and war, everywhere now, sweeping the surface of our planet, and what does it all amount to? A grotesque kind of nostalgia" (241). Elaborating further, the writer effectively highlights the connection between terror and nostalgia through a list of combat tactics adopted by today's terrorists:

> the primitive weapons, the man in the rickshaw wearing a bomb vest. [...] The small homemade explosive. And on the battlefield, assault rifles of earlier times, old Soviet weapons, old battered tanks. All these attacks and battles and massacres embedded in a twisted reminiscence. The skirmishes in the mud, the holy wars, the bombed-out-buildings, entire cities reduced to hundreds of rubbled streets. Hand-to-hand combat that takes us back in time. No petrol,

no food or water. Men in jungle packs. Crush the innocent, burn the huts and poison the wells. Relive the history of the bloodline.

(241)

Not only do terrorists use the past as a weapon against the future, they also "take us back in time" as DeLillo has it. Beneath the description, here, there is also an underlying critique of 'late capitalism,' which not only distributes resources unevenly—there is no petrol, food, or water, only warfare—but even disrupts temporality since, according to this logic, to be poor is to be primitive and to be primitive is to live in the past. Terrorism is a rejection of this distribution as much as anything. Its violence seeks to erase all those solid edifices that indicate modernity and restore a kind of parity. But this parity is defrauded by terrorism's own fascist purity and gender bias: the men hunt in 'jungle packs'; 'the innocent' and their 'huts' are 'crushed.'

Despite the supposed ideological motivation for Islamic State's deter-mined ruination of the ancient structures in the Syrian city of Palmyra—the claim that such destruction is religiously motivated, an attack against sites deemed idolatry—it is tempting to instead read the violence as an attempt to challenge the permanence of history and tradition. This, how-ever, gives such actions a revolutionary glamor that they do not deserve, since the aim is not to inscribe a new history but rather to reassert a domi-nant form of patriarchal violence that has in itself *become* history. It is not a form of creative destruction, more a destructive abjection of the present. As DeLillo noted only a short time after the 9/11 attacks, "the terrorists of September 11 want to bring back the past" ("ruins of the future"), and this is a trend that has continued, even if the methods have shifted. This is because the values Islamic State challenges are those of tolerance in the face of religious, ethnic, gender, and sexual difference that have, at least to some extent, advanced under liberal political trends. Indeed, the goal here appears to be the revival of a fascist patriarchy that the group hopes to bring about through the reactionary politics that come as a response to the terrorization of society; the post-9/11 media and political shift to-ward confrontational, masculinist discourse that Susan Faludi observes in *The Terror Dream* is precisely the outcome they desire. To some ex-tent, the election of Donald Trump is the culmination of this; it was in part caused by the increasing influence of Islamic State on the ideological level. Trump's hyper-masculine bravado—which during the election cy-cle stretched from promises to crush Islamic State to absurdist comments about his own sexual potency and revelations about what he described as 'locker-room talk' in which he effectively boasted about sexually assault-ing women—is surely a further plunge into this masculinist discourse im-posed as a 'naturalized' response to times of crisis and war.

America's reaction to terrorism on the home front has, since 9/11, tended toward a similar paranoid retreat. The 9/11 attacks in particular

instigated a boom in building operations in the United States. This clear message of defiance—what you destroy we will rebuild taller and stronger—however also involves another subtler form of American *re*building that has had a rather sinister and regressive impact on the psychology of its civilians. In his introduction to the edited collection *Indefensible Space: The Architecture of the National Insecurity State*, Michael Sorkin cites the growth and proliferation of defensive structures in the U.S. as part of an insidious threat inflation designed to internalize fear of attack. He suggests that, "for every bomb that falls on Iraq, it seems 20 bollards (generally with little actual defensive value) are added in front of yet another high value target at home" (vii–viii). Going further, Sorkin speaks on a grander scale of this "new Fortress America," arguing that the purpose of these barriers is not solely to protect against an external, physical threat but rather that "the barrier turns inward as well, making each of us simultaneously soldier and suspect, enmeshed inextricably in the permanent warfare of all against us" (viii).

Similarly, for Trevor Boddy, "the architectural symbol" of the Bush Junior presidency was the New Jersey highway barriers that began to spring up in front of governmental buildings in 2002 and 2003, becoming "the first visual icon of the Homeland Security era" (277). These 'architectural embellishments' he describes as the "architecture of dis-assurance" and "the visual analogue of the rhetoric of the war on terror, a concrete icon inserted into the city to sustain the 'all is changed' sense of unease amongst law-makers, lobbyists and the media" (278). Like Sorkin, Boddy recognizes the ineffectiveness of the Jersey barriers as deterrents to terrorist attack since they cannot possibly prevent the deployment of suicide vests or do anything to discourage another aerial attack, but he also highlights their key psychological function aimed not at terrorists but rather at ordinary American citizens: "Although the Jersey barriers were largely pointless as security devices, they succeeded brilliantly as emblems – visual symbols anchoring deep emotions, like flags in wartime" (278). Thus for Boddy, whilst architectural criticism has tended to speak of *ideas*, the securitization of architecture after September 11th was far more about manipulating *emotions* than it was about offering any concrete conceptualization of the present moment.

For Boddy and for Sorkin, who argues that "especially since 9/11 – virtually every aspect [of design] is being reimagined from the perspective of threat" (xiii), the September 11 attacks had a profound impact on architecture in the U.S. But Stephen Graham extends this to "the production of permanent anxiety around everyday urban spaces, systems, and events that previously tended to be banalized" (9) highlighting that after 9/11, spaces were transformed not only physically but psychologically too. Thus, outside of the fortification of government buildings and key targets, open communal and commercial spaces like shopping malls, sports arenas, and concert venues took on a more threatening

appearance for the populace at large. The cultural embodiment of this nationwide anxiety and paranoia was surely 24's Jack Bauer (Kiefer Sutherland), who, in a series spanning 2001 to 2010, confronted every terror threat imaginable from hostage scenarios, assassination attempts, and bombings to the deployment of chemical and even nuclear weapons. Even the CTU (Counter Terrorist Unit) headquarters building in which Jack and his fellow agents worked was targeted four times in eight seasons of the show, demonstrating, perhaps, the need for a few more Jersey barriers outside. The dramatization of terror events in the high-octane television show helped both to heighten the general sense of fear and to offer a salve. As the danger posed by terrorists was exaggerated, so too was the power of the U.S. intelligence agencies to surveil and combat such threats. 24 pitted the U.S. against an innovative, highly organized, and malicious terrorist threat; its arms race mentality continually vindicating Jack's hardball tactics and justifying every breach of law, protocol, and constitutional right in the name of defending the homeland.

Beyond this, America's response to terrorism abroad has also been heavily focused on architecture (and its destruction) and, in the absence of the spectacle of height, American forces have chosen sheer volume. For example, William Merrin cites one general who commented that the war in Iraq was an exercise in "turning big bits of rubble into small bits of rubble." Indeed, the daily pounding and aerial bombardment of Iraq and Afghanistan after 9/11 seemed to be an attempt to offer a counter-spectacle. Similarly, Bevan points to the staged toppling of Saddam Hussein's statue in Paradise Square, "an irresistible piece of iconoclasm" as he puts it, as evidence of the American desire to transmit a clear and coherent message about the war in Iraq (91). This propaganda stunt failed not least of all because the misreporting of the event became widely known—the suggestion that it was spontaneous and that there were far more Iraqis present than there were in reality coupled with the fact that the U.S. military originally draped an American flag over the statue's head only to replace it with an Iraqi flag after the faux pas had been realized meant that this 'celebratory' moment became yet another reason for Iraqi citizens to resent their American occupiers. But Bevan highlights that this is only the beginning of the story since "toppling effigies of dubious aesthetic value and recent origin is one thing, but the destruction of Iraqi built heritage is a different matter," citing the danger the war posed to all of Iraq's historical buildings (92).

Taken together, it seems that the 9/11 attacks precipitated a change in psychology that extended beyond American architecture and became cyclically violent. A final image that might best articulate this can be seen in the operations carried out by the USS *New York*, an American Navy battleship launched in 2007. A small portion of the warship's material comes from World Trade Center steel recovered from the rubble and melted down for use in its construction. In this way, America's own

destroyed architecture has been quite literally deployed in the counter-violence, recycling destruction. In the 21st century, the actions of both terrorists and governments have exploited architecture's symbolic cultural impact in order to terrify. In sum, the redefining of architectural space in response to terrorist attacks has instigated, on all sides, a terrifying nostalgia for a simple world in which homes, places of work, leisure facilities, even heritage sites function as intended rather than as targets. Indeed, our buildings mean a great deal—we marvel in wonderment as they go up, and cower in sublime terror when they come down—but as more and more of these places, all over the world, are transformed into rubble both by terrorists and in response to acts of terrorism, we retreat further into the past. Instead of using such moments as opportunities to rebuild for the future, they become excuses to perpetuate a cycle of violence that can only erode progress through the destruction of people's sanctuary, livelihoods, and ultimately their very existence. On this level, at least, both forces in the War on Terror seem to represent a threat to architectural heritage, creating a curious alliance in which both sides yearn for the past but seem only capable of destroying our historical monuments in an attempt to reach it.

# 2 The Stockhausen Syndrome and the Role of Art, Image, and Spectacle in an Age of Terror

Speaking to the BBC a day before the first anniversary of September 11, controversial British artist Damien Hirst, famed for his bombastic and grotesque animal carcass pieces, spoke of the attacks with an excitement that bordered on reverence: "you've got to hand it to them on some level," he said

> because they've achieved something which nobody would have ever have thought possible, especially to a country as big as America. So on one level they kind of need congratulating [...]. The thing about 9/11 is that it's kind of an artwork in its own right. It was wicked, but it was devised in this way for this kind of impact.

The comments, for which Hirst—himself a kind of artistic terrorist—later apologized, caused understandable consternation, but their interpretation likely depends upon the receiver's own view of Hirst both as an individual and as an artist. For fans, Hirst is a visionary, his works definitive in an age of philosophical art that has made a break with long-established forms, aesthetic principles, and taboos. For many, however, he symbolizes all that is wrong with contemporary art, a talentless exponent of shock and awe whose penchant for the gruesome defies meaning. Hirst is therefore, perhaps, the best example of the tension in the term 'con-art' in which 'con' can stand in for conceptual or be read literally as the defrauding of 'true' art. Whatever one makes of Hirst, his impact has been undeniable. He, along with fellow British artist Tracy Emin, whose exhibit *My Bed* (1998)—the recreation of her bed in a state of disarray within the gallery space—recently sold for roughly $3.5 m, was at the forefront of the Young British Artists (YBA) movement, which made waves in the 1990s. The movement, at least in part inspired by Marcel Duchamp's 1917 urinal titled *Fountain*, seems now somewhat dated, feeling very much of the 20th rather than 21st century. But while Emin's work, despite the inflated price tag, seems disengaged with today's politics, Hirst's decision to comment on the 9/11 attacks was more appropriate. As the most successful (if success is measured by earnings, at least) living artist and an exponent of terror in artistic form, his work

retains a resonance that the majority of the other members of the YBA movement now seem to lack.

Gene Ray reads Hirst's work in relation to terror and art, choosing to focus on the controversial and provocative exhibition *A Thousand Years* as reimagined in Wolfsburg, 2002. The piece is Hirst's attempt to show an entire life cycle in a box. But given his dark imagination, the work recreates the pain and suffering of life, actualizing it by breeding flies in one half of a glass container only for them to periodically die in the other half where an electric fly killer cruelly extinguishes them with the snap of a blue spark. As Ray suggests in his astute analysis of the work, "materially, what Hirst confronts us with here is a structure that produces, contains, and destroys life." Continuing, he reads this as a demonstration of "a status quo, a blind machine for social reproduction" (*Terror and the Sublime*, 83). Ray claims that our most obvious response to this is "we are *like* those flies." "The model," he argues, "shows us [...] our own fate under the rule of exchange value. Capitalism as the miserable, ever-changing repetition of the always-the-same" (*Terror and the Sublime*, 83). But as Ray suggests, the comparison only goes so far, since the flies are themselves helpless victims rather than complicit producers of their own social death, revealing both the barbarism and cruelty of Hirst himself and the flies' difference from us as humans. It is, therefore, better to read Hirst's pieces not as statements on life or death but as a series of potential questions. On some level, at least, we could read *A Thousand Years* as being about ethics, and not just the ethics of art. In this reading, the key is actually to suggest that we are *not* like the flies. To revel in the death of the flies, as Ray suggests some onlookers do (including the oblique suggestion that Hirst himself does), is not so much evidence of a sadism but rather of the different value we assign to life in its various guises. When confronted with the meaningless and mass-produced death of *A Thousand Years,* we can either turn away in disgust or watch gleefully as the flies repeat the same cycle of birth and death over and over. Both reactions demonstrate the impossibility of a true connection with the fly. But can this not also be extended to our ability to empathize with the other in today's global climate of fear and mass *in*difference? Is this same confrontation not taking place in Hirst's dissected animal works, a confrontation with that which we abject as well as with our own hypocrisy?

Many of Hirst's pieces could be considered sublime since they contend with our difficulties when confronted with death. Works such as *For the Love of God* (2007), a platinum cast of a human skull encrusted with more than 8,000 diamonds, and *For Heaven's Sake* (2008), which follows a similar concept as the former only using an infant's skull and pink diamonds, document the decadence of society but also highlight our obsession with immortality. In *The History of Pain* (1999), a reworking of the earlier more optimistic *Loving in a World of Desire* (1996), Hirst

uses an air blower to permanently suspend an inflatable ball above a block of sharpened knives. As the ball bobs gently up and down on the air current, mimicking life's precarity, it is only ever a gust away from disaster. Perhaps his most enigmatic expression of this theme is carried by *The Physical Impossibility of Death in the Mind of Someone Living* (1991)—Hirst's iconic shark preserved in formaldehyde. As one of the works that made his reputation, *Physical Impossibility* grapples with our inability to process the greatest unknown. It is about fear, of course, but more than that, the shark—nature's most terrifying creature, symbol of the unfathomable depths and of death itself—is the perfect evocation of the sublime. In the piece the tiger shark, positioned as if still swimming, jaws opened wide to display its pointed teeth, goes beyond a museum exhibit in its evocation of genuine fear in its spectator: there is always the suggestion, when viewing the piece, that the shark might not truly be dead.

Hirst's shark, as the embodiment of a natural sublime that inspires both terror and awe, is a relic of the 20th century, a century that saw World War I, World War II, the Holocaust, Hiroshima, and nuclear escalation. Ultimately, however, it is the journey from *Physical Impossibility* to *Leviathan*, a huge 6.8-meter basking shark exhibited in Doha 2013, that best represents the conceptual politics of our time and signals the shift into the 21st century. Like *Physical Impossibility*, in *Leviathan* Hirst again positions the shark with its jaws open as it swims toward the viewer. *Leviathan* is a monster of the deep, at almost double the length of Hirst's tiger shark its size is intimidating, and on this level the creature lives up to its name. However, while fear looms even larger in this 21st-century piece, it is ultimately all a façade, a playful dance with death rather than its execution. The basking shark may look scary, but it is ultimately harmless to humans whether dead or living. In *Leviathan*, terror is overblown, a cartoonish simulacrum. What Hirst, whether wittingly or not, stumbles upon with the piece, then, is the impact of contemporary aesthetics itself, a suggestion that the constant state of fear produced by today's society is an illusory special effect, or at least a misreading of the situation. *Leviathan* plays on our instinct for terror but in so doing highlights not only its artificiality but also art's own complicity in its creation.

The complex relationship between politics and art was evident in the reaction to September 11 in both the media and in cultural forums at large. From early on, plans for the reconstituted World Trade Center included an art gallery to display some of the work produced in response to the attacks, but this idea was later dropped after disputes over which art could be deemed appropriate (Prince, 123). This is symptomatic of the cautious approach taken by many in the media and the world of art to the events of 9/11 more broadly. While Hirst appears to trample over this, his subsequent apology shows the power post-9/11 sentiment had

over rhetoric, a control that still largely exists today when we consider responses to more recent terrorist acts. Hirst was, on this occasion, however, guilty of a lack of originality considering the same idea had already been expressed only days after the attacks by Karlheinz Stockhausen, a then-renowned German composer. On September 16, 2001, Stockhausen described the World Trade Center attacks of five days previous in words that have been roughly translated as: the greatest work of art there has ever been. Although he later claimed that his comments had been misconstrued, his words provoked a vociferous critical response, prompting the cancelation of a number of his shows. Despite the injudicious nature of their remarks, both Hirst and Stockhausen display a crude awareness of the purpose of the act itself, recognizing its aesthetic dimension.

Perhaps one reason for the extent of the anger both Stockhausen and Hirst attracted was that their comments highlighted the artifice not just in the staging of the attacks, but in our response to them. While they ran the risk of trivializing the deaths by reducing them to a mere sideshow, they nevertheless pushed at the boundaries of acceptable discourse, in so doing acknowledging the media's fascination with the spectacle. By reconfiguring the terrorist as performance artist, those that died were, to some extent, imagined as being exhibited like one of Hirst's flies, participants in a cycle of destruction beyond the scope of real human empathy and connection. By focusing on the sublime aspects of the 9/11 attacks, these artists attempted to render intelligible a moment that has been remarked upon more often than not for its unintelligibility—'how could they do this to us?' This is where art becomes important. By its very nature, artistic forms are expressions of what cannot be said. Artists often visualize because this is the only way they find to articulate. They provoke in order to inspire a discussion that they themselves feel incapable of having. We should, therefore, consider what art can tell us about the terror spectacle in the 21st century. In the absence of a genuine political discourse, perhaps the complexities of art's relationship with terror can help reveal some of the more nuanced ways in which the image, terror, and spectacle have shaped imagination after 9/11.

## Icarus

He was a falling angel and his beauty was horrific.

(*Falling Man*, 222)

Nothing challenged the relationship between art and terror quite like the image of the Falling Man captured by Richard Drew on September 11, 2001. The photograph, one of many taken on the day of people falling from the Twin Towers, sparked both grim appreciation from a few and

outrage from many. Whether it is the terrifying geometry and sublime scale of the buildings pictured behind him, or the apparent beauty and grace with which the man falls, the Falling Man has gained great importance in debates surrounding the recording and understanding of the events. These debates center, sometimes unwittingly, on the role of art both in terms of bearing witness to terror and as a method of recovery. But the Falling Man is also much more since in its representation of the death of American innocence it has become an important source of the melancholic sublime.

Since journalist Tom Junod's powerful 2003 *Esquire* article, in which he attempts to uncover the identity of the man in the photograph, the Falling Man has been widely recognized as both the most resonant image displaying the true horror of the day, the human cost of terror, and as the one image that Americans refused to confront. Few newspapers ran the photograph the day after the attacks, and those that did were met with a backlash from angry readers. Junod writes "the desire to face the most disturbing aspects of our most disturbing day was somehow ascribed to voyeurism," that, "instead of being central to the horror," those who fell were considered "tangential [...], a sideshow best forgotten." For Junod, this cuts against the more general response to "the most photographed and videotaped day in the history of the world," which was, of course, to gaze in astonishment at the images, consuming them greedily in a repetitious loop.

The power of the Falling Man photograph is undeniable, and yet its self-imposed media censorship has meant that critics have also often attached further meaning to the picture. Anne Longmuir, for example, suggests that,

> while the media usually cited "good taste" as their grounds for the suppression of such photographs and footage, it is essential to consider the ideological implications of this censorship. Importantly, their reluctance to publish or broadcast these images reflects the wider tendency, apparent almost immediately, to understand the attacks on Manhattan and Washington as a moment of American fortitude rather than vulnerability.
>
> (50)

Therefore, rather than singling out this particular photograph here, Longmuir positions it within the greater narrative reflected by the media coverage of 9/11, her words chiming with a number of critics who have seen in this a careful construction, or at least maintenance, of an image of American invincibility. For instance, Susan Faludi argues that "what mattered was restoring the illusion of a mythic America [...] vanquishing the myth's dark twin, the humiliating 'terror-dream' that 9/11 had forced to the surface of the national consciousness" (118). Thus, both

the proliferation of images of heroism—heroic firemen hoisting aloft the American flag at Ground Zero or striding out of the dust cloud carrying the wounded—and the disavowal of images like the Falling Man are consequences of a media doing *its* part in rewriting the narrative of the day. "By September 12," argues Faludi, "our culture was already reworking a national tragedy into a national fantasy of virtuous might and triumph" (289). This reworking included the necessary erasure of certain images like the Falling Man from the collective consciousness.

Slavoj Žižek highlights this as the fundamental difference between American media coverage of 9/11—coverage that Mikita Brottman describes as "remarkable not for its horror but for its *absence* of horror" (166)—and its reporting on foreign wars stating that

> while the number of victims – 3,000 – is repeated all the time, it is surprising how little of the actual carnage we see – no dismembered bodies, no blood, no desperate faces of dying people ... in clear contrast to reporting on Third World catastrophes, where the whole point is to produce a scoop of some gruesome detail.

From this, he reaches the rather grandiose question: "is this not yet further proof of how, even in this tragic moment, the distance which separates Us from Them, from their reality, is maintained: the real horror happens *there*, not *here?*" (*Welcome to the Desert of the Real*, 13). At least in part, the absence of the brutality referred to by Žižek can be explained by the lack of such dismembered bodies—the vast majority of the 9/11 victims were vaporized when the buildings came down—but still, as Karen Lang suggests, "the paradox of 9/11 and its representation—the reason why response to the loss of built space came to exceed response to the loss of human lives—lay in a desire to imagine and a desire not to see" (25).

This is not reflected, however, in the literature that followed. In Jess Walter's *The Zero*, Brian Remy—a New York cop—is one of many charged with the search for Ground Zero survivors and the recovery of body parts, but he laments that "the slick bags sat piled up on the sidewalks and the meat trucks sat empty" while they searched desperately for what they knew to be the death that waited below the rubble (17). To some extent, then, both Žižek and Remy voice a desire to see that which was *not* on display, mirrored in a more general longing for bodily evidence that would bring a kind of closure to families and perhaps to the public at large. Indeed, this is echoed in Jonathan Safran Foer's *Extremely Loud and Incredibly Close,* in which nine-year-old Oskar Schell, whose father Thomas died in the attacks, decides he must sneak into the cemetery after hours, dig up his father's empty coffin, and fill it with letters from his estranged grandfather. Thus, writing on 9/11 is frequently concerned with the issue of absence of bodies/body parts,

and this also resonates in Reflecting Absence, the 9/11 memorial—even if such an absence remains ambiguously tied to the buildings themselves as much as the victims.

When critics like Anthony Lane, writing for *The New Yorker* after the attacks, noted the similarities between 9/11 and disaster movies it was not simply the images of the buildings' destruction that attracted such comparisons but also the choice by Hollywood filmmakers to focus on architectural destruction over human suffering, the collateral over the personal. 1990s disaster films such as *Independence* Day (1996), *Armageddon* (1998), and *Godzilla* (1998) all favored the spectacle of material destruction; the creation of rubble over visceral violence and injury. Indeed, on some level, their bombastic aesthetics paved the way for the disbelief felt by the U.S. public after 9/11, evident in the number of conspiracy theories that sprang up on the Internet appearing to suggest that the collapse of the Twin Towers was caused by a controlled explosion. How could the attacks be believed when no one really saw the blood, the pain, the victims? This is played on in the recent, long-awaited sequel *Independence Day 2* (2016), when Jeff Goldblum, reprising his role as David Levinson, says with irony, "they like to get the landmarks," in response to the fictionalized destruction of *London*'s iconic skyline.

While it might seem morbid not to engage in such willful denial and to, instead, focus on the jumpers, such a focus has often enabled observers to draw the most profound and uplifting of messages from the victims' deaths. Indeed, Lane writes that

> the most important, if distressing, images to emerge from those hours are not of the raging towers, or of the vacuum where they once stood; it is the shots of people falling from the ledges, and, in particular, of two people jumping in tandem. It is impossible to tell, from the blur, what age or sex these two are, nor does that matter. What matters is the one thing we can see for sure: they are falling hand in hand.
>
> (Lane, 7)

Similarly, in his account of the controversies caused by Drew's photograph, later turned into a documentary film by Henry Singer, Junod romanticizes the image of the Falling Man, suggesting that, "although he has not chosen his fate, he appears to have, in his last instants of life, embraced it. If he were not falling, he might very well be flying." Such an image is also recalled by the concluding pages of Foer's *Extremely Loud*, during which Oskar flicks backward through a series of images of a man falling from one of the towers to create the illusion that he is floating back up and into the safety of the building.

But the man *is* falling, and it is Drew's capture and freeze framing of the turbulence that transforms the violence of the man's death into

a moment of stillness and calm that transcends, but ultimately also defrauds, the attacks. Is this attempt to romanticize the jumpers not also a disavowal of the horror? As Jessica Auchter describes, "while we know they are now dead, as we are viewing the image, they appear starkly alive, even 'free', as Junod describes." Thus, the photograph offers catharsis rather than a window into the traumatic experiences of those forced to jump. The Falling Man image, so perfect in its symmetry as to appear staged, imposes an order on the chaos of descent and so cannot possibly offer a true reflection of the horror these women and men confronted. Any number of the photographs of people falling from the towers, limbs flailing as if attempting to swim upstream, show in a far more appropriate manner the tortured deaths of the jumpers.

It is this absence of horror that a number of 9/11 fictions attempted to fill with disturbing accounts of what happened on the day. So, in *Falling Man*, DeLillo offers us a description of protagonist Keith's attempts to rescue his mutilated friend Rumsey in the last few pages of the book, but he also gives this rather gruesome depiction of the after-effects of a suicide bomb attack on survivors:

> The bomber is blown to bits, literally bits and pieces, and fragments of flesh and bone come flying outwards with such force and velocity that they get wedged, they get trapped in the body of anyone who's in striking range. Do you believe it? A student is sitting in a café. She survives the attack. Then, months later, they find these little, like, pellets of flesh, human flesh that got driven into the skin. They call this organic shrapnel.
>
> (16)

In Gibson's *Pattern Recognition* "the impact of the second plane," seen through the television, is described:

> Cayce [...] will watch the towers burn, and eventually fall, and though she will know she must have seen people jumping, falling, there will be no memory of it. It will be like watching one of her own dreams on television.
>
> (137)

The focus here is on the inadequacy of description and the extrasensorial, so "what she will retain is that the exploding fuel burns with a tinge of green that she will never hear or see described." In a similar way, *The Zero* lays claim to the 'true' horror by referring not necessarily to what the recovery workers at Ground Zero could *see* but what they could *smell*: "you knew what was happening below, you could smell what was happening, the quickening decay and dissolution" (17). Indeed, throughout the novel, protagonist Remy continually refers to this smell even

when it has become conspicuously absent after the clear-up operation has been complete. And from this, Walter moves to that other sense in describing the sound; "what you didn't get on TV":

> it was so *far up there*, it didn't seem real, not until someone jumped, arms flapping crazy like they could change their minds, but of course, they couldn't... and you'd watch 'em grow as they came down... hitting like fuggin' water balloons, but deeper, you know–thumping and... and... bursting.

(25)

This final, visceral, account seems an attempt to subvert the censorship of the images of people falling by focusing on what could not be blurred: one could look away from the spectacle, but it was impossible to drown out the sound of the bodies as they hit the ground.

In this last account, Walter's choice of the word "flapping" is also instructive since in Greek mythology the iconic falling man is Icarus, son of Daedalus, who in classic telling flew too close to the sun so that his wax wings melted. In the myth, later depicted by Roman poet Ovid in *Metamorphoses*, Daedalus—the master Athenian craftsman—fashions two sets of wings from feathers and wax so that he and his son Icarus, imprisoned by King Minos on Crete, might fly to freedom. Although warned not to fly too close to either the water or the sun, Icarus ignores his father's advice and pays the ultimate price, eventually falling into the Icarian Sea that bears his name. Ovid details the tortured image as Icarus attempts wildly to flap his arms but, the wax having melted and his wings no more, the son's fate is sealed, and his fall will offer a lasting image referred to in Western art and literature from the Ancient Greeks to the 21st century. Thus, in Walter's description, the image of the Falling Man becomes exemplary of the Icarus myth, the figure transformed into the naïve and overreaching American whose towers scrape the sky and whose fall is tragic but also inevitable.

In this image we can see a certain nostalgia, an insistence that the lessons of the past have not been heeded, a marker of change and, thus, also a yearning for the invincibility of a triumphant post-Cold War America. And while it could be dangerous to see in the Falling Man an image of mythical proportions, or to attempt to read the attacks through such referential iconography, the prevalence of images of people falling from buildings in the 21st century is at least a historical aside to accompany the picture. Whether such images have become more commonplace or have simply taken on a new significance post 9/11 is difficult to determine, but it seems that even the act of falling was in some way rewritten by the attacks. In Hollywood, for example, prominent scenes in which people fall from buildings in *The Matrix Reloaded* (2003), *The Happening* (2008), *Watchmen* (2009), *Inception* (2010), *High-Rise* (2016), and many more

spring to mind. In literature, *The Zero*, *Extremely Loud and Incredibly Close*, and, of course, *Falling Man*, make use of extensive reference to the image. In art, reference can be made to the controversy surrounding Eric Fischl's *Tumbling Woman*, which went on display a year after the attacks in September 2002 at New York's Rockefeller Center only to be covered up within a week, after complaints and even bomb threats.

Fischl's piece is particularly interesting not only for the controversy it caused but because it seems to represent the inverse of Drew's Falling Man, shying away from the masculinist, grand narrative occupied by the anonymous and unfathomable male at the center of the photograph. By attempting to name the Falling Man, Junod hoped in some way to demystify the image, but the picture, he suggests, still transcends identity. If this anonymity allows the Falling Man to stand in for something larger and more symbolic, then *Tumbling Woman* provoked the same response but for differing reasons. Instead, Fischl's artwork gives us something tactile; it is what Karen Lang describes as "human particularity" (31). As sculpture, it is knowable in the very way that the photograph is not; every inch of its surface covered with marks, impressions left by the hands of the artist indicating a presence: a person beneath. *Tumbling Woman* also strikes a chord with the work of another visual artist. At the same time as Damien Hirst was *talking* about 9/11, the work of Sam Taylor-Johnson, another member of the Young British Artists who burst onto the 1990s art scene, seemed to be reliving it. Taylor-Johnson, a photographer who often stages and manipulates her stills (frequently self-portraits), has been exploring the concept of falling throughout the body of her 21st-century work. In 2003, she produced a series of images titled *Falling* that captured acrobats in various states of freefall. In 2004, *Self-Portrait Suspended* displayed the artist suspended, again in various positions as if falling. Although supported by wires, Taylor-Johnson removed these from the image in order to give the impression of either suspension or falling, depending on how the images are interpreted. Perhaps her most interesting pieces, however, are contained in her 2008 series *Escape Artist* in which she, again in self-portrait, suspends herself just above the ground and ties balloons to her limbs in order to give the impression that she has been saved from the consequences of her fall. Further references can be drawn to the pieces *Ivan (ladder)* (2003) and *Strings* in the same year.

It is interesting that both Fischl and Taylor-Johnson share a fascination not just with the human form, but also the naked body. Not only is Fischl's *Tumbling Woman* nude but a substantial body of his work has involved painting the naked female form. Although the men and women in Taylor-Johnson's falling pieces are clothed, she has produced a number of graphic sexual photographs in *Passion Cycle* (2002) and recently directed the adaptation of E. L. James' hugely popular erotic fiction *Fifty Shades of Grey* (2015). It was, perhaps, this interest that drew

them to the vulnerability exhibited by the falling figures of 9/11. Fischl's piece in particular seems to speak for those female victims effaced by the Falling Man and the U.S. media coverage, highlighting that 9/11 was configured as a male tragedy. Not only were the heroes represented as male, the firefighters who risked everything to rescue those trapped inside, but so too were the victims; children lost their *fathers* and women lost their *husbands*. In reality, while the ratio was something like three to one in favor of male victims, as Susan Faludi argues persuasively in *The Terror Dream*, the refusal to show women as anything other than grievers post 9/11 amounted to a "thorough erasure of women from ground zero" altogether (81). This was part of a masculinist discourse that nostalgically attempted to articulate male patriarchal power as the solution to the crisis that now confronted the country, a return *to*, rather than a break *from*, the past.

A clear articulation of this narrative can be seen in the iconic photograph of Marcy Borders, who would later become known as the Dust Lady, taken on September 11th. The photograph, which features the bank clerk Marcy, then in her twenties, covered from head to toe in dust after her escape from the towers, was taken by AFP photographer Stan Honda and was offered as an image showing the shock of those New Yorkers caught up in the terrorist attacks. Marcy's look is one of apparent confusion that mirrors the 'this can't be happening here' sentiment that accompanied the seeming improbability of American vulnerability in the period leading up to 9/11. What the photograph keeps hidden, however, is the visceral damage to the woman's body. While she is positioned as a victim, this can be articulated because we *see* no bodily harm. That the Dust Lady would die in 2015 of stomach cancer aged just 42 is a grim footnote to an image that became iconic precisely because it was one of a number showing Americans emerging *un*harmed from the cloud of dust. Indeed, a great many of the day's survivors and those who worked at Ground Zero in the immediate aftermath to help clear the rubble and search for survivors have since become victims of the carcinogens released into the Lower Manhattan air after the collapse of the towers.

Turning to consider another controversial image captured on 9/11, Thomas Hoepker's picture, which shows five Americans apparently relaxing in the sun in Brooklyn whilst smoke pours from the WTC in the background, provoked outrage for another reason entirely. Hoepker himself waited until 2006 to publish the photograph, and Jonathan Jones, in his article for *The Guardian*, suggests this reason for his hesitancy:

> It is the only photograph of that day to assert the art of the photographer: among hundreds of devastating pictures, by amateurs as well as professionals, that horrify and transfix us because they record the details of a crime that outstripped imagination [...] this one

stands out as a more ironic, distanced, and therefore artful, image. Perhaps the real reason Hoepker sat on it at the time was because it would be egotistical to assert his own cunning as an artist in the midst of mass slaughter.

(Jones, 6)

Jones appears somewhat kind in his suggestion that Hoepker may have chosen not to publish in order to avoid the trappings of his own ego; it seems more likely that he feared the same kind of treatment as Stockhausen received following his comments about the connection between art and 9/11, particularly considering those in the photograph themselves claimed afterwards that it misrepresented their feelings at the time. It is the otherwise picturesque nature of the scene, if we remove the image of the smoking towers, that in fact endows the people with an apparent sense of indifference and even pleasure. It is the way the light reflects in the expanse of water that both metaphorically and physically distances these people from the dramatic scene developing across the city. But this is only appearance. Just as the Falling Man photograph seems to exhibit a calm stillness as the victim falls, terrified, from the North Tower, this photograph too only makes sense as a piece of art when it is divorced from the context of the internal thoughts of those portrayed. It is this fraudulent starting point that allows the photograph to be read as a comment on American ignorance and un-touch-ability.

Considering the torrent of images disseminated following 9/11, it is telling that Drew's Falling Man and the Hoepker image, so completely different in nature, produced such a stir. What they have in common is that they both lie outside the dominant ideological reading of the attacks as a moment of American valor and unity. Whilst the Falling Man purportedly shows the most disturbing aspect of the day itself, the 9/11 ghost, Hoepker's photograph appears to depict a world that carries blissfully on, a world where *nothing*, rather than *everything*, changed. But more than this, Hoepker's piece is controversial because it exposes us to the idea that was most rejected in the American media after 9/11, the idea that, for some, 9/11 was a *delightful* terror; in their distance from it, these individuals reveal the destruction as sublime.

The idea that 9/11 was somehow delightful, a sublime fantasy, has been recurring in responses to the events from critics such as Jean Baudrillard—who famously claimed that, "they *did it*, but we *wished for* it" (*The Spirit of Terrorism*, 5)—to a great number of accounts in fictional texts in which characters grapple with mixed feelings in reaction to September 11th. In *The Zero*, Remy's partner, Paul Guterak, claims after the attacks that "he'd never been this happy" (9) since, as surviving cops, not only is the experience effectively life affirming, "we're alive, man," (10) he says, but they are also treated as heroes. Perhaps more startling, protagonist Changez, proclaimed a "lover of America" on

page 1 of Mohsin Hamid's *The Reluctant Fundamentalist*, later smiles in response to seeing the towers collapse on television (83). And, in *Falling Man* Martin Ridnour, asks, "weren't the towers built as fantasies of wealth and power that would one day become fantasies of destruction?" (116). Ultimately, what attracts these critics, protagonists, and even artists such as Hirst and Stockhausen is not just the artistry of the attacks, but rather the sublimity of the spectacle they created. Like Lianne Glenn in *Falling Man*, who "every time she saw a videotape of the planes [...] moved a finger toward the power button on the remote. Then she kept on watching" (134), these characters, critics, artists are transfixed, even seduced, by images of destruction and the transformative potentialities such images provide.

The reason these images, and more specifically the connection being made between art and terror, is controversial, then, is the underlying implication that we gain some enjoyment from them. Even Damien Hirst's pieces that expose a brutality and cruelty are to be enjoyed on some level, since what they provoke is a delightful horror. For Longmuir, "DeLillo [...] suggests that terrorists are usurping the traditional role of artists" (44). She cites DeLillo's novel *Mao II* as an example of this idea being played out in literature prior to the attacks but also argues that this same feeling is evident in Robert Altman's disgust at filmmakers whom he claimed had "taught them [terrorists] how to do it" and with this had suggested that movies could be held, at least partially, responsible for inspiring such acts. This helps make some sense of Stockhausen and Hirst's statements since terrorism, in this reading, engages visually in the same way as art has always sought to, even to some extent threatening to replace it in the 21st century as the primary source of the delightful horror of the sublime; a sublime designed ultimately to provoke. This same idea is evident in DeLillo's most recent offering, *Zero K*, in which art is shown to be powerless in the face of modern terrorism. In the novel, protagonist Jeffrey Lockhart explores an underground facility in which bodies are cryogenically frozen at the moment of death in order to preserve them for revival in a future where medicine has advanced sufficiently for them to live again. Doorways are painted unusual colors; mannequins hide in rooms and corridors, imitating the life that would be preserved; twins embark on a philosophical sales pitch for life after death in a way reminiscent of performance art; and screens around the walls pulse with images and films that can only be described as an abstract form of art. Thus, instead of modern art creating emptiness in contrast to terror, terror *becomes* modern art or is incorporated *by* modern art, suggesting the ineffectuality of both. In one significant moment during which the screens display an attack, designated as part of the War on Terror, Jeffrey cannot discern if this is art, propaganda, or reality. Is it all or none of these? The scene described he later discovers to have been real, but DeLillo focuses on the camera work and the soundtrack

as a way of emphasizing its artifice: "it looks and sounds like traditional war" [...] "and the soundtrack flows into the action, loud, close, voices calling, and I have to step back from the screen even as the camera becomes more intimately involved" (262–263).

Ultimately, what these cases demonstrate is that, in the 21st century, art competes with terror in its search for the sublime image—the image that will provoke, that will cut through the noise of the contemporary world. Often in the process, the boundaries between terror and art are blurred, giving credence to Nye's suggestion that, "one person's sublime may be another's abomination" (xvii). Whether this art, that draws on or even inspires terrorism, is bold and provocative, or shameless and exploitative depends very much on one's position. As is revealed in the title "Falling Man as Heartless Exhibitionist or Brave New Chronicler of the Age of Terror"—the name of a panel discussion at a school in *Falling Man*—the actions of the performance artist draw in both responses simultaneously: is he an artist; a terrorist; both; or neither (220)? Does the photograph or the performance artist here suggest something about the fall of America, the end of American innocence, like Icarus falling from the sky? And Hoepker's photo too, does its power come from the way in which it positions the Americans in the frame as somewhat impervious to the terror raging in the background, a sign of hubris? Or, are these images emptied of their significance by the vacuum of terror, with art being rendered meaningless in the face of the sublime destruction offered by the terrorists? There is a certain truth in all of these readings. Both Drew's and Hoepker's photographs provide new ways in which to read and interpret the act of terror. In doing so, they were controversial but also, again, testament to the power of the image.

## Attention Deficit Disorder: Contemporary Terror Attacks and Spectacle

In 2011, Terry Castle, an English Professor at Stanford, lamented that she couldn't teach her class on 18th- and 19th-century gothic literature without showing her students images of the Twin Towers burning as comparison pieces to sublime painting of the period. "Uncanny resemblances were everywhere" she writes, "collapsing buildings, clouds of black smoke, victims fleeing in panic—all the lurid microdrama of cataclysm and death." For Castle, then, the images produced by 9/11 offered a distinct evocation of the sublime as characterized by Edmund Burke in the middle of the 18th century. Images of turbulence, chaos, and threat shown in works like J. M. W. Turner's *Dutch Boats in a Gale* (1801), or Albert Bierstadt's *A Storm in the Rocky Mountains, Mt. Rosalie* (1866) and *Storm in the Mountains* (1870), showcased the dominance of nature—the inferiority of the human scale. Other works tended toward the apocalyptic as in the paintings of John Martin such as *The*

*Destruction of Sodom and Gomorrah* (1852) and *The Great Day of his Wrath* (1853). These images forced the viewer to gaze at subjects of such size and potency that humanity appeared insignificant by comparison. Whereas in the aftermath of the 9/11 attacks Baudrillard moved swiftly to proclaim that "both images and events" had been "resuscitated" (*The Spirit of Terrorism*, 27), the spectacle witnessed on September 11th actually began to cannibalize other such destructive images. Hence, it became impossible for Castle not to see, in these centuries-old paintings, the image of the towers' collapse. Another example of this occurs in *Falling Man* when Martin Ridnour and Lianne Glenn describe how they see, in a Morandi still-life painting, the residue of the towers in a pair of bottles that are ominously backgrounded. The implication, therefore, is that all images have been changed, redrawn so to speak, in the aftermath of the *witnessing* of destruction. "Everyone carries with them some imprint of the images of destruction – the collapse of the towers, the image of the second plane, the falling bodies, the tangled ruins" argues W. J. T. Mitchell (80).

The resonance of this idea is captured in the work of contemporary German abstract artist Gerhard Richter whose 2005 painting, *September*, gives the viewer cause for doubt, just for a brief moment, as to the painter's intention. While the painting does, indeed, show the towers with smoke billowing from their sides, were it not for the title one might be left unsure as to its resemblance of the Twin Towers. In a similar way, Richter's *Stripes, WTC* (2006), which places three abstract images of grey lines and shapes alongside four photographic images of the WTC towers exploding, asks similar questions of the viewer: do we see in these lines and shapes the image of the WTC because we are instructed to do so by the name or by the photographs? Indeed, would we have seen such an image without these guides? Was the artist aware when creating the lines and shapes that what he was producing was in some way an echo of the towers? If not, was it coincidence or the work of the subconscious? Thus, Richter revives the history painting for the 21st century by articulating our uncertainty not just in terror itself—how scared should we really be?—but in the mediated image more broadly. If 9/11 offered a concrete image of sublimity, the terror since has come, at least in part, from the undermining of any such concrete expectation. Today's attacks are designed to provoke *doubt*. Whereas the sublime of the romantic period offered images of apocalypse, and the sublime of the 20th century offered the desolation of its own bloody history, the sublime of today is located in the power of the image itself, the rush of images and the confusion with which their antagonistic voices leave us. Indeed, Mitchell sees in this cacophony of images both a sublimity and a type of melancholia:

> When images fail like this we can call it sublime from an aesthetic perspective, or melancholy from the standpoint of psychology.

Perhaps they come to the same thing at some level. For Freud, it is the failure to mourn that leaves only melancholia, an inability to let go, to bury the dead, to return to the living. It is not that this trauma, any more than the Holocaust, is incapable of being represented. The problem is just the reverse: too many representations, too many images and bad dreams, and no way to arrive at a consensus, a communal acceptance.

(Mitchell, 80–81)

If contemporary terror attacks are any indication, it would seem that the sublime is located in the visceral turmoil, the creeping fear and uncertainty, the erosion of our faith in our common practices and the institutions created to protect them, and us.

9/11 proved two things: first, that with a relatively small number of fanatics willing to die for a cause, a great deal of carnage can be wrought and second, that spectacle trumps all else in the war for media attention. It is upon these two terms that all terrorist acts have since had to compete. On the evening of the 13th of November 2015, and into the next days and weeks, Facebook feeds were awash with the colors of the French national flag as huge numbers of users, with the aid of a Facebook function, added the tricolor to the background of their profile pictures after terrorists in Paris left 130 dead and over 350 injured. Similarly, in early 2016, terror attacks in both Brussels and Orlando prompted users to change their pictures again in a show of support (although it is worth noting that this time it was not offered as a function of the site). Many stopped to point out the double standards at play; we don't change our pictures in support of Iraq when another suicide bomb goes off in Baghdad. A number of articles were also subsequently published across the Internet questioning the use value of these actions. For all the solidarity it appeared to offer, what exactly was the message being transmitted, and what did it ultimately achieve? What this flood of banal images served to demonstrate is not just the pervasiveness of today's coverage of terrorist actions, but also the ambiguity of such coverage. For all that has been written on the complicity of Western powers in the creation and maintenance of the forces of terror, are we—the public—not also, in part, to blame?

What is it that politicians, artists, writers, performers, and terrorists all have in common? They are competing for our attention. It is this singular fact that has led to the continual reproduction of the melancholic sublime in the 21st century, a century in which the Internet, social media, and obsessive news coverage has enabled almost anyone to compete and to add his or her voice to the chorus. "Our time has witnessed," argues Mitchell, "not simply *more* images, but a *war* of images in which the real-world stakes could not be higher" (2). But, although these images have often been polarizing, the critic highlighting the war in Iraq

as the Bush administration's attempt to offer a counter-image to that supplied by the terrorists on September 11th—an image in which a figure is made villainous, deposed, statues of him torn down, and towns and peoples liberated—the multiplicity and polysemous nature of these competing voices cannot be underestimated. Today, both politicians and terrorists compete in a public forum in which only the most spectacular of news stories can maintain an interest for more than a day.

As Jacques Derrida highlighted in 2003, both the terrorists and the government (who wished to exploit the new reality of fear the attacks would usher in) stood to gain from maximizing the coverage of 9/11 (108). By consuming images of the collapsing towers, the general public was, in some way at least, complicit in not only its own terrorization, but also its own manipulation. Since, as Alasdair Spark suggests, the purpose of the attacks was to "dominate American (and world) television with terrifying images," an agenda that helped to explain both the targets themselves and the timings of the attacks—in order to catch the morning news rather than necessarily deal maximum collateral damage—"we have to recognize" he argues, that "our consumption of the spectacle of America has become not just more complex, but also more complicit" (226). Thus, in today's world in which news, information, and opinion seem to flow continuously and multidirectionally, the public is also responsible for the production and construction of the spectacle of terrorism.

The importance of spectacle to organizations like the Islamic State group, and Al-Qaeda before it, is demonstrated by the way in which recent terrorist atrocities have been tailored for Western media (including social media). The filmed executions of Western prisoners by Islamic State and the targeting of concert venues—which has ensured a ready supply of shaky, handheld, media footage from the general public—for example, have encouraged the dissemination of terrorist 'propaganda' material. While these attacks have, as of yet, failed to reach the magnitude of the destruction wrought on those in the Twin Towers, their theater is still evident. Who can have watched the footage of Michael Adebolajo justifying the brutal murder of Lee Rigby (shot by a bystander immediately after the attack, his hands still drenched in blood and carrying the cleaver with which he had, only moments before, attempted to hack off the fusilier's head) and not considered the cruel interplay between technology and barbarism, between theater and death? This man, whose calm demeanor and steady rhetoric stood in such stark contrast to the drama that had just unfolded on the normally quiet suburban London street, signals not so much a change in tactics as a change in our own consumption behaviors. As with the beheading videos, in which our attention is drawn to the man at the center and the look on his face in his last televised moment, the video footage of Adebolajo's cold and calculating rationalization *is* the spectacle. As Will Self suggests in his

*Guardian* piece on the beheading videos, whether or not we have seen the violence itself, we all at least *feel* like we have.

This is where the sublimity is really located. To show death and brutality offers mere terror, but to refuse to show it offers the sublime. It leaves questions open. It forces us to rethink our relationship between the individuals involved, not just the victims but the terrorists too. There is a sublimity as we attempt to fathom, to understand, what can possibly motivate this person: what causes, visions, horrors, delusions, can have fostered a state of mind we find so alien? It forces us to confront the possibility that reducing this to the concept of 'evil,' as both politicians and the media did after 9/11, does not quite cover it. Zygmunt Bauman, in *Liquid Fear*, exposes the inadequacy of the term: "The question 'what is evil?' is *un*answerable," he writes,

> because what we tend to call 'evil' is precisely the kind of wrong which we can neither understand nor even clearly articulate, let alone explain its presence to our full satisfaction. We call that kind of wrong 'evil' for the very reason that it is unintelligible, ineffable, and inexplicable. 'Evil' is what defies and explodes intelligibility.
>
> (54)

And so, when our designations fail, we must stop and reconsider the attacks in the wake of such a failure. Ultimately, is there not an extent to which we search for the violence? Surely its absence in the image, and the footage, makes us wonder as to the terrorists' aim. They do not parade it as one feels they should. If the aim was simply violence, then why not show it? Why keep it hidden from us? It is not enough to suggest that our censorship from the violence of terrorism is self-imposed or imposed by the media or even the government: it seems that the terrorists wish to protect us from it too, hence the emphasis since 9/11 has been on the recording of speeches rather than of the actual violence. Where violence is captured on CCTV, or on mobile phones, it is seen only as a blurring whirr of motion: people running, yes; people hunched over, or lying prostrate, but not the loss of limbs, not the hideous burns, and not the final moment of death itself.

When on European or American soil, recent targets have been chosen carefully in order to make grandiose political statements as with the murder of Fusilier Lee Rigby in Britain 2013, the Charlie Hebdo massacre in Paris 2015, the attacks months later in the same city, and the Orlando shootings at a gay club in 2016. What all of these attacks demonstrate is a determination to infiltrate the public consciousness. Soft targets like nightclubs (the Bataclan and Pulse), airport entrance lounges (Istanbul, Brussels, Glasgow), individuals such as police officers (Jean-Baptiste Salvaing), off-duty military personnel (Lee Rigby), members of the media (those murdered in the Charlie Hebdo attacks,

and notably also James Foley the American journalist captured by the Islamic State group and beheaded in a video circulated on YouTube in 2014), and even children (as with the bombing of the Ariana Grande gig in Manchester, 2017) are not simply chosen for being easy to attack; they also showcase the terrorists' desire to undermine public faith in the safety of leisure pursuits, travel networks, and institutional authorities. As Mitchell suggests, terrorism is "a form of psychological warfare designed to attack, not military opponents, but symbolic targets (preferably including 'innocent victims'). It is an assault on the social imaginary designed to breed anxiety, suspicion, and (most important) self-destructive behavior" (12). For Mitchell, "terrorists [...] perform and stage the unimaginable," (63) a comment that seems in keeping with Nyan Chanda and Strobe Talbott's statement that the 9/11 attacks were "mass murder as performance art, the staging and timing guarantee[ing] maximum coverage worldwide" (xiii). The coordination of 9/11 was repeated again in 2004 when four bombs exploded at around the same time on Madrid commuter trains, killing nearly 200 and injuring just short of 2,000. In July of 2005, another four separate bombs were detonated in an attempt to disrupt London commuter networks, killing more than 50 people and injuring a further 700. Although the next ten years saw only minor incidents in Europe and America, the rise of Islamic State in Iraq and Syria has led to a fresh round of coordinated attacks, most notably in Paris 2015 where three distinct locations were targeted including outside the Stade de France where the French and German national soccer teams were playing in a friendly match.

The nature of these attacks leads us back to the comments of German composer Karlheinz Stockhausen, whose 'appreciation' of the attacks was premised on this very coordination, or rather *orchestration*. What Stockhausen saw in the 9/11 attacks as artistic was the collaboration the work entailed, "people rehearsing like mad for ten years, preparing fanatically for a concert, and then dying." In this he notices that, rather than our terror being predicated on the randomness of attacks, it is rather the terrorists' planning and precision that most disturbs, the idea that these attacks were carried out by people who had thought about them a great deal, who had carefully considered the eventualities. The attacks were not simply reactionary, the lashing out of a frustrated loner, but rather a collective will to disavow contemporaneity. "By comparison," uttered Stockhausen, "we composers are nothing." In this, however, he fails to fully realize the implications of his own statement. By Stockhausen's account, the power of the terrorists comes from the idea that they *are*, in essence, composers. It is the synchronicity between his and their performance that leads to his own grudging admiration. What is left of art in the face of this when death and terror take on all the same hallmarks? Theodor Adorno famously suggested in "Cultural Criticism and Society" that "to write poetry after Auschwitz is barbaric" (34). Of

course, this did not mean that poetry no longer had any use, it merely emphasized that the state of the art had shifted, or changed, after the 20th century's greatest act of barbarism. To suggest that the same might be true after 9/11 is, perhaps, an abuse of memory and proportionality, but rather than indicating that 9/11 itself changed art, it might be more cautious to see the change as reflective of a new relationship between art and terror in the 21st century.

The reaction to Stockhausen's regrettable outburst, exemplified by Anthony Tommasini's scathing indictment of the composer—described in his piece in *The New York Times* at the end of September 2001 as an "egomaniac" and "perhaps [...] a raving has-been"—proved that it has become dangerous to equate art with terror. Yet, as has been discussed, they both desire to harness the power of the sublime image, the image that can stand out in a world of image saturation. "Art may be hard to define, but whatever art is, it's a step removed from reality. A theatrical depiction of suffering may be art; real suffering is not," asserts Tommassini. But like the Stockholm syndrome—which manifests itself as an attraction toward one's kidnapper—Stockhausen's syndrome was considered so perverse because he seemed to find a kind of beauty in the devastation wrought by the attacks, mixing up what was, for many onlookers, a clear distinction between 'real' life and art. Perhaps a more interesting interpretation of Stockhausen's response considers it a reaction to the sublime rather than a perverse attraction toward the deaths of innocent people. Like so many others who saw the events unfold only through the television screen, Stockhausen could delight in a terror that had been mediated by distance, offering a sublime experience. Thus, rather than simply dismissing Stockhausen's comments as confused, we should look at the questions they prompt, the way in which they highlight not just the fine line between terror and art, but the competition that both artists and terrorists find themselves locked in, a kind of sublime arms race for the most arresting image.

As I have argued here, the connection between art and terror has been particularly contentious. In a *media*ted world in which information and opinion circulate instantaneously and in a wide variety of forms, the image has been the locus of the battle between terrorists and governments. Understandably, while terrorists have tried to provoke fear and retaliation through the mobilization of images of death and destruction, and governments have responded by offering counter-images of bravery, sacrifice, and the overwhelming military and civil power at the disposal of Western capitalist democracies, artists have utilized images of the sublime in an intervention that muddies the clearer black and white tones of the rhetoric. These images suggest that neither side holds a monopoly on perception. Moreover, recent terror attacks that have specifically targeted the producers of images (particularly notable with the Charlie Hebdo massacre) or have mimicked an artistic theatricality in terms of

their orchestration and dramatic delivery (from 9/11 to the Islamic State beheading videos and the murder of Lee Rigby) continue to imply a connection between terrorists and artists. But, as Stockhausen's comments highlighted, perhaps the defining characteristic of terror in the 21st century is that it has become less and less clear who is mimicking whom. While artists recreate images of terror as provocative pieces, it seems that just as often terrorists borrow both the images and techniques of artists in order to compete in a world in which only the most sublime images—those that conjure fear, uncertainty, and inconsequentiality—can punctuate the noise of contemporary life and capture our attention.

# 3 The Sublime Moment in Contemporary Literature and the Nostalgia for a Lost Innocence

"Suzannah was in the shower when the world changed. The world probably changed on many mornings while Suzannah was in the shower: floods, plagues, coups, murders, and so on, all wreaking havoc while she conditioned her hair" (*A Day at the Beach*, 42). Why has Helen Schulman chosen to write about this particular catastrophe? Because, perhaps, it is that rarest of tragedies: one that happens *to* the American middle classes. It is for this reason that Suzannah finds herself wondering, as she watches from her bathroom window "the people fall from the wounded, burning tower" why one victim hasn't taken off his tie before jumping (47). That Schulman makes acute the class signifiers throughout her novel—through the references to classical music, ballet, haute cuisine, fine wines, luxury apartments, and the family's au pair—highlights the classist undertones in the response not just to September 11 but to terrorism more broadly: as her protagonist ironically proclaims, her family had become "refugees to the Hamptons" (83). *A Day at the Beach* is filled with soaring hyperbole: "was it true" Suzannah wonders,

> that no matter the power of one's government or the strength of their army, how wealthy or how smart or how pretty or how accomplished one was, the color of his or her skin, the depths of his or her education, the thread count of his or her sheets, the rarity of his or her wine, how *loved* someone was [...], that anyone was safe? Today had proven otherwise. The human being is nothing.
>
> (155)

For Suzannah this is the ultimate truth of 9/11: even the rich can be victims.

While Suzannah showers, her husband, Gerhard Falktopf, waits downstairs for a phone conversation with his lawyer Shingshang who is having breakfast at the Windows on the World restaurant. Gerhard, a writer and choreographer, like the artists in Chapter Two, sees something in the attacks that calls to his artistic nature: "for the first time in forever he existed as a creative force, far outside of commerce, struggles for control, litigation, competition" (130). So, like Schulman, herself a

writer called to the event, Gerhard finds the terror attacks liberating on a creative front. Like Damien Hirst and Karlheinz Stockhausen, he sees an artistry in the terror attacks, themselves a "shocking, brutal performance" (212). An image of the North Tower on the television speaks "like a strange object of art [...] already framed and turned into an artifact, like looking instantly back at the past" (57), and Gerhard feels "a rush of pleasure [...] from top to bottom" as he adjusts to his newly masculinized role in the post-9/11 family unit (130). But the text is filled with a nostalgia. On waking their au-pair to tell her what has happened, Suzannah muses that "looking at Celine, this young-stemmed beauty, yawning and scratching, younger and more vulnerable upon waking, was like looking at the world before, before whatever just happened" (72), and for Gerhard, the ultimate truth of the attacks, what he eventually learns on that day of infamy, is that "art didn't matter" (210).

Terrorism is an affront to us not just because of its brutality, but also because it is, perhaps, the only threat specifically targeting the Western middle classes. This demonstrates the inadequacy of the pervasive political mantra dictating that terrorists 'hate us because of our freedom,' clearly only a partial truth. Aside from the obvious question of the very nature of such a freedom, there is another problem. It is more what we do with our 'freedoms' that terrorists tend to hate—interventionist foreign policy measures, the blind exploitation of foreign workers and lands, and our ideological and moral certitude. It is also for this reason that writers, who traditionally occupy a middle-class or elitist profession, have been so swayed by the moment. Maria Manuel Lisboa offers a counter-narrative in which 9/11 "was not the end of anything, merely the re-visiting of a not even-particularly new or original, although undeniably vicious circle" (10). In literature, however, authors were falling over themselves to proclaim the day a historical watershed, perhaps because they felt they themselves were under assault.

## Foregrounding the Moment of Terror in Literature

> It was not a street anymore but a world, a time and space of falling ash and near night.
>
> (Don DeLillo, *Falling Man*)

The opening line of Don DeLillo's *Falling Man* evokes a moment of apocalyptic reckoning. Recalling the imagery of Pompeii, it asks the reader to envision the victims of 9/11 fossilized in their moment of terror as they flee screaming from the suffocating cloud of ash and dust created in the wake of the towers' collapse. Like the people of Pompeii, they too have been frozen for eternity, memorialized as they are in the footage of the attacks and in the swathe of cultural reimaginings that followed.

Akin to that archetypal disaster scene, it is not so much the eruption itself that is recalled but those who were left behind, the powerful image of the town's ashen people who, like history's messengers speaking their warning of the sublime power of the world over the individual, retain a resonance long after their departure.

This image articulates a constant tension between the desire to memorialize 9/11 and attempts to move beyond the tragedy into the wider expanse of the 21st century. That this street stretches far beyond its bounds, reconfiguring the world as it goes, demonstrates the hyperbolic way in which 9/11 is defined in such texts. Indeed, in post-9/11 narratives the date has tended to be employed as a structuring device in order to establish the moment as a kind of temporal impasse. We are reminded of this overtly in *Falling Man*'s Chapter 9, which concludes with, "thirty-six days after the planes," an indication that time is stratified, leaving behind only a before and an after (170). It is as if the planes themselves have forcibly split time, cleaving it in two as they hurtle toward historical destiny and inevitable catastrophe. This device is used by DeLillo on multiple occasions to bridge passages, but the compulsion toward measuring elapsed time since 9/11/2001 is not the attempt at temporal distancing it may, on the surface, appear to be (8, 34, 170). Instead, it reinforces the notion that not only is 9/11 present in the text at that moment, the planes seeming to erupt from some subconscious space in order to *inter*rupt the narrative flow, but also that it has always been present in the text to the point at which these eruptions structure the text's very existence. There is no indication that this counting will ever stop. What happens when the characters reach hundreds and then thousands of days after the planes?

It is as if, in order to imbue meaning, a myth has developed around the event that perpetuates this distinction in time epitomized by that popular claim that on September 11, 2001, "everything changed." This claim, described by David Sterritt as "conventional wisdom" (64), has been challenged by critics such as Isabelle Freda, who suggests that, "While everywhere people felt that 'everything had changed,' this sense of a break was far in excess of the attacks" (238). In "Melancholic and Hungry Games: post-9/11 Cinema and the Culture of Apocalypse," citing former President Barrack Obama's 2008 election campaign slogan, "Change we can believe in," I argued that the recent growth in apocalyptic culture can be linked to a catastrophic loss of belief in political change caused directly by the missed opportunities for progressive and utopian rebirth in the aftermath of 9/11. Here, I wish to take that argument further to consider the way in which post-9/11 texts often use the moment as a disjuncture and, in so doing, justify the ongoing memorialization of 9/11 and actively historicize it as the point of rupture, the point at which, rather than meekly bleeding into the 21st, the 20th century instead literally erupts in a radical transformation of

the sociopolitical landscape of the 'West.' In doing this, these texts construct not just a post-9/11 world of terror but also a nostalgia for the time of 'innocence' that preceded the attacks, the days *before* the planes. This is echoed in Ian McEwan's novel *Saturday,* which suggests that 9/11 precipitated a fundamental adjustment in perception. "Everyone agrees, airliners look different in the sky these days," he writes, "predatory or doomed" (16). Thus, after 9/11, the implication is that we *see* the world as a more dangerous place.

Stephanie Hoth claims that: "When an event is declared to be historical, it gains the quality of a caesura which divides the world into a 'before' and an 'after'" (286). The texts in question here affirm this relationship in reverse, however, *declaring* the event historical *through* the division of each fictional world-space into a before and an after. In choosing to establish 9/11 as the fulcrum of a narrative, the author is bound to the notion that the day is a point of change, an apocalyptic juncture after which the lives of the characters are turned upside down. Some texts achieve this in an overt fashion, as with *A Day at the Beach* and, for example, Jonathan Safran Foer's 2005 novel *Extremely Loud and Incredibly Close* in which narrator Oskar, a nine-year-old boy whose father died in the 9/11 attacks, refers not to the event itself but to "the worst day," echoing DeLillo's refusal to name the day directly but, in doing so, reinforcing its continued centrality to the narrative's action (12). In Jess Walter's *The Zero*, protagonist Remy suggests that the event disturbed even the progression of night into day: "it seemed to him sometimes that that was the *last* morning; every day now started at noon" (218). But in other examples, the decision to focus on the period preceding 9/11 is enough to imply its centrality as with Claire Messud's *The Emperor's Children* (2006) and Julia Glass' *The Whole World Over* (2006). Such a dramatic turn foregrounds the impact of the attacks, implying not just a seismic shift in the period following the attacks but an active nostalgia for the times of innocence before the destruction of a way of life. For so many authors, it seems, life had become, as Schulman writes in *A Day at the Beach*: "a compendium of the innocent moments *before*, like the carefree snapshot of a day at the beach that sometimes accompanies the story about a murder victim" (146–147).

The sheer volume of texts in the fledging 9/11 canon can make it somewhat difficult to establish which might be worthy of critical attention. Online editor Jimmy So comments on this, suggesting first that, as of yet, no definitive 9/11 novel has been written and second that, "we even seem to have decided that September 11 was such an abrupt, transformative event that fiction dealing with the tragedy squarely cannot possibly come close to measuring its vibrations." This, we can presume, accounts for the fact that many post-9/11 novels prefer to deal with the attacks in an oblique fashion rather than confront the tragedy directly. While there are some exceptions to this, noted later, any novel

that uses 9/11 either as its backdrop or as its showpiece must contend with critics ready to brand such usage as an ill-judged attempt to either honor the memory of victims or exploit the moment as an opportunity for creative exchange. Ruth Franklin hints at the difficulty facing writers in the field: "in the immediate wake of 9/11, there was something superfluous about the all-too-deliberate search by some writers for new ways to describe an event that the vast majority of Americans had already seen for themselves on television." Thus, writers who have tackled 9/11 cannot only be challenged in relation to the ambiguity of their motives, but also in relation to the importance—even use-value—of their written accounts of an event that said more through the images of destruction it subsequently produced than, perhaps, can be conveyed in literary accounts.

One way in which writers of 9/11 literature *have* sought to make sense of the attacks, however, is through the articulation of a violence largely ignored in the media coverage. This has been more extensively highlighted elsewhere in this book in relation to the falling figure but is nevertheless worth noting here as a key element of the ways such texts confront the issue of terror. Even novels that manage to avoid the trappings of the *everything has changed* mantra still appear to offer at least some rearticulation of the brutality of the September 11 attacks, as in the case of Ken Kalfus' 2006 *A Discourse Peculiar to the Country* (essentially a dark comedy about a husband and wife who, in the middle of a bruising and bitter negotiation over their divorce settlement, are momentarily joyous when they believe each other to have died in the attacks). While Kalfus, through the novel's name—a clear critique of the state of the nation—and its comic tone, highlights the excessive rhetoric that surrounded the day in passages such as, "despite Marshall's restrained denials, they believed the [divorce] action stemmed from 9/11. At his firm 9/11 was the alpha point from which history moved forward, the Big Bang, Genesis 1:1" (154), the novel actually undermines this position with the inclusion early in its narrative of a gruesome account of Marshall's attempt to rescue another man, Lloyd, only for "half his head" to be "ripped away" (17).

In his critical work *On the Natural History of Destruction*, focused on the literature produced in the aftermath of the Allied bombing of Germany's towns and cities, and after a horrific description of the raids on Munich, W.G. Sebald writes:

> The remarkable aspect of such accounts is their rarity. Indeed, it seems that no German writer, with the sole exception of Nossack, was ready or able to put any concrete facts down on paper about the progress and repercussions of the gigantic, long-term campaign of destruction.

(30)

If, as Sebald's accounts appear to indicate, German literature after the war failed to help heal the German people because writers seemed incapable of confronting the horrors suffered on account of the bombing raids, alongside an accompanying national guilt, 9/11 literature fails for the exact opposite reason. 9/11 texts overcompensate for the absence of horror witnessed by the majority by recreating a horror that was largely kept hidden from public view despite the ubiquity of images of the attacks. In so doing, they enshrine the moment as the tipping point of 21$^{st}$-century experience. This is the melancholic sublime at its most dangerous. By creating such a watershed, 9/11 literature asks readers to look to the past for solutions to contemporary conundrums. Writers rehearse the attacks out of a desire to return to the point before the planes. Thus, when Schulman refers to the attacks as a "holocaust" (94), she falls into the trap of reinforcing the hyperbole that was already reshaping American discourse, in doing so exaggerating the impact of the attacks and generating nostalgia for an imagined lost innocence that disappeared the moment the second plane struck.

In other texts, what is *not* said about 9/11 creates the impression of a deep and silent shift in consciousness for those close to the event. Joseph O'Neil's 2009 *Netherland* is an interesting example: a novel that, while seemingly indebted to 9/11, barely references the day at all. The novel, set primarily in New York, centers on the upheaval in the life of its protagonist, Hans van den Broek, in the wake of September 11, 2001. Importantly, it would seem that the breakdown of his marriage is in some way connected to that day as if it were the cause of a rift between Hans and his wife or the catalyst for the revival of some underlying problem. Perhaps Hans, in seeking to cope with and explain his marital difficulties, has merely projected them onto 9/11, or perhaps the attacks really did have an impact; this is left for the reader to surmise. What becomes important is the reader's desire to apportion blame for this breakup, which leaves 9/11 as both a convenient point of historical departure and as the marker of a change in personal attitudes.

These works of fiction offer something concrete onto which can be projected the neuroses of a post-9/11 terrorized society, but they are more explicitly works about fear and trauma and as such struggle to expand their scope outside that of the individual's experience of the event. Thus, these texts fail to define the post-9/11 age as anything radically different from the world that preceded it. 9/11 has become the frame or structure upon which to hang attempts to rationalize the present, and yet, like the World Trade Center buildings themselves, it is an empty signifier. The buildings may have been *interpreted* as a signifier of America's power and of the undisputed rule of capitalism, but their collapse did not instigate the collapse of that which was supposedly signified. Just as these fictional works fail to articulate any tangible difference outside of the lives of particular characters who may have been directly affected by

the event, it is hard to identify exactly what has changed in its wake. 9/11 fiction, not to mention much of the related nonfiction produced since, has not only proclaimed 9/11 an event productive of change, but even more an event that *changed everything*, that has, in effect, reordered the world. And yet, such a response is disproportionate and serves to restrict the resulting discourse.

It should be acknowledged that in the very act of writing about 9/11 one concedes that at least *something* has changed. To this extent, nearly every statement made serves to further the misnomer that 9/11 *changed everything*. Even writers like Slavoj Žižek, who astutely recognized the attacks as a product of, rather than a break from, history, were lured into making grandiose statements. The very idea of America waking up to the "desert of the real" echoed in the title of his 2002 response—admittedly a limited reading of his much more complex thesis—chimed nicely with the rhetoric of commentators like *Washington Post* columnist George Will who famously asserted, the day after the attacks, that America's "Holiday from History" was now over. Of course, many of these statements were made in the immediate aftermath of the attacks when feelings were still particularly raw—even DeLillo, in his article for *Harper's Magazine* on December 21, 2001, described the event on the scale of a grand narrative, saying that: "all this changed on September 11. Today, again, the world narrative belongs to terrorists" (33)—and so, while it would be easy, from such an objective distance, to criticize these initial responses, some level of caution is required. The reason these early accounts should be considered and critiqued, however, is that they would come to shape both the literature and discourse in the years to follow.

Fiction has subsequently, and often reductively, echoed these early knee-jerk reactions to the event and continued to propagate this narrative. However, none of the concepts that have, at some point in time, been used to define the post-9/11 era (terrorism, fear, U.S. imperialism, radical nationalism, religious fundamentalism, random acts of violence, restrictions of liberty) are new. In their book, *America between the Wars*, Derek Chollet and James Goldgeier begin by stating that, "Although 9/11 created the illusion that America's purpose was once again clear... the questions America grappled with in the first decade after the Cold War remain unanswered" (xv). Indeed, the lack of coherency with regards to U.S. foreign policy in the years following September 11—the war in Iraq, former President Barack Obama's dropping of the term "War on Terror," and his inability to close Guantanamo Bay standing as the most overt of examples—suggest rather that indecision and contradiction have been the hallmarks of the U.S. political reaction to 9/11.

So, how is it, then, that 9/11 fiction continues to obstinately claim that *everything changed*? As Richard Gray suggests, "while many novels [...] may accommodate the claim that things have fundamentally changed

since the terrorist attacks, their forms do not necessarily register or bear witness to that change" (51). The false predication of these works of fiction seems to center on their tendency to focus on the individual only to then, as a kind of sleight-of-hand move, apply these individualized impacts outward, projecting them onto an unsuspecting world in that very American way of claiming that 9/11 was not an attack on the United States, or an attack on capitalism, but an attack on "freedom." This is, surely, a displacement of convenience.

This type of projection is exemplified in *Extremely Loud and Incredibly Close*, which organizes its narrative around adventure and discovery. Oskar's search for the lock that fits his father's key is the spur for an exploration of New York City not as it was but as it is after September 11: inhabited by the pain and individual stories that grew out of the attacks. As Oskar, with the aid of his estranged grandfather, traverses the city in an attempt to meet everyone with the surname Black (the name on the envelope in which Oskar finds the key) he uncovers a network of personal grief:

> Albert Black came from Montana. He wanted to be an actor, but he didn't want to go to California, because it was too close to home, and the whole point of being an actor was to be someone else. [...] Alice Black was incredibly nervous, because she lived in a building that was supposed to be for industrial purposes, so people weren't supposed to live there. [...] Allen Black lived on the Lower East Side and was a doorman for a building on Central Park South, which was where we found him. He said he hated being a doorman, because he had been an engineer in Russia, and now his brain was dying. [...] Arnold Black got right to the point: "I just can't help. Sorry." I said, "But we haven't even told you what we need help with." He started getting teary and he said, "I'm sorry," and closed the door.
>
> (196–200)

To this extent, Foer's novel is representative of a widespread characterization of the 9/11 attacks as both a national trauma and, at the same time, a vast web of individual tales of tragedy and heroism, recalling those faces of the missing that sprang up on posters all over Manhattan, or the "Portraits of Grief" printed in the *New York Times* (over 1800 obituaries featured over the subsequent weeks). Indeed, Martin Randall emphasizes the ubiquity of such personal narratives. "This intertwining of the intimate and the social is a major theme in writing about 9/11" he suggests, continuing to mark this as essential to the interaction between the personal and the political in these texts: "the trope of an individual's sudden, unexpected and accidental 'entry' into the flow of history and politics informs the majority of 9/11 fiction" (26–27). This has the effect of effacing the differing proximities of those who witnessed the

event, blurring the lines separating victims, survivors, those who saw it unfolding firsthand, those who lost loved ones, and the majority whose experience was *media*ted through television, newspaper, or Internet coverage. Finally, this gesture toward the personal depoliticizes the attacks through their 'domestication,' subsuming them into narratives about work/leisure routines, marriage, or the innocence of childhood trauma/ victimhood.

The term Ground Zero places Manhattan at the heart of events both national and personal. David Simpson highlighted Ground Zero as one of the terms, among a host of others, that became 'naturalized' and circulated "without question in the national media and the popular imagination." For Simpson, "the normalization of these terms within the standard lexicon so that they can be reported without question is precisely one of the most effective ways in which culture is remade" (17). An evocative term, Ground Zero reorganizes history. Gene Ray suggests that the rapid adoption of Ground Zero to refer to the site of the former World Trade Center represents the "potent return of repressed American history" (*Terror and the Sublime*, 51). Indeed, it has almost entirely replaced the symbolic dimension of the term as a reference to the site of the 1945 Hiroshima nuclear detonation, reconfiguring the author of that original Ground Zero as the *victim* of this particular historical episode. For Ray this is a necessary prerequisite for the War on Terror that America could only wage "by rigidly denying that it has itself perpetrated terror and atrocity" (*Terror and the Sublime*, 58). In *The Zero*, Jess Walter makes the location of specific importance. Once again, it is the term's connotation of absence that comes to the fore. It is a void to be filled:

> Zero. The absence of all magnitude or quality. A person or thing with no discernable qualities or even existence. The point of departure in a reckoning. Zero hour – that sort of thing. A state or condition of total absence. The point of neutrality between opposites. To zero in: to concentrate firepower on the exact range of something.
>
> (309)

But these meanings given are conflicting: a point of absence, a departure or beginning, a neutral zone, and the focal point of great firepower. This final meaning evokes the suffering of Hiroshima. Ray points to the lack of a response "led by American artists, writers, and activists, that would have rendered the links between Hiroshima and the response to September 11 visible and thinkable to the general public" (*Terror and the Sublime*, 59), that the War on Terror only served to "enforce a longstanding ban on self-critical reflection" (100). In so doing, he pinpoints the dropping of the atomic bomb as being at the Ground Zero of this very ban itself, seeing American remembrance of this moment, which to much of the rest of the world, alongside the Holocaust, is

perhaps the low point of human civilization and proof that the march of progress was dead, as a denial of historical reality. Nevertheless, *Extremely Loud and Incredibly Close* did make the link between the two, even if it is, perhaps, rendered oblique.

In Foer's novel, two strands of narrative occur simultaneously. Oskar's attempts to cope with the death of his father shape its primary thread, but the sections detailing the memories of Oskar's grandfather and the trauma he experienced at the hands of the allied bombing of Dresden in World War II exist as a mediator between the past and the present. Indeed, it is in this latter account, expressed through a series of letters the grandfather writes but never sends to his now deceased son, that a truly awful violence is depicted and shared with the reader. The character describes animals on fire, screaming from the trees; he writes, "I saw humans melted into thick pools of liquid, three or four feet deep in places, I saw bodies crackling like embers" (211). The question as to whether these letters exist to suggest a concordance between the bombing of Dresden and September 11th and if so what such a link is intended to mean is left open. Either September 11th was *like* Dresden and similarly awful, or September 11th does not compare to the awfulness of history. Foer, however, also incorporates a relatively lengthy reference to Hiroshima in the novel, which serves at its most incendiary as an accusation to America (you had this coming!) and at its least as a diminishment of the pain of the September 11 attacks. In this account, Foer unleashes the most disturbing details when Oskar brings in to his school, during a show-and-tell session, an interview with a Japanese survivor of the nuclear holocaust. "I saw a young girl coming toward me. Her skin was melting down her. It was like wax" (187), says the interviewee, matter-of-factly. But even worse is when he finds his daughter:

> there were maggots in her wounds and a sticky yellow liquid. I tried to clean her up. But her skin was peeling off. The maggots were coming out all over. I couldn't wipe them off, or I would wipe off her skin and muscle. I had to pick them out. She asked me what I was doing. I told her, "Oh, Masako. It's nothing." She nodded. Nine hours later, she died.
>
> (188–189)

Again, whether Foer intends to draw attention to other Ground Zeros in order to elevate the personal tragedy of the 9/11 attacks or he is suggesting a historical counter-narrative to America's response to the terrorist act seems to matter relatively little. While the novel is precisely framed by history, such history is largely effaced by the text's highly emotive core narrative. As powerful as both the grandfather's Dresden testimony and the interviewee's Hiroshima account are, they occupy only the margins of a novel focused more clearly on the nine year old's personal

tragedy: the loss of his father at America's own Ground Zero. The child's innocence is cruelly stolen from him by unseen forces, the result of his forced engagement with the brutality of 20th-century history in this supposed new age. Thus, the novel reminds us that today's children, or any child, should never have to experience such a loss. This is articulated neatly in the novel's ending during which Oskar reorders the images of the man falling from the tower suggesting a hollow resolution, a fraudulent catharsis. Narratives, the ending suggests, are a way of bringing the dead back to life, but such resurrections are both cheap and temporary: history reminds us of this.

If we return to the point of origin, to that street on which DeLillo's America/Americans are trapped in a cloud of dust, the realization occurs that the victims there are not enshrined in amber, as with those of historical tragedies like Pompeii. In fact, these are images of survivors who come only to *symbolize* the dead of 9/11. While the images from the day, to quote Laura Frost, "the arrested, suspended bodies reflect a tendency to think of 9/11 as a moment frozen in time" (cited in Darlington, 243), their residence there is dependent on the culture through which they vicariously exist. They are just as fragile as the cultural construction of 9/11 itself and, if one were to reach out and touch these people, they would crumble into ash and be blown away on the wind before our very eyes. They are symbolic not of any hardened, concrete, historical disjuncture, but rather of a memorial culture that, when the dust finally settles, is little more than the repackaging of a tragedy as a global disaster and a call to arms. Literature has, in its own way, attempted to reanimate these bodies but has done little if anything to escape the idea that 9/11 was *the* moment of change. Thus, the movement these texts evoke—the progression of time that stretches beyond the day and into the *mourning* after—is a reflection of a nostalgia that looks backward in an attempt to recover a lost innocence, detracting from any critique offered by such texts of the actions that followed America's 'worst day.'

## In Search of a Lost Innocence

In *After the Fall* Richard Gray identifies a "recurrent tendency in American writing, and in the observation of American history, to identify crisis as a descent from innocence to experience" (2). Gray sees within this an accompanying predisposition toward "a powerful vein of nostalgia" (3). "Innocence is shattered, paradise is lost, thanks to a bewildering moment, a descent into darkness, the impact of crisis," he writes (3). It is worth pausing here to note that a number of more recent 9/11 novels, however, have attempted to break with this tradition. Writing about Thomas Pynchon's 2013 *Bleeding Edge*, for example, Darlington argues that the novel "stands as one of the first reassessments of the events of 9/11 from beyond the grip of the image" (244). Following on, the critic

explains that "Pynchon [...] gains from a decade's distance and draws attention to 9/11 as a moment embedded within history, demanding serious attention and nationwide analysis—thought and work, rather than just coping strategies" (244). For Darlington, 9/11 novels, Pynchon's aside, have seemed incapable of imagining/interpreting the event in different ways, failing to grasp that, "a multiplicity of traumas, confusions, convictions, new understandings, and events emerged from 9/11 and its aftermath and helped to shape the landscape of the 21st century we now inhabit" (245).

While true of many 9/11 texts, Darlington's assertions here seem somewhat unfair on novels such as *The Reluctant Fundamentalist*, which presents a varied and subversive account of the attacks, *Extremely Loud and Incredibly Close*, which David Simpson argues "bravely [reminds] us that 9/11 was not only not the first such event, but that it was also by no means the major one and that some of the others were performed by the civilized west upon its enemies" (221), and Teju Cole's 2011 *Open City*, which openly historicizes the events, seeing them as a continuation of New York's ever-present architectural rejuvenation:

> This was not the first erasure on the site. Before the towers had gone up, there had been a bustling network of little streets traversing this part of town. Robinson Street, Laurens Street, College Place: all of them had been obliterated in the 1960s to make way for the World Trade Center buildings, and all were forgotten now. Gone, too, was the old Washington Market, the active piers, the fishwives, the Christian Syrian enclave that was established here in the late 1800s. The Syrians, the Lebanese, and other people from the Levant had been pushed across the river to Brooklyn where they'd set down roots on Atlantic Avenue and in Brooklyn Heights. And, before that? What Lenape paths lay buried beneath the rubble? The site was a palimpsest, as was all the city, written, erased, rewritten.
>
> (*Open City*, 58–59)

In this interesting passage, Cole situates 9/11 within a history of New York's own architectural self-erasure. Similarly, by choosing the backdrop of the bursting of the dot.com bubble as the starting point of the narrative *over* the 9/11 attacks, Pynchon's *Bleeding Edge* challenges the generalized narrative of 9/11 as the moment everything changed. The novel's reference to the 'other 9/11' (the CIA-backed coup that killed Chilean president Salvador Allende on September 11th, 1973, installing Augusto Pinochet in his place and resulting in decades of brutal dictatorship in the country) through the shadowy FBI agent Nicholas Windust, who was in Chile at the time, continues this attempt to destabilize the significance of the date as the definitive marker of change in the 21st century. For Darlington, what differentiates Pynchon's *Bleeding*

*Edge* from other 9/11 novels, then, is that through the text's historicization of the attacks the author "sews the inexplicable images back into the fabric of lived history" (245). Thus, coping with 9/11 becomes not about retreating *into* history, a rejection of the present in the face of crisis, but rather about assimilating the event *through* its history in order to track both its origins and assess the likely impact on the future.

To demonstrate this further, Cole's meditative *Open City* lays siege to the attacks not just as a point *of* history but also as a point that *has* a history, a critique achieved through the signification of the name itself and its inadequacy. In one of his many monologues, protagonist Julius complains that

> the place had become a metonym of its disaster. I remembered a tourist who once asked me how he could get to 9/11: not the site of the events of 9/11 but to 9/11 itself, the date petrified into broken stones.
>
> (*Open City*, 52)

Thus, the term is described as effacing rather than testifying to destruction. Similarly, on the very next page, one of the many characters that flit in and out of the book makes a comment that links the September 11 attacks to the Columbine shootings of just over two years earlier, suggesting a pattern of violence that both precedes 9/11 and is to follow it:

> You know Littleton, right? The massacre happened just after I arrived there. Terrible thing. Same thing happened with New York, I got here in July 2001. Crazy, right? Completely crazy, so I don't know whether to warn the next city I move to!.
>
> (53–54)

The exchange clearly shows a continuation of violent history rather than marking 9/11 as *the* moment of rupture. In many ways this fits with Darlington's assertions about *Bleeding Edge*, that in the novel, "the transnational qualities of conflict in the 21st century are shown to precede 9/11—in some senses predict it, in some senses become clear only in its aftermath" (246). *Open City*, a novel perceived of as global, also draws on the transnational aspect of this violence with Julius, who was born in Nigeria, traveling from his home in New York City to Brussels in search of his grandmother only to meet and befriend a Muslim resident whose beliefs and views border on, but carefully skirt, a dangerous radicalism.

Thus, novels concerned with the global rather than the personal have been best placed to offer a more nuanced reflection of the impact of 9/11. Furthermore, understanding the relationship between 9/11 and history can be seen here as essential to any effective evaluation of the event's

impact. As Darlington suggests, "marking 9/11 as a historical moment rather than as a contemporary event allows us to reconnect it to the flows of history and to begin the work of diversifying our narrative imagination beyond the stock phraseology wherein 'everything changed'" (245). Where Darlington, perhaps, misinterprets 9/11 fiction more broadly, however, is in his assertion that, commonly, such texts have treated the moment as continuous with the preceding period of postmodernity or have at least interpreted the events *as* postmodern. "The postmodernist reading of 9/11 suggests that its trauma lies in its unintelligibility, failing to recognize that it is unintelligible only under the terms of postmodernist analysis" (244), he offers, but surely the treatment of the date as pronouncing a radical schism suggests that 9/11 fiction more generally claimed the end of postmodernism encapsulated in the collapse of the Twin Towers. It is an interesting side note that the designer of the WTC buildings, Minoru Yamasaki, was also responsible for the design of the Pruitt-Igoe housing development in St. Louis, Missouri, completed in 1956, which, when it was demolished in the 1970s was said to herald the end of the so-called *modern* architectural project largely inspired by Swiss-French architect Le Corbusier in the 1920s. Thus, on some level, if 9/11 can be considered to mark the end of postmodernism, then the destruction of two of Yamasaki's building schemes bookend the periods of modernism and the postmodern. A postmodern reading of 9/11 would likely attempt to understand the attacks within the broader framework of the movement itself, as an event continuous rather than discontinuous with postmodern existence. On some level, to suggest that everything changed implied the end of postmodernism. When DeLillo pronounced in "In the Ruins of the Future" that "again, the world narrative belongs to terrorists," (33) it was in order to establish the date as a break with the postmodern not as its continuation.

For DeLillo in particular it must have been tempting to speak of the attacks as a continuation; after all, in his prescient 1991 novel *Mao II*, the American writer had already made a number of connections between terror, art, and the future that now stand as uncanny reminders that radicalism was not born on September 11, 2001. In *Mao II* DeLillo envisages writers as locked in competition with terrorists:

> for some time now I've had the feeling that novelists and terrorists are playing a zero-sum game. [...] What terrorists gain, novelists lose. The degree to which they influence mass consciousness is the extent of our decline as shapers of sensibility and thought. The danger they represent equals our own failure to be dangerous.
>
> (156–157)

But even before the 9/11 attacks, this was a battle his character Bill Gray, himself a novelist, suggests had already been lost as, "after [Beckett], the

major work involves midair explosions and crumbled buildings. This is the new tragic narrative" (157). However, for DeLillo, the novel's jamming together of art and terror comes with a hint of irony that sees both writer and terrorist in a play for media attention that trumps, rather than necessarily creates, death and destruction. For example, the terrorists in *Mao II* set off a bomb while Gray is in London but fail to kill anyone—in fact Gray, who is caught in the blast but escapes unhurt, thinks in that moment that "he would have to remember to be impressed" (125). In a discussion between Gray and an intermediary of terrorist leader Abu Rashid—George Haddad—the latter tells Gray "your safety was foremost in mind" (155), emphasizing, in ironic fashion, the playful nature of the terror spectacle in *Mao II*. This seems not only postmodern, but also taboo in a post-9/11 world. By the time we reach DeLillo's later response in *Falling Man*, such irony seems conspicuously absent.

Similarly, and as elsewhere mentioned, Jean Baudrillard's suggestion that the 9/11 attacks "resuscitated both images and events" implied the dismantlement of a postmodern sensibility concerned primarily with the emptiness and vacuity of such events (*The Spirit of Terrorism*, 27). Baudrillard, it is worth noting, was the arch-critic of the postmodern philosophy considering his provocative writings on the Gulf War as media spectacle and his proposition that the fighting never really took place (not because people didn't die but because all war in the postmodern era has been fought in the arena of the image and was of the order of the hyperreal). In fact, in many quarters, 9/11 was referred to as heralding the end of irony—an expression that widely made the rounds in the media, Eric Randall highlighting the phrase's ubiquity in various forms and from a number of different sources, such as *Vanity Fair* editor Graydon Carter and *Time* writer Roger Rosenblatt, in the weeks following 9/11. Instead of suggesting that 9/11 fiction tends to treat the events as a continuation of postmodernity (even as its logical conclusion), then, it might be more accurate to argue that 9/11 fiction was quick to proclaim the end of postmodernism but did so before being able to offer anything concrete in its place. Thus, for early 9/11 literature at least, what the events left was an open wound, an unfillable void (both Kalfus' and Pynchon's more ironic portrayals were not possible until quite a number of years later). The concern shifted to the absence at the heart of New York City. Indeed, Gray identifies this as "a failure of mourning: a failure that leaves an open wound, a gap or emptiness in the psychic life of the nation – the operative symbol for which is Ground Zero" (8–9).

As covered earlier, there are many examples of the way in which images of absence were prominent in the aftermath of the attacks, from Art Spiegelman's cover of *The New Yorker* in late September 2001 that shows the towers black on black so as to give the impression that they are only shadows (the same cover he later used for his own *In the Shadow of No Towers* in 2004), to the very name of the memorial that now sits

at the foot of the new WTC complex. Of Spiegelman's cover, Richard Gleijzer suggests that the image "posits an inability to give coherence to the very object of trauma: all that remain are shadows" (107). On the fifth anniversary of the attacks, *The New Yorker* replicated this sentiment by showing a wire-walking figure (presumably echoing Philippe Petit) suspended at the top of a blank page. When the reader opens the edition, the same figure is shown in midair above Lower Manhattan and the empty footprints of the towers, the absence of his rope emphasizing the absence of the buildings Petit famously crossed between in 1974. In writing on the subject, we could recall Baudrillard's comment that "even in their pulverized state, [the towers] have left behind an intense awareness of their presence" (*The Spirit of Terrorism*, 48), since the critic evokes the idea that their absence is so powerful that it, itself, seems to give the towers a presence, a new form even. In a similar statement, Stephanie Li argues that, "ironically, through their absence the once inelegant, though imposing, Twin Towers became newly elevated symbols of national identity" (82). In literature, we could refer back to the aforementioned concern in *Extremely Loud and Incredibly Close* with the father's empty casket and the need to fill such an absence (the absence of bodies being a key operator in the trauma theory that has grown up around the subject of the attacks). Another example the novel offers is Oskar's grandfather's descriptions of the 'Nothing Places' he and his wife created in their home that started off at the foot of their bed and were "a good place to disappear" but eventually expanded until their apartment "was more Nothing than Something" (109–110). One text in particular, however, seems to be all about this *psychic hole* at the center of American consciousness. It is, unsurprisingly, a text that focuses on exactly the dilemma of what should fill the void at Ground Zero: Amy Waldman's 2011 novel *The Submission,* which depicts an America embattled by conflicting ideologies, fictionalizing the narrative of the 9/11 memorial. In this fictionalization, Waldman attempts to politicize the process of construction and seeks to reflect many of the issues that surrounded Michael Arad's controversial Reflecting Absence design, but the novel expands this into the problematic dynamic of race relations in New York after September 11.

In the novel, which takes place only a short number of years following the destruction of the towers, an anonymous competition is launched to design a suitable memorial. After a jury, made up mostly of artists, is persuaded by Claire Burwell, the jury's lone widow to the attacks, to back a design known as The Garden, there is shock in the room when the chairman finally reads out the name of the architect behind the design: American Muslim, Mohammad Khan. These events seem inspired by the process of selection for Maya Lin's Vietnam Veterans Memorial in Washington DC since Lin—then just a 21-year-old architecture student at Yale—was also a controversial winner of an anonymous competition.

Now frequently listed as one of the most powerful and impressive memorials in world heritage, Lin's was controversial not simply because of its design—Vietnam Vet and later Virginia Senator Jim Webb described it as a "nihilistic slab of stone"—but because of the idea that the vision of an Asian woman might come to represent the grief of those who had lost loved ones in America's conflict on this very same continent (Goldberger). Lin, it must be noted, was also on the selection committee for the 9/11 memorial design. Ultimately, the selection of Khan in Waldman's fictionalization is even more controversial given that 9/11 was a direct attack on America and the novel establishes him as a scapegoat for a reignition of the hatred and division within America between the American Muslim population and those who see their religion as responsible for the attacks of 9/11. The novel itself is filled with the hyperbolic language of conflict, but the division becomes much more complex than Muslim versus Christian or Muslim versus victim. When racial hatred begins to spill out onto the streets, with Muslim women having their headscarves pulled from their faces, groups of Muslims themselves make public their desire for Khan to withdraw his entry.

Both Mohammad Khan (Mo) and Claire find their principles severely tested by the situation. Mo is a challenging hero character, if, indeed, he can be described in this case as a hero at all, who, at times, struggles with his own motives; is his relentless pursuit of his right to design the memorial based on his own ambitions as an architect, a move to further his career, or a statement of the liberal sensibilities he believes should be the foundations of America? As one character puts it, "There's more, much more, at stake here than a memorial" (201). By the time Claire and Mo finally meet, Mo's cynicism, justifiable after his brutal treatment at the hands of both the press and public, has hardened him beyond the reach of Claire: "She didn't understand her own country, he [Mo] thought: it would take more than a new memorial to unite it" (274). His simple explanation of The Garden barely becomes an issue as both his name and heritage overwhelm most talk of the design itself.

Explaining the design, Mo describes it as having an "order," which is "an answer to the disorder that was inflicted on us." He continues that, "It's not meant to look like nature. Or like confusion, which is what the attack left behind. If anything, it's meant to evoke the layout of the city it will sit in" (139). This stands in stark contrast to the alternative memorial fought for by some members of the jury, the name of which, The Void, seems to evoke Reflecting Absence in both its darkness and its suggestion of a hole rent in the American psyche that can never be filled. While Reflecting Absence seems to combine elements of both these designs, the novel carries with it at least some form of implicit criticism of the design process itself. The novel ends by jumping some twenty years into the future to a student, Molly, who has decided to make a documentary about The Garden and the struggles involved.

Through Molly's visit to Mo, the reader hears how the story unfolded: Mo eventually withdrew his plans due to relentless public pressure, but in an interview the now-ailing Claire Burwell describes with distaste what was built in its place:

> A Garden of Flags? Hideous. As ugly as the whole process. ... And so many more Americans ended up dying in the wars the attack prompted than in the attack itself that by the time they finished this memorial it seemed wrong to have expended so much effort and money.
>
> (295)

Although not clearly specified, it can only be assumed that this "Garden of Flags" is a rather "hideous" spectacle in Burwell's estimation because of its connection with symbolic nationalism. Such jingoism was, of course, rife post 9/11 but also extremely damaging to internal relations between many Americans and the U.S. Muslim population.

*The Submission* suggests in its finale that the sacrifice made by Khan is indicative of a "submission" of the American Muslim, who must give up certain rights in order to reside in a post-9/11 United States. Although it appears that, in the twenty years after Khan withdraws his design, relations have healed considerably, it would seem that it is largely through the "submission" of the American Muslim population rather than the giving of ground by the majority of the U.S. public. The novel, therefore, attempts to strike a balance showing sympathy toward the victims of 9/11 and those who lost loved ones, while centralizing Mohammad Khan and his struggle against prejudice. It cannot help but promote empathy for those whose religious beliefs have made them the target of much racial hatred in the aftermath of the attacks. Mo is presented as a headstrong yet likeable and contemporary character. He is distinctly unthreatening and barely even religious. For these reasons, his persecution appears so out of proportion. In the novel, Ansar, a member of the MACC (Muslim American Coordinating Council), lays the blame for the difficulties squarely at the feet of culture, declaring that,

> when you watch the movies, you root for the cowboys, but when you read the history, you root for the Indians. Americans are locked in a movie theater watching Westerns right now, and we've got to break down the walls.
>
> (80)

In referring the conflict back to the symbolism of the Hollywood Western, the novel attacks culture for its establishment of a world of black and white binaries in which you are either a cowboy or an Indian, a patriot or a terrorist, a Muslim or an American.

Ansar's statement suggests that 9/11 *did* precipitate a shift in attitudes and rhetoric but certainly not a shift toward anything new. Rather, this shift is symbolic of a retreat into the binary language of good versus evil, an area that has also been the subject of a number of studies (Bernstein, 2007 and Fitzsimmons, 2010), that imagines the world neatly split along fault lines reminiscent of a Cold War-era dichotomy or, indeed, of classical Hollywood genres. More than this, the renewed relevance of the Western in the account positions September 11 as the driver for a cultural nostalgia that sees Americans reliving historical narratives that were, in themselves, already fantasies of identification whereby the moral complexities of the present world are obfuscated by tradition and the willful erasure of historical guilt. If, as has been established, the majority of 9/11 fiction tends to somewhat overplay the attacks as the definitive moment of 21$^{st}$-century history, the moment *everything changed*, this seems difficult enough. On at least one level, this fiction is dangerous since it responds by echoing, rather than challenging, the rhetoric of the Bush administration that, as Simon Cooper and Paul Atkinson note, showed an "uncanny resemblance between the starkly rendered political landscape of the "war on terror" and the moral universe of the mainstream comic book" (60). But, in order to move on from the tragedy of September 11 and to look toward the future, an articulation of what comes after such a moment is needed, and this is where 9/11 fiction has often failed. Martin Randall suggests that the literary response to terror has been hampered by "tropes of melancholy, trauma, respectfulness and bewilderment" (135). This melancholic bewilderment is the product of a confusion highlighted in Art Spiegelman's image in *In the Shadow of No Towers* of Spiegelman himself carrying around his neck an eagle that squawks "everything's changed!" as well as "Go out and shop!"—two entirely conflicting messages (2). Thus, while *everything has changed* made for a useful slogan on some level, encouragements to go out and shop, and pronouncements that America is open for business (delivered in George Bush's address to the nation after the attacks), revealed the tension at the heart of America's desire to endlessly relive the attacks whilst simultaneously expunging them from memory.

Even 9/11 novels in which the author is able to portray the subtleties of the constructions already in place defining the victim, the terrorist, and the hero—novels like Hamid's *The Reluctant Fundamentalist* which attempts to offer an alternative perspective on the racial politics that the attacks brought to the fore—lack the clarity to decide whether the date represents a historical impasse or a moment that merely exposes that which was already known. For example, protagonist Changez hints that the fissures in American race relations are already visible beneath the surface, papered over by the opportunities afforded to those traveling to work in the most prosperous country in the world, when early in the narrative he describes himself as "well-liked as an exotic acquaintance" (19). Changez's sense

of belonging, therefore, is characterized as both fragile and superficial. Nonetheless, 9/11 is given pride of place at the very center of this novel—positioned intentionally at almost exactly the halfway point it forces the reader to consider the moment as a point of departure. This confusion leads to nostalgia for a lost innocence, a nostalgia both created in the text (as with Changez's wistful recollections of his life and love in America prior to the attacks) and simultaneously critiqued through the characterization of his once lover Erica, whose name clearly signals her symbolic value as representative for the American nation. Randall describes Erica as "another 'reluctant fundamentalist'" in that,

> she narrows her life down to living only in the past (a deeply romantic past) that mirrors America's cultural and political retreat into the nation's cherished myths and legends. Both Erica and America withdraw into what Changez calls a 'chronic nostalgia'.
>
> (140)

But this chronic nostalgia is fostered in 9/11 fiction itself, and for every attempt made to overcome such a nostalgia the narratives just as easily slip back into its clutches.

In *The Reluctant Fundamentalist*, 9/11 fails to bring about a cultural adjustment and instead reveals an underlying fissure at the heart of American race relations. That this fissure exists in advance of 9/11 suggests that the novel attempts to reveal the historical dimensions of these failing relations and, thus, encourages readers to empathize with others. The novel presents an America in which racial dialogue is no longer really possible. However, this confused position in which 9/11 fiction often finds itself—inclined to critique the forces of nostalgia and yet in the same moment seemingly beholden to them—suggests a key reason for the difficulties so many prominent and technically gifted authors have encountered when attempting to explore this subject matter. Too often, the lost innocence uncovered by 9/11 novels valorizes the past as blissfully ignorant rather than highlighting how the experience could be more usefully co-opted in order to create a more cohesive and caring global community that will allow people the 'space' to co-exist. Those texts, like *Open City*, *Bleeding Edge*, and to a lesser extent *Extremely Loud and Incredibly Close* and *The Reluctant Fundamentalist*, that attempt to conceptualize the attacks within a historical frame of reference still struggle to overcome the longing felt for a pre-9/11 world. Other texts, like *Falling Man*, *A Day at the Beach*, *Netherland*, and *The Submission* are tinged with longing and sadness for that absence that can never be recaptured. Thus, for many 9/11 novelists, the attacks provoked a melancholic nostalgia that crippled any chance to think progressively, even in the literary form, the form that prides itself in expressing the inexpressible, thinking beyond the pages of history. If literature is stuck facing backward, what hope is there for other forms of culture?

Part 2

# The Sublime in the Digital Age and Nostalgia for the Real

# 4 Digital Nostalgia and the Sublime Utopias of Cyberspace

Vincent Mosco argued in 2004 "cyberspace has become the latest icon of the technological and electronic sublime" (24). The crushing weight of data flows that have followed our passage into the Digital Age (sometimes also aptly referred to as the *Information* Age), alongside both the invisibility of such data and its incredible multivalency—its potential to entirely reshape our daily lives in all manner of ways—would be enough to suggest that it might elicit the sublime. But more than this, the fluidity of cyberspace—an ever-shifting landscape—has encouraged the cultural abandonment of fixed meaning, an extension of Baudrillard's ideas about the simulacrum. Baudrillard opens "Simulacra and Simulations" with an epigraph purported to be from Ecclesiastes. "The simulacrum is never what hides the truth – it is the truth that hides the fact that there is none. The simulacrum is true," it reads (169). But this 'quotation' is itself a fabrication and not a direct reference to Ecclesiastes, even if it can be argued that it captures a certain essence of the biblical text. Perhaps, through its fraudulence, the author intends to make a little fun of our attempts to anchor such meaning back to the epigraph, demonstrating, in a more subtle way, that the simulation cannot be so easily disentangled from the 'real.' This 'impossibility' of affixing meaning comes to promote a melancholic sublime in the Digital Age—our sense that, for all the perceived benefits digital technology has brought us, life was not only simpler, purer perhaps, but also more 'real' before its insidious encroachments on day-to-day living.

In the final episode of the first season of *Mr. Robot* (a 2015 show created by Sam Esmail that follows the exploits of a mentally unstable hacker named Elliot [Rami Malek]), a confrontation takes place between the protagonist and his imagined father, Mr. Robot, played by Christian Slater. When Elliot, in an attempt to exorcise his father's spirit from his mind, says forcefully "you're not real," Slater's Mr. Robot launches an extraordinary attack on the concept of 'reality' in the 21st century: "and what, you are?" he asks, as he pins Elliot against an electronic billboard.

Is any of it real? I mean look at this, look at it: a world built on fantasy; synthetic emotions in the form of pills; psychological warfare

in the form of advertising; mind-altering chemicals in the form of food; brain-washing seminars in the form of media; cold, isolated bubbles in the form of social networks. Real? You wanna talk about reality? We haven't lived in anything remotely close to it since the turn of the century.

"You have to dig pretty deep, kiddo, before you can find anything real. We live in a kingdom of bullshit," he emphatically declares. One cannot help but think of Baudrillard here. For Mr. Robot, 21st century living is a simulation and the only way to expose this is through the destruction of the capitalist world order. Much like Tyler Durden's plan to destroy the headquarters buildings of the world's major credit card companies in Fincher's *Fight Club*, Elliot and Mr. Robot target the electronic data records of the fictitious creditor Evil Corp, initiating a financial melt-down that will, they hope, liberate the ordinary American citizen from a lifetime of debt. Their plan also serves to demonstrate the fragility of the financial system today that, at its heart, is little more than lines of code, zipping at extraordinary speed through the invisible networks of cyberspace.

In 1999, as a new millennium was dawning, optimism about the mon-eymaking potential of the Internet was soaring. Web space was bought up at an incredible rate, and share values were skyrocketing simply with the addition of the prefix e- or the suffix .com. On March 10th, the Nasdaq reached a then record high of 5,048 points. There seemed to be no limit to the moneymaking potential of Silicon Valley, the new center of a bright future for 21$^{st}$-century America. In less than a year the bubble had burst, and by October 9, 2002, the same stock market had bottomed out at 1,114 points. Realization had struck of the irrational exuberance that had fueled the surge in tech stocks. The reality was that this fledgling industry growing out of San Francisco had little idea how to monetize the huge numbers of users that its companies would even-tually accumulate. Returns would be slow and substantial investments needed, with no guarantee that companies could ever make profits. It is estimated that only around 50% of the dot-com businesses survived the bursting of the bubble. Between 2000 and 2002, $5 trillion were wiped off the value of tech companies, but this was all hypothetical value anyway. As DeLillo's protagonist, Eric Packer, in *Cosmopolis*, imagines while looking at his wife's fortune on a glinting cashpoint screen, "it was all air anyway. It was air that flows from the mouth when words are spoken. It was lines of code that interact in simulated space" (124).

The intangibility of value is exaggerated in the digital world, a world in which wealth is hypothetical and fluctuating, lines of code spoken through confidence in the enigmatic movements of global markets. It is a world of magic for the few who become multimillionaires overnight, and a nightmare dystopia for the many whose lives are impacted by decisions

enacted on their behalf by politicians and CEOs worldwide. *Cosmopolis* is able to articulate the uncertainty this environment induces where the very fabric and texture of speech becomes a means to test the viability of an investment that can make or break lives:

> There's a rumor it seems involving the finance minister. He's sup-posed to resign any time now [...]. Some kind of scandal about a misconstrued comment. He made a comment about the economy that may have been misconstrued. The whole country is analyzing the grammar and syntax of this comment. Or it wasn't even what he said. It was when he paused. They are trying to construe the mean-ing of this pause. [...] So the whole economy convulses [...] because the man took a breath.
>
> (47–48)

The fragility of the system—exposed by the bursting of the tech bub-ble and then, even more dramatically some five years after DeLillo's prophetic novel, by the global financial crisis of 2008—is made visi-ble in *Cosmopolis'* hyperbolic, yet startlingly believable, account of the finance minister's gaffed breath. As David Harvey indicated as early as the late 1980s,

> the world's financial markets are on the boil in ways that make a snap judgement here, an unconsidered word there, and a gut reac-tion somewhere else the slip that can unravel the whole skein of fictitious capital formation and of interdependency.
>
> (17)

The dystopian nature of this new digital world in which capital zips at lightning speed around the globe, not like nourishment in a body heading to where it is most needed but in a seemingly arbitrary set of randomized movements beyond the anticipation of even the brightest of economists, mirrors too the fears, not just about financial apocalypse, but about the exploitation of such systems and technologies by proponents of anarchy and terror. This 'dark side' of technology has meant that, alongside the naïve optimism of the cyber utopians the other dominant techno-narrative espoused by the digital dystopians has gained significant traction.

In *The Digital Sublime*, Mosco suggests that this dichotomy is at the heart of what makes cyberspace sublime. It is, he argues, "praised for its epochal and transcendent characteristics and demonized for the depth of the evil it can conjure" (24). Indeed, in this chapter the twin concepts of the cyber utopia and the digital dystopia are reviewed as representative of the simplification of a more nuanced understanding of how technology impacts our lives. These ideas, which most coherently organize the space of public discourse on the subject, help us to understand the nostalgic

draw as a product of our encounters with the digital sublime. It is no coincidence that the hackers in *Mr. Robot*, for example, base their operations in an abandoned amusement arcade at Coney Island: for them, the arcade stands for purity, innocence, the physicality of 'play,' and a return to a lost childhood in a digital age that, as 'Mr. Robot' himself articulates, has accelerated the cultural abandonment of fixed meaning. The weight of digital information and the potential for its destructive use take on a sublimity for the hackers, a sublimity that feeds a nostalgic desire to escape to the safety of childhood amusements. While the show delights at hinting, continually, that these young technocrats know and understand more than the rest of us—they are, after all, the keepers of the means of production in today's digital world—it is not the case that we must walk around blinded to our own ignorance. Rather, it is the anxieties about our own *lack* of understanding—the threat of being hacked, of having our identities stolen, of encountering our impostor, the simulacrum— that undermine any sense of security we might wish for and promotes nostalgia for the safe places and technologies of our past.

## Cyber Utopia

Utopianism, the belief in a better future, from the Greek 'Eu-topos' (good place) and 'Ou-topos' (no place), finds its home in the digital world. Although through language predicated upon its own impossibility— utopia can never be fully realized because it is a 'no place'—the promise of the digital is that utopia becomes a practicable state. Inside the pixelated worlds and narratives we build for ourselves in the infinite horizon of cyberspace, the sense of *ou-topos*, of no-place, begins to make sense. We have for some time been heading toward a future in which perfection is possible through the building of a new *digital* world, and its reality, or lack thereof, might seem somewhat inconsequential for some. The promise of such a future is articulated by Ernest Cline's 2012 novel *Ready Player One*. Set in 2044, the novel follows its protagonist, Wade Watts, and his online avatar, Parzival, as they engage in a hunt across a simulated universe known as the OASIS for the prize of unimaginable wealth and, ultimately, control of the OASIS itself. In this future, much of the planet seeks refuge in this huge online environment from an outside, or 'real,' that has been ravaged by a global energy crisis. This seems to matter very little for characters whose lives are shaped by teleportation to other worlds, vast spaceships, and magic, all of which allow users to indulge themselves in this gamers' fantasy.

In *Ready Player One*, the OASIS has not only solved the real-life problems of the energy crisis and liberated people, it has even solved social issues for those who might otherwise be victims of prejudice. In the final part of the novel, it is revealed that Wade's long-term online friend Aech, who has been masquerading as a white male for business purposes, is in

fact an African American lesbian; "the OASIS," we are told "was the best thing that had ever happened to both women and people of color" (320). This cyber utopia, a place promised by Donna Haraway's famous 1985 "Cyborg Manifesto"—a rather tongue-in-cheek feminist reading of the potentials of technology for women in an emerging digital age, credited with birthing the 'cyber-feminism' movement—all but erases the lines of race and gender. Thus, *Ready Player One* readily draws on and rearticulates pop-cultural ideas about the utopian potential of digital technology and in particular Virtual Reality (VR) echoed in games such as *The Sims* franchise (first game in 2000), *Second Life* (first launched in 2003), and Massively Multiplayer Online games (MMOs) such as *World of Warcraft* (established in 2004). It is also worth noting that the protagonist of the worldwide highest-grossing film of all time (James Cameron's 2009 *Avatar*), a crippled Marine, is able to walk/run/ leap again thanks to his inhabitation of a blue alien avatar.

The utopian image of the avatar, through which users are able to tran- scend the 'limitations' of the body, however, has proven to have a signif- icant number of side effects. Indeed, *Ready Player One* seems to assume that people would be both willing and eager to relinquish their racial, ethnic, or gendered selves and adopt the hegemonic cultural identity, a concept that, if true—and fortunately it seems largely not to be—would only compound the subjugation of those forced to adopt new personas. Indeed, with this example, one is reminded of the problematic nature of 'passing,' which ostensibly came into common usage in the highly seg- regated environment of 1920s America in which fairer skinned African Americans would often attempt to 'pass' as white in order to escape the persecutions of racial discrimination. Beyond the double bind this cre- ates, there is a question of how the anonymity afforded by the avatar has affected prejudice.

In recent years, social media platforms—particularly those that pro- vide users with a form of anonymity, like Twitter—have become the breeding grounds for Internet 'trolls,' effectively online bullies who use the more open online environment to abuse others. Many offensive mes- sages are of a racist or sexist nature. While it has been demonstrated that websites such as Twitter can help combat prejudice and its negative effects—for example, a study by Mindi Foster in 2015 suggested that "tweeting about sexism may serve as a collective action that can en- hance women's well-being" (629)—sexist and racist comments on the Internet more worryingly have the potential to silence subjugated users who fear the backlash their comments will arouse. Fox, Cruz, and Lee give some positive examples in which Twitter has afforded the oppor- tunity to combat sexism, citing trending hashtags such as "#Everyday- Sexism," "#YesALLWomen," "#WomenAreTooHardToAnimate," and "#NotBuyingIt" as illustrations of the way in which the platform can offer solidarity to users (437). However, their 2015 study "Perpetuating

Online Sexism Offline: Anonymity, Interactivity, and the Effects of Sexist Hashtags on Social Media" suggests a more sinister use of viral hashtags:

> Some sexist hashtags, such as #LiesToldByFemales and #IHate-FemalesWho, promote stereotypes and hostility toward women. Others, such as #RulesForGirls and #MyGirlfriendNotAllowedTo, suggest that men are responsible for regulating women's behavior and that women should submit to male authority. Some of the most appalling, such as #ThatsWhatSlutsDo and #ItsNotRapeIf, promote rape myths and dehumanize women as objects whose only function is sex.
>
> (437)

It would seem, however, that anonymity is no longer a prerequisite for many users who happily propagate racist and sexist sentiments through much more open platforms like Facebook. For example, shortly after the election of Donald Trump a local Mayor in Clay County, West Virginia, was suspended after she responded to a racist Facebook post about former First Lady Michelle Obama by local resident Pamela Ramsey Taylor that read "It will be refreshing to have a classy, beautiful, dignified first lady in the White House. I'm tired of seeing a Ape in heels" [sic]. The Mayor, Beverley Whaley, wrote back "Just made my day Pam."

Moving beyond the specifics of whether or not the Internet perpetuates prejudice, *Ready Player One*'s willingness to figure this aspect as utopian is typical of a cyber utopianism—distinctly American in nature—that often links technology to increasing levels of liberty and democracy. This is a connection that, according to David Nye, goes back to much earlier days in the foundation of the American national project; it is linked to a specific species of sublime that he attaches to manmade objects of technology. "The popular sublime," Nye argues,

> became part of the emergent cultural nationalism of the United States in the nineteenth century. The American public celebrated the fact that a spectacular sight was the biggest waterfall, the longest railway bridge, or the grandest canyon, and they did so with a touch of pride that Europe boasted no such wonders. Natural places and great public works became icons of America's greatness.
>
> (32)

What is important is not just the privileged place of technology in the American mythos, but the further idea that such technology advances democracy and with it social liberation. Nye continues, "by the 1930s, [as such technology was increasingly seen in large public works] sublime technological objects were assumed to be active forces working for democracy" (33). It was the power of these objects/works to draw sublime

admiration from crowds for what could be achieved with human inge-
nuity, capitalism, and togetherness that placed technology at the heart of
American democratic expansionism.

The reimagination of technology as utopian can also be seen as an
extension of the arguments made for the inevitability of capitalist liberal
democracy by Francis Fukuyama in *The End of History*. The winning
of the Cold War was meant to be the signal fire that drew the attention
of the last remaining autocracies. There is inherent in this belief the un-
derlying homogenizing assumption that, given enough technology, the
world would all want the same thing: democracy. This line of think-
ing is mirrored in the key role that the Internet and social media now
play in American foreign policy objectives. The rewards for America
seem obvious when U.S. tech giants like Microsoft, Apple, Google, and
Facebook appear to spread the ideological values of their parent nation
while simultaneously opening up global spaces for the advancement of
capitalism. Evgeny Morozov highlights that the idea technology was the
key to the spread of democracy lay in the same argument that Soviet ex-
posure to radio and television technologies helped to end the Cold War.
For those who make such an argument, human connectivity is essential
for social and political change. This has been seen in the way that the
media has jumped on any example in which technology seems to have
played a role in promoting protest and revolution in autocratic nations.
However, in response to the failed Iranian revolution of 2009, Morozov
suggests that "the intense Western longing for a world where informa-
tion technology is the liberator rather than the oppressor, a world where
technology could be harvested to spread democracy around the globe
rather than entrench existing autocracies," says more about Western ide-
ology than it does the factual impact of such technologies in these au-
tocracies (5). While in brief moments social media platforms like Twitter
have seemed more powerful than national police forces, governments,
or even multilateral action, the democratic victories they have won, like
those in Egypt, have often been short lived, and autocratic governments
have quickly recognized the threat posed by such technology, instead
harnessing it to impose further controls and monitoring on already sub-
jugated civilians.

Morozov highlights the naivety of certain comments by world lead-
ers such as, then- UK Prime Minister, Gordon Brown, who seemed to
indicate that genocide was no longer possible in today's technological
world because the public pressure on governments to intervene would
be too great, an idea made all the more problematic in the wake of the
mess in Syria and the resultant European refugee crisis. Morozov terms
this the Google Doctrine, a technological utopianism entirely reductive
of social, cultural, and political factors that assumes that technological
power is unidirectional and cannot just as easily (if not more easily) be
exploited by those in power to collect information and track and clamp

down on dissidents. It assumes that people (particularly the young) will be politically engaged or motivated through this technology rather than pacified, an idea belied by David Levi Strauss' claim that in the aftermath of the 9/11 attacks "more people clicked on documentary news photographs than on pornography for the first (and only) time in the history of the Internet" (184).

The naivety of the cyber-utopian position is illustrated by the problematic arguments surrounding its two central beliefs: that human interconnection brings greater understanding and togetherness and that such an understanding and togetherness could help to bring about progressive political and social change. To take issue with this first stance, as much as technology has brought like-minded people into contact, it has also instigated cultural collision. The terrorist attacks across America and Europe in the 21st century have shown the power of only a handful of determined terrorists to reverse the direction of democratic liberalism, changing both policy and the grounds for debate over immigration, integration, and military intervention. More than this, we should consider issues with this second leap from interconnection to progressive political/social change. What is proposed in the conclusion of this book is actually the opposite; that the increasing interconnectedness of the globalizing, digital world has brought about a melancholic sublimity when we consider our role in changing the global political landscape. This sublimity drives us toward nostalgia, passivity, and eventual apathy when imagining the seemingly negligible impact we can have on world affairs. This is evidenced in the phenomena of 'slacktivism' and 'clicktivism' in that, when prompted to act, the Internet has merely facilitated the easy way out for the politically disenfranchised: we ease the guilt of our lack of participation through the new currency of 'shares' and 'likes' across our various social media accounts. Thus, the interconnectedness of the digital world has not resulted in a utopian, shared, global consciousness, but has rather thus far repeatedly demonstrated its failure to overcome political and social pressures.

This failure could be illustrated by the response to the European refugee crisis that resulted from conflict in Syria. While initially, European governments, notably in the UK and Germany, were put under pressure to allow entry to refugees from Syria largely thanks to images circulated on social media and in the news of young migrants being drowned, this momentum stalled rather abruptly. After a time, these images no longer continued to have the same impact and, as many people in Europe became acclimatized to them, suddenly the pressures of immigration became the more common narrative. The terrorist attacks in Paris, Belgium, and Berlin that came later merely added to the claims, mostly from the European political Right, that to allow such immigration was a risk to the integrity and security of European nations. The reaction to the immigration crisis demonstrated the power of the mediascape to

shape public opinion and inform policy but, at the same time, exposed its fickle nature and limits. Indeed, when, through overexposure, we become desensitized to reporting on the misery of refugees, a retreat toward nationalistic politics and strong borders seems like a safer solution. To some extent, the prevalence of such images makes them easier to shut out, along with the people themselves, presented as a degenerate hoard interested only in exploiting our more 'generous' social welfare schemes.

On some level, at least, cyber utopianism is to be admired for its optimism. Digital technology is simply too powerful to ignore, and it seems likely that in order to affect change, we must at least be open minded about the potentialities such technology may offer us. However, I want to offer one final critique of cyber utopianism. Even in the supposedly liberating arena of cyberspace and the virtual reality of the near future, cyber utopias may not be as open as they seem. In a piece on cyber utopias and the politics and ideologies of computer games, Tom Henthrone begins by espousing their supposed strengths over the classic literary utopia:

> Like traditional literary utopias, these cyber-utopias develop alternative realities that, in addition to providing entertainment, offer social commentary. Unlike literary utopias, however, cyber-utopias are interactive texts to the extent that they respond directly to user input; players feel as if they are constructing their own worlds, or "personal utopias," even though these utopias are largely computer generated. Rather than simply provide escape, cyber-utopias induce players to rethink the nature of their social lives as they play out alternative social realities.
>
> (64)

This is a promising offer, indeed, since the ability to rethink the *nature* of our social world is surely the starting point for any attempt to escape it. For example, what if, through video games, players could create a world that welcomes refugees or come to some greater understanding about their plight. Indeed, in 2005, the UNHRC (United Nations Human Rights Council) sponsored the development of a game called *Against All Odds* in order to do just that. A more recent interactive website called "Two Billion Miles," created in 2015 for the UK's Channel 4, allows visitors to "follow in the footsteps of migrants and refugees as they face the hardships of months on the road." More than this, users can select their own migration paths and "make tough decisions in this interactive video story, featuring real footage from extraordinary journeys made this year," thus highlighting the potential for video games to allow insight into the hardships others face.

Henthrone, however, also highlights the much less anticipated restrictions placed on freedom within virtual environments that are not,

contrary to expectations, simply relating to the limitations of technology or imagination. For Henthrone, the problem is ideological. Ultimately, he argues, computer games, while seeming to offer free play and utopian open decision-making, actually constrict gamers within certain designed world laws and rules based primarily upon the ideologies of those who create the games. The examples used to demonstrate this are world-building games like *SimCity* that make certain assumptions about the functioning of economics that come directly from the designers' political beliefs. These games can in turn become didactic and tend to reinforce American ideological norms.

Another limitation is spatial. Those who have played computer games will, I'm certain, have at some point or another experienced the disappointment felt when reaching 'the edge of the map,' so to speak. One can imagine him- or herself as Truman in Peter Weir's 1998 film *The Truman Show* as the character reaches the horizon of his world only to be confronted with a painted wall—a moment that confounds meaning because it highlights immediately the fraudulence of the world that character inhabits. Gaming worlds (even those that emphasize expandable, open universes) and narratives inevitably have limits beyond which players cannot venture. These limits are designed to keep those who play within a narrative framework and structure, but also to ensure the integrity of the gaming world. Moving outside of the imagined bounds of a gaming world will mean that players encounter glitches as they exercise unforeseen protocols. What is hacking, cheating, or modding—inputting a code that gives you unlimited finance in your SimCity, for example, or grafting the skin of a character from one gaming world into another—if not an attempt to break through these limitations? While Henthrone's article is now outdated in terms of what games offer their users, his ideas still hold true for the vast majority of contemporary games since, whilst many recent games have provided players with an open moral universe (exemplified by Shooters such as *Mass Effect* and *Call of Duty*, which allow you to decide on the fates of various characters, or the *Black and White* series, which allows play as either a benevolent or a malevolent god depending on your desire, or of course most famously the *Grand Theft Auto* games in which law-breaking violence and activities are positively encouraged), they remain ideologically tied and programmed to the dominant forms of American late capitalism. In an interview for Citylab.com, a website dedicated to thinking about cities of the future, Game designer Stone Liberande tells writer John McDermott, in relation to an expansion for *SimCity* called *Cities of Tomorrow* (2013) that, "utopia, in general, is boring for game play. So if we set up a utopian city there'd be nothing for the player to do." Beyond this, Marcus Schulzke suggests that even "virtual worlds and video games that attempt to represent ideal worlds tend to reproduce and glorify existing social institutions and values," meaning that, "the utopian

potential of games and virtual worlds often goes unrealized" (322). This seems to echo Liberande's statement that "SimCity is a mirror in a way. The city you make is a reflection of who you are."

Returning to *Ready Player One*, ultimately Cline's novel encounters the same limitations imposed on *its* utopian vision of cyberspace. Far from being the open and limitless world promised by its maker, James Halliday, the OASIS is rigidly controlled by the fundamental principles of capitalism. While the novel itself seems to offer escape into a virtual world as a means to transcend capitalism, given that *Ready Player One* readily critiques the damage done to the environment through egregious capital accumulation, the OASIS imagines little beyond the same principles that apply equally between its real and virtual worlds. Many lengthy descriptions of the difficulties of having no credits in the OASIS help to parallel Parzival and Wade's real versus virtual poverty. These difficulties are acute whether you are a real life gunter (egg hunter) needing a direct, speedy connection to the OASIS—essential if you want to be the first to find Halliday's Easter egg (the ultimate prize)—or if you're an avatar needing to fund exorbitant teleportation costs and the purchasing of powerful armor, special artifacts, or spells. If the OASIS, and the cyber utopia of the future, is like anything, then, it is the move abroad that looked so attractive until you realize when you arrive that life follows you and that all the laws of capital accumulation still apply. Holidays don't last forever, not even in the utopian glow of cyberspace.

## Digital Dystopia

For all the optimism offered by Cline's *Ready Player One*, with respect to the impact that digital technology and virtual worlds could have on social justice, the narrative is undercut by the lingering suspicion that this cyber utopia is not only fraudulent but that it has been instrumental in the breakdown of real-word society. The protagonist explains that Ogden Morrow, the co-founder of the OASIS, left the business because for him "the OASIS had evolved into something horrible. "It had become a self-imposed prison for humanity, [...] a pleasant place for the world to hide from its problems while human civilization slowly collapses, primarily due to neglect"" (120). Indeed, Morrow's pessimism contrasts with the stoic optimism of co-creator Halliday, essentially a nerd who saw a free and open OASIS as the means to escape the problems of a world in crisis. Nevertheless, even Halliday's optimism is tempered by lingering self-doubt. When Wade/Parzival reaches the final prize, uncovering the location of Halliday's egg, he is confronted with a projection of the now-dead tech-geek oligarch. As Halliday essentially hands over the keys of the OASIS to the protagonist, he also informs him of a button that will, if pressed, effectively dismantle his creation should Wade

ever feel that the OASIS is no longer a force for good. Justin Nordstrom highlights the moral message at the heart of this end game scenario:

> that Halliday would offer the possibility of irrevocably destroying his own creation, suggests the ambiguous place that gaming holds in Cline's utopia. While the novel doesn't reveal whether Wade obliterates the online world that had previously given him solace, Halliday's avatar provides one final piece of advice, which might serve as Cline's cautionary tale to all OASIS "gunters"—I created the OASIS because I never felt at home in the real world.... Don't make the same mistake I did. Don't hide in here forever.
>
> (246)

Thus, while the OASIS provides escape and safe haven, its creator credits it with the dissolution of life in the real world. *Ready Player One* does not offer the users of the OASIS the best of both worlds, so to speak, but rather suggests that the advantages of one must come at the cost of the destruction of the other.

To some extent, then, Cline's novel recycles a number of popular ideas about the impact of digital technology on life in the 21st century. There are essentially three dystopian narratives told about this. The first, a rather straight-forward and ubiquitous belief, is that digital technology is reshaping the way we communicate with each other in such a manner that it privileges instantaneity and convenience over personal interaction. The second is that digital technology offers merely an extension of capitalism and increases the power that mega-corporations, and those with wealth, wield over our lives. The final narrative is that our reliance on digital technology makes us more vulnerable as a society, that polarization and radicalization rather than communication are the result of its increasing prevalence and use. In this section, I'd like to briefly explore all three of these directions, before focusing in more detail on the latter, in order to consider the way in which digital technology generates a fear of the future and a nostalgia for a time when such technology seemed much more innocent.

In 1999, as a digital frenzy was taking the business world by storm, critics and web heads clamored to prophesy the coming of a new era, an evolutionary period in which we would become cyborgs, part human and part machine, as technology penetrated every corner of our new cyber world spaces. For some, this technology would change the way our very brains operated. Marc Prensky was one such optimist, positing that the generation now growing up with technology (the 'digital natives' as he termed them) would speak an entirely different language from that of their predecessors, the 'digital immigrants.' It was the older generations' task to stay relevant, he claimed, and the job of educators to get with the program and learn how to use these powerful new tools to maximize the potential of future generations.

Prensky's ideas are interesting because they cut against the trend in this area for older generations to bemoan the youth of the day for their lack of interpersonal skills. It is easy to blame technology for shortening attention spans and lapses in traditional 'manners,' but criticisms often go beyond this and become dystopian when they stretch to the idea that in the future people will become insular and reclusive Internet addicts who only come out of hiding when it is absolutely necessary. To some extent, the future imagined by *Ready Player One*, in which people readily prefer online interaction to face-to-face meetings, is already here, but this can, of course, be liberating as well as extremely cost effective and efficient. Thus, Prensky's defense of the way in which young people used, and will come to use, digital technology was a useful intervention in the debate forming at the time and still holds some weight today, even if it did reduce the complexity of the way in which technology was being taken up and used by various social groups. As the characters in *Ready Player One* attest, the challenge has actually been in determining the value of our duplicate selves: to what extent does the cultivation of a strong online presence and identity hinder or aid the advancement of our 'real' selves? For optimists like Prensky, the two are inseparable, but for the digital dystopians, one is elevated at the cost of the other.

Another reason Halliday and Wade fear the corruption of the OASIS replicates the second common dystopic narrative concerning digital technology, that is, that the Internet and other forms of communication technology are just another evolution of capitalism, another way to sell you shit you don't need, as *Fight Club*'s Tyler Durden might have it. Wade's eventual success in Halliday's egg hunt is in fact wished for by the masses who would rather see a true gunter, an authentic lover of 1980s pop culture, have control of the OASIS than the corporate machine built by company IOI (Innovative Online Industries) in order to systematically hunt for the prize and gain control of the online environment so many depend upon. Indeed, Wade polarizes the debate just as we have here between a free utopia and corporate dystopia: "The moment IOI took over, the OASIS would cease to be the open-source virtual utopia I'd grown up in. It would become a corporate-run dystopia, an overpriced theme park for wealthy elitists" (33). Of course, this also seems like a thinly veiled criticism of the present state of the Internet rather than just a battle line, made even clearer by his description of the nature of such a dystopia:

> I was horrified at the thought of IOI taking control of the OASIS. [...] They would start charging a monthly fee for access to the simulation. They would plaster adverts on every visible surface. User anonymity and free speech would become things of the past.
>
> (33)

For Cline, we can assume that this corporatization of cyberspace has already occurred as these accusations echo contemporary beliefs about

the state of Web 2.0 in our current climate. The gradual encroachments of advertising into previously championed sites such as YouTube and Facebook is enough to suggest that a digital dystopia has arrived. The monetization (and with it legalization) of streaming through the likes of Spotify for music and Netflix and Amazon Prime for film and television media undercuts utopian ideas prevalent in the early days of the Internet—namely that it would remain a free and open source for the education and liberation of the masses. Where many associated early versions of the Web with altruism and the subversion of capital/big business through means like the pirating of content on sites such as Napster—the music sharing site to which metal band Metallica famously and vociferously objected—Web 2.0 has finally been conquered and colonized by mega companies all clamoring for users' attention.

In 1989, Harvey argued that organizational shifts in the methods of production (primarily the switch from Fordism to flexible accumulation), driven by technological developments in transportation and manufacture, allowing for the offshoring and outsourcing of labor, created a curious effect on the individual at the center of the rapidly globalizing world. He termed this effect 'time-space compression,' which was, in essence, a shrinking perception of the size of the outside world and a quickening of time as experienced by the consumer in late capitalist society. Writing largely before the explosion of digital technology synonymous with the 1990s and beginning of the 21st century, Harvey recognized the enormous impact it was *already* having:

> Accelerating turnover time in production entails parallel accelerations in exchange and consumption. Improved systems of communication and information flow, coupled with rationalizations in techniques of distribution (packaging, inventory control, containerization, market feed-back, etc.), made it possible to circulate commodities through the market system with greater speed. Electronic banking and plastic money were some of the innovations that improved the speed of the inverse flow of money. Financial services and markets (aided by computerized trading) likewise speeded up, so as to make, as the saying has it, 'twenty-four hours a very long time' in global stock markets.
>
> (6)

Thus, for Harvey, technology has not transformed the ways in which we live our lives so much as it has accelerated the same processes already in play toward the end of the 20th century—these processes being primarily economic in nature. Since Harvey's writing, 'time-space compression' has advanced into every area of daily life for the masses hooked up to the Internet. No longer simply dominating the flow of capital, distances are collapsed by the virtual environments through which so many interact,

transactions occur at the click of a button, and trends spread like wildfire with the simple addition of a prefixed hashtag. More recently, Douglas Rushkoff, in his book *Throwing Rocks at the Google Bus*, has made similar claims about this technology-driven economy. "By applying our technological innovations to growth above all else," he writes, "we have set in motion a powerfully destabilizing form of digitally accelerated capitalism" (9–10). As dystopian as this sounds, ultimately Rushkoff is an optimist who sees the potential in digital technology that, if it can be unlocked, will be truly transformative. We are caught in what he terms 'the growth trap,' focusing singlemindedly on the application of digital technology in the sphere of economics and growth-driven profiteering to line the pockets of shareholders at the expense of the real 'value' that many businesses, he argues, can add.

This dystopic narrative runs in contrast to utopian ideas about the opportunities for democratization offered by digital technology and the motivations of the U.S. super corporations that use it to spread American ideology, as cited in the previous section. It sees corporations as the enemy—indeed, Rushkoff visualizes them as great big sucking entities, built to *extract* value from local areas in order to convert this into profit for CEOs and shareholders—and it suggests that, far from putting ordinary people on an equal footing with big corporations, digital technology has simply provided the big hitters with another, more powerful, tool with which to game the system. As Morozov argues, the

> belief in the democratizing power of the Web ruins the public's ability to assess future and existing policies, not least because it overstates the positive role that corporations play in democratizing the world without subjecting them to the scrutiny they so justly deserve.
>
> (21)

But, the dystopian version is no better either since, as Bruce Robbins in his article "The Sweatshop Sublime" suggests, one cause of contemporary apathy and inaction is the very concept that "everything is political" and that "all corporations are evil," because this leads to the idea that nothing can be done about the situation (93). Each of these arguments can be sustained, but both are equally disempowering for the individual at the center. This is seen in *Ready Player One* in the different plans Parzival and Art3mis, his cyber crush, have for Halliday's prize money. While the former wants to use the winnings to cut himself off from the world, preferring the existence offered by the OASIS to anything that can be achieved in 'reality,' Art3mis wants to use the money to solve world hunger and poverty. Although Parzival initially calls out Art3mis for her naïve optimism, his own ambitions are crippled by his confrontation with the global sublime, and he is instead drawn to the utopian possibilities of play.

In the third narrative, cyberspace and its encroachment on our everyday lives present a concrete security risk both to the individual and to the sovereign nation-state. This final narrative dictates that cyberspace will be used by malevolent forces, such as terrorists, to hide, organize, and launch attacks, claiming that the 'freedom' many of us enjoy online must be curtailed lest we risk becoming the targets of anarchy and terror. It calls for greater cyber security, tougher restrictions on the use of, and access to, the Internet and its various tools, and stricter government monitoring of users. Like the previous argument regarding corporate dystopia, we need to move beyond the initial polarizing response to this idea; either digital technology is bad/ dangerous because it can be used by terrorists to organize and recruit for attacks or digital technology is good because it is used by the government to protect us. These positions, in fact, fluctuate in popularity depending on current events and ideological positions. For example, in the aftermath of a coordinated terrorist attack, discourse seems to reflect the former, but the idea that digital technology is key to protection and prevention is also supported as an ideological position for the majority of the time.

Will Self's piece about the Islamic State beheading videos, which first began appearing on the Internet in 2014, suggests that this narrative is in constant flux and that the way terrorists use technology has shifted: "the collision between the most primitive and visceral violence and the most up-to-date media makes us profoundly queasy" he writes, before highlighting the media's fixation on the Islamic State's "sophisticated [...] camerawork." "In all the scores of news stories I've read or heard about the beheadings, the emphasis on the technology of their visualisation has been egregious – yet surely it's our own uneasiness that this registers," claims Self before suggesting that we, ourselves, feel we are being left behind by this technology: "the jihadists get out – and they take their iPads with them; the use of the web to radicalise young British Muslims and recruit them to the cause is an established fact." Thus, Self taps into a common narrative in which the Internet is imagined as a dystopian space primed for the creation and dissemination of violent propaganda material, but the reality of such claims is more difficult to support, particularly as sources tend to cite very different evidence in support of their cases. While American Terrorism Consultant Evan Kohlmann, for example, suggests that "90% of terrorist activity on the Internet takes place using social networking tools," this kind of information seems loaded and does not mean that such usage actually translates into success. Scholar William McCants counters, for example, in relation to earlier terrorist campaigns that

> the numbers of recruits are quite small, estimates both by militants aligned by Al Qaeda and by outside researchers (are) that only .00001% of people who look at propaganda actually decide to take up arms on behalf of Al Qaeda. That's a vanishingly small number.
> (Cited in Bernard, 4)

There is at least some truth to the idea that, whereas traditionally terrorist organizations had to rely on 'push factors' for recruitment, the Internet and in particular social media have enabled them to communicate with a much greater number of people and use their agenda to 'pull' in ways not previously possible. When platforms such as Twitter and YouTube are used to spread images and messages, there is very little control, and it is virtually impossible to prevent the dissemination of this type of material. The ability of users to create multiple free accounts quickly means that images such as those of the Islamic State beheadings will always find their way into the public domain in the Digital Age. Thus, for Self, today we must confront questions about our own complicity and passivity in the viewing of such images, asking if, "as a conscious, compassionate and engaged person [one should] actually look at these videos?" The answer, of course, is not straightforward and essentially depends upon our response mechanism. Do the violent images we see force us to think actively about the global situation, or do we acclimatize to them, becoming what Self terms "passive consumers of the pornography of violence"? For Self, we are generally the latter since,

> even being compelled for a couple of minutes to actively sympathise with these men's predicament was too much for us – we don't want the responsibility it necessarily entails, it's too uncomfortable; it forces us to think – it may even force us to act.
>
> (23)

Returning to Levi Strauss' claim, then, that "on September 11th more people clicked on documentary news photographs than on pornography for the first (and only) time in the history of the Internet," it would seem that he is only half right (184). There is, in fact, a startling overlap between the function of this type of violent material and pornography in its expression of horror, fascination, and fantasy.

To some extent, the Internet makes us all radicals. While it might appear outwardly that the increased accessibility of information in the Digital Age should generate consensus and understanding, we are instead confronted by a deluge of information that divides and polarizes public opinion. This is the 'digital sublime,' an overwhelming volume of media offering not just differing but conflicting accounts as authoritative insights. The concepts of fake news, confirmation bias, and filter bubbles, for example, have all received particular attention since the election of Donald Trump, demonstrating that more information often results in more miscommunication and confusion. It is worth noting that these ideas are hardly new, however. We could even go back as far as Ancient Greece to see a similar dialogue in action. Plato, in *Phaedrus*, gives voice to Socrates' distrust of writing—perhaps, the technology of its day—which, he says,

> will produce forgetfulness in the minds of those who learn to use it, because they will not practice their memory. Their trust in writing,

produced by external characters which are no part of themselves, will discourage the use of their own memory within them. You have invented an elixir not of memory, but of reminding; and you offer your pupils the appearance of wisdom, not true wisdom, for they will read many things without instruction and will therefore seem to know many things, when they are for the most part ignorant and hard to get along with, since they are not wise, but only appear wise.

(274)

Does the Internet not generate some of these same concerns for the digital dystopians of today? The moral certitude with which people adopt their political opinions is founded largely on their steadfast belief in the authority of Internet sources. Socrates considers students ignorant not because they cannot repeat information, but because they have yet to learn the ability to mediate *between* differing accounts. This is a learned skill, and one we tend to forget when filter bubbles mean that the only information we are introduced to conforms to the opinion our search engine believes we already hold. Even when stepping outside of our bubble to be confronted with 'alternative facts' it is all too easy for us to dismiss these as fake news lest such contrasting ideas disturb our neatly ordered worldview. It is hardly surprising that in these circumstances radical views can be formed, and even less surprising that the volume of information available to us online has the effect of pacifying us rather than engaging us, generating nostalgia for a plain and simple truth that never really existed in the first place.

A quick examination of the digital reaction to the Charlie Hebdo attacks in 2015, in which twelve people were killed (later this number rose after further attacks sprang up during the manhunt for the perpetrators), helps reveal the complex role that digital media played in their consumption. Reporting for *The Guardian*, Jane Martinson wrote that "if 9/11 made global viewers of us all, the Charlie Hebdo massacre was the moment when online and social media were where we gathered: it dominated the information we shared and reacted to." This was played out in the way that the event became known primarily by its hashtag (#JeSuisCharlie). Martinson further reports that, "by the day's end [social media] had spread the story of solidarity and within 24 hours there were more than 3.4 m mentions of #JeSuisCharlie." On some level, this, along with the anti-terror protest marches through Paris and around France that followed, drawing out millions including world leaders, demonstrated a failure on the part of the terrorists who had seemingly stirred and solidified sentiment against their agenda. However, this simplistic reading of the response to the Hebdo shootings overemphasizes the power of social media to influence policy and reform. What, for example, does a march against terrorism actually achieve? As has been highlighted repeatedly here, and by critics more broadly, for

terrorists publicity is the *desired* outcome. But even ignoring, for a moment, the futility of such a march we must also ask exactly what all those tweets, retweets, likes, and updates of Facebook profile pictures shaded by the tricolor really meant or achieved. This is a particularly challenging question considering that, while global media and world leaders branded the Hebdo attacks an assault on free speech, in their aftermath it was actually the French government that decided to crack down on that very same freedom. In the months that followed, scores of French citizens were arrested for making comments about the attacks, none more high profile than comedian Dieudonné M'Bala M'Bala, who was given a two-month suspended sentence for a Facebook post he made after the protest march in which he wrote "Je Me Sens Charlie Coulibaly" (I feel like Charlie Coulibaly), in reference to Amedy Coulibaly, a terrorist who took hostages at a kosher supermarket the day after the Hebdo offices were attacked. Dieudonné's politics are controversial, and he has a history of trouble with the police, particularly relating to anti-Semitic comments, but nevertheless it is difficult to see the French authorities as anything other than complicit in the restriction of the free speech the terrorists supposedly sought to attack. Thus, 'slacktivism'/'clicktivism,' the idea that individuals can click their way to utopia, or even any sort of political reform, belies the evidence with which we are frequently presented. Indeed, this offers the opposing meaning to that intended by Nicholas Kristof when, commenting in a piece in *The New York Times*, he suggested that "the quintessential 21st-century conflict [was represented by] on one side [...] government thugs firing bullets... and on the other side [...] young protestors firing 'tweets'" (cited in Morozov, 2). Whereas Kristof's phrasing implies a certain substantial power behind tweets that can by *fired* in response to bullets, the image also seems to perfectly illustrate the impotence of 'clicktivism.' It matters not just that you *show* solidarity, but that such solidarity culminates in action and change.

What was, perhaps, most interesting about the Hebdo attacks, and generally overlooked in the media frenzy that surrounded #JeSuisCharlie, was the decision by the Kouachi brothers *not* to commit suicide. If anything was indicative of a changing strategy and relationship to technology, it was this. The traditional use of suicide as a weapon by jihadi terrorists is founded partly on an ideological interpretation of various religious beliefs but is also an extension of a technological disempowerment. In her respected piece, "Can the Subaltern Speak?" Gayatri Spivak uses the example of the Hindu practice of Sati (widow burning) to show that within certain ideological structures people feel they cannot enter into dialogue with the dominant discourse without resorting to a dramatic bodily display. In order to make a statement, martyrdom was often required. In some ways, the self-immolation of monks and nuns in Tibetan protests over what the Dali Lama called "cultural genocide"

by the Chinese government since 2009 forms a more recent example. In other words, suicide is viewed as the only way in which a voiceless minority might 'speak' on the global stage. Although the monks have a peaceful agenda, one could liken aspects of their actions to those of Islamic extremists in the 21st century. What was 9/11, or any large-scale terrorist attack, if not an attempt to send a message that could only be delivered through bodily sacrifice? But, today, such a sacrifice is no longer always necessary. The Kouachi brothers' refusal to end their own lives suggests that the digital world has given a voice to terrorists. Clearly, this is the dark side of free speech viewed with concern by critics such as Self. It immediately highlights the dual promise and danger that digital technology represents without even stopping to consider the threat that other types of technology pose to security or where technology is being used to amplify the impact of an attack. For this we need only cite the contemporary obsession with shows like *24* (2001–2010) and *Homeland* (2011- ), in which almost every conceivable terrorist disaster scenario is played out for the victimized viewer.

On some level, then, when presented with the two opposing sides to this story of the impact of digital technology, the cases of both the cyber utopians and the digital dystopians appear inadequate in their attempts to express the complexities of our relationships with such technology. Unable to grasp a clear narrative, it is hardly surprising that, in a world in which the march of digital technology seems inexorable, its sway overwhelming, its reach all encompassing, often our response has been to look backward to a time in which such technology was both simpler and more innocent in appearance. A cultural nostalgia for a time when digital technology filled our minds with wonderment, when it seemed as harmless as a game of *Pong* or *Tetris*, and when the ability to email business associates was considered exciting rather than a chore, seems as inevitable as it is regressive. When confronted with the digital sublime, we are no longer awed by its potential to transform our lives, rather we are fearful of such potential and *over*awed by information overload, a deluge of data points that entirely fail to render the world readable in the manner we would like, revealing, instead, only an increasingly complex picture. In these circumstances, rendered melancholic, we turn to the past in search of comfort. Even as digital technology offers a glimpse into the future, we are in full reverse, ever mindful that the road ahead is long and dangerous.

## Retro Gaming: Nostalgia and the Celebration of the Pixel

"The digital seems to promise nothing less than an escape from materiality itself," suggests Mark Fisher in his 2014 book *Ghosts of My Life*. But with this 'escape' comes a nostalgia since, in the "switch from

the fragility of analogue to the infinite replicability of digital[,] what we have lost, it can often seem, is the very possibility of loss" (144). One could also recall, here, Freud's description of the melancholic in "Mourning and Melancholia"—"melancholia," he writes,

> may be the reaction to the loss of a loved object; where this is not the exciting cause one can perceive that there is a loss of a more ideal kind. The object has not perhaps actually died, but has become lost as an object of love.
>
> (155)

These ideas seem encapsulated in the current trend toward the purchase of material items such as vinyl discs, the market for which exceeded $1billion in the U.S. in 2015, and continues to rise, according to figures released by the Recording Industry Association of America—that's more than the contributions of Spotify-free, YouTube, and Vevo combined. "Digital archiving" continues Fisher,

> means that the fugitive evanescence that long ago used to characterize, for instance, the watching of television programmes – seen once, and then only remembered – has disappeared. Indeed, it turns out that experiences we thought were forever lost can – thanks to the likes of YouTube – not only be recovered, but endlessly repeated.
>
> (144)

What do we make of the Netflix binge-watching culture in light of this? Is this, perhaps, an attempt to recapture the materiality of analogue? Rather than put this behavior down to addiction or impatience, it might be worth considering the idea that binge watching generates the same feelings that accompany participation in an anticipated and unique event. While the program will remain viewable at any time, the desire to watch every episode—or as much as possible—on the day of release replicates the emotions one used to feel when waiting for that CD or DVD to arrive in the post or of queuing up outside the record store for an album that might even sell out. Along with the increased popularity of vinyl, then, these behaviors can be read as an attempt to reclaim a lost materiality that has even become apparent in a number of video games, including those in the Bioshock and Dishonored franchises, in which narrative backstory is developed through the player's recovery and collection of fragmented recordings, complete with 'authentic' associated crackle—indeed, "crackle" notes Fisher "connotes the return of a certain sense of loss" (144).

2013 saw the continuation of the highly successful BioShock franchise with *BioShock Infinite*, released by Irrational Games. *Infinite* adapts the earlier games' premise of a failed utopian city, Rapture, under the sea,

transforming the setting to the 1912 fictional city of Columbia anchored above the clouds. Unlike Rapture, the leaking, creaking, dystopian re-imagination of a 1940s/50s America where capitalism and competition have run rampant, seen in the first two BioShock games, when we are first transported to Columbia we encounter what appears to be a *functioning* utopia where citizens are content and environments clean, spacious, and, above all, beautifully rendered. As we navigate our central character, Booker DeWitt, through the early scenes in the game, we are, of course, waiting for this to unravel. Familiarity with the first two games, and indeed with the nature of this as a first-person shooter, means we know that at some point this utopia will descend into a chaos and violence befitting the genre. The player is not disappointed. Some thirty minutes into the game and we engage in a troubling scene, the first signs that all is not well in Columbia. As Booker comes across the site of the 1912 raffle and selects his free entry baseball with the number 77 scrawled in an ominous red on its surface, the raffle announcer asks his baying audience, referring to the woman handing out the balls, "Is that not the prettiest white girl in all of Columbia?" The intrusion of the word white clearly disturbs. Unsurprisingly, number 77 is the winning entry and the player is confronted with a choice: to throw the winning prize ball at a squirming young interracial couple who have been slowly rolled to the front of the stage having been tied to stakes, or to reject the institutional racism by throwing the ball at the announcer. As time ticks down, the announcer goads the player: "come on, are you gonna throw it... or are you taking your coffee black these days?" A further third option is to let the time run out and do nothing but, unfortunately, whichever choice the player makes results in Booker being stopped before he throws the ball and the gamer is thrust into his/her first bloody action sequence.

Aside from the fact that this episode has the unfortunate side effect of falsely implying a present day postracial United States, reminded as the player is likely to be that in his/her world a black president had oc-cupied the White House for the last five years at the time of the game's release, its ambiguity helps to demonstrate the game's major failing. Although the gamer is clearly intended to find the supremacist racial politics of Columbia dystopian, the choice (to affirm racism, to reject it, or to remain silent over it) and the fact that the outcome of each choice is the same, means that little can be gained from the incident. Ultimately, *BioShock Infinite*'s attempts to offer social critique fail directly because of its nostalgic elements that undermine the game's attempts to present a racist America as dystopian. Since the rest of the game lavishes the player with beautiful and ethereal locations such as the beaches of Battleship Bay, which seem to emit their own warm glow in a way reminiscent of a Jack Vettriano painting, nostalgia is the overriding sense with which the player is left, a nostalgia that cripples the player's ability to make choices and to judge the very nature of the dystopia.

Robin Sloan argues that the narrative techniques used in *BioShock Infinite* confuse references to the past since the game

> uses the narrative genre of alternative history and the science fiction theme of parallel universes to weave a variety of 20th-century popular culture references throughout its story world. In fact, Bioshock Infinite mixes nostalgic references, for example, by taking music from one time period (such as music by 1980s new wave band Tears for Fears) and adapting it to an early 20$^{th}$-century folk music style. The end effect,
>
> (527)

as Sloan concludes, "is the embedding of nostalgic references within nostalgic references, to the point where historicity is replaced by an ambiguous image of the past" (527). This is, perhaps, stylistically unavoidable since *Infinite* uses a steampunk aesthetic, which is naturally inclined toward anachronism. But, nevertheless, the game deliberately mashes together time periods and realities in order to suggest that utopia is located somewhere in our past, or is, perhaps, the very experience of pastness itself. An example of this can be seen through the character Elizabeth, whom the player is tasked with rescuing from the outset of the game. Elizabeth is able to open what are described as tears in space-time that allow her not only to see other places, time periods, and alternate worlds, but also to interact with these in a limited way. In the player's first sighting of the character, we see her obsessing over an image of Paris. As the scene plays out, we witness her open a tear to a beautiful rendering of a night-time city street, the Eiffel Tower in the background clearly signifying the location for the player. A cinema in the foreground showing "La Revanche Du Jedi" (The Revenge of the Jedi—the original working title for Lucas' third *Star Wars* film) puts the date at around 1983. This, it would seem, is Elizabeth's unattainable object of nostalgic romance (even though technically a future for her, rather than a past, considering the 1912 setting). Encapsulated in this image is the nostalgic longing for the gamer's childhood return to *Star Wars*, wrapped up in a romantic image that condenses and collapses time, place, and memory. Additionally it rewards the gamer for recognizing the intertextual link being made and, in so doing, reinforces a reverence for past cultural artifacts and forms.

*BioShock Infinite* and, indeed, the other games in the franchise represent what is often described as retrofuturism, an aesthetic style that throws together the old with the new in a way that seeks to render the future intelligible and interpretable through the technology of the past. As Aldred and Greenspan remark, the BioShock world "[constructs] a historically disjunctive retrofuture that simultaneously interrogates and celebrates utopian notions of technological progress and free will."

Regarding the darker dystopian world offered by Rapture in the first two games, they suggest that, "although BioShock outwardly seems to critique both technology and capitalist excess as ruinous forces, as the gameplay and story unfold, they subtly recuperate the power of corporate capitalism and managerial principles for stable social engineering" (481). Thus, as critical of capitalism as the games may be, they fail to offer an alternative and, by situating their action in a nostalgic past, they also tend to reaffirm technology's journey from past to present as bringing with it both beauty and destruction in a *romanticized* sense. Aldred and Greenspan argue that the "intentionally antiquated, historically disjunctive gameworld" (483), offered by Rapture in *BioShock* and *BioShock 2* shows a "general ambivalence toward technology as both functionally utopian and nostalgically counter-utopian" (488). However, it is difficult to see the BioShock franchise games as anything other than celebrations of technology given that as games they make use of the latest digital aesthetics in order to sell their particular retrofuture.

The popularity of retrofuturism in gaming today is particularly strong. The third best-selling game of 2015 was *Fallout 4* (the first was notably *Call of Duty: Black Ops* 3, which, despite being set in 2065, tells its player in the opening sequence that after a long period of steady deterioration, they have entered into a "new Cold War"). The Fallout series invites players into a post-nuclear detonation future. *Fallout 4* is set in Boston in the year 2287, but our central character is introduced in his/her home environment in 2077 moments before a nuclear strike irradiates the landscape and the player escapes to a vault to be frozen in order to re-emerge over 200 years later. Through this manipulation of time streams, the player is able to encounter a limited amount of futuristic technology (notably weaponry, power armor, and synthetic humans) among a sea of retro household junk. Its initial setting looks more like 1957 than 2077, with the exception of a household tin-can-like robot servant called Codsworth who seems distinctly out of place. Perhaps one of the most evocatively nostalgic elements of *Fallout 4* is its monetary system through which characters trade Nuka Cola bottle caps, the most popular soft drink in America before the nuclear war of the 2070s. Thus, the red and white image of Coca Cola comes to dominate this retrofuture landscape, taking the player back to a predigital age of black and white TV, billboard advertising, and white picket fenced suburbs since laid waste in a nuclear holocaust.

*Fallout 4* clearly fits the pattern identified by Sloan in which "many nostalgic video games place symbolic content within a modern structure." As he continues, "these videogames tend to have a modern core (modern technologies, engines, gameplay programming) and a nostalgic shell (audio, visual, and narrative designs indicative of a bygone age)" (534). Another successful, long running, series of games that operates through such a framework is Ubisoft's Assassin's Creed games, the

first release of which was in 2007 but has seen a new game produced each year since. In Assassin's Creed, the player explores a different historical time period depending upon the game. Some examples include *Assassin's Creed Syndicate* (2015) set in Victorian London in 1868; *Assassin's Creed Rogue* (2014), set in New York in 1758; and *Assassin's Creed: Revelations* (2011), which has a frame narrative set in the present but returns the player to 16$^{th}$-century Constantinople. The overall premise of the Assassin's Creed franchise is that through a futuristic device called the Animus, which on some level mirrors the gamer's use of videogaming to explore the past, the protagonist is able to live out the memories of Assassins throughout the ages. Thus, the games make the assumption that for the player the past is a more interesting location for the action to take place than the present environment, with only the occasional jump between the two. Of course, this is not nostalgia in the technical sense of the term since players cannot possibly be old enough to have lived in such times themselves. Nevertheless, the effect is similar if not more troubling. While living through a past period might bring brief episodes of nostalgia to those encountering objects, thoughts, memories, senses, which re-engage them with that period, such episodes tend to be framed *as* nostalgia and, hence, are soon disregarded by those experiencing them as somewhat fake reimaginings of a past in which life was probably not as great as it now seems. When such experiences are unavailable, there is a danger that 'reliving' these older times (not as they were, but as nostalgic fantasies) might lead to a reordering of both the player's understanding and perception of history.

Returning to Fisher, he argues that,

> while 20th century experimental culture was seized by a recombinatorial delirium, which made it feel as if newness was infinitely available, the 21st century is oppressed by a crushing sense of finitude and exhaustion. It doesn't feel like the future. Or, alternatively, it doesn't feel as if the 21st century has started yet.
>
> (8)

While Fisher's comments here are more broadly aimed at the music industry in contemporary Britain, this same sentiment can be read in relation to retrofuturism, which sees the future only through the lens of the past. This also seems to echo Lyotard's description of the difference between the melancholic sublime—which looks backward toward a comforting sense of harmony—and the novatio, which, by contrast, suggests a future orientation alongside the potential for infinite variation.

Recalling *Ready Player One*, Cline's novel is one of the most interesting and vibrant examples of retrofuturism. Justin Nordstrom describes the text as "a montage of futuristic dystopianism, retro 1980s kitsch, and virtual reality gaming" (239). In the novel, Halliday is able to

*virtually* recreate the 1980s through making the OASIS, in effect, a giant museum to the decade in which its inhabitants can permanently live so as to escape the present predicament through Halliday's own nostalgia. This can be seen in Wade's direct eulogizing of the past early in the novel when describing the current state of life in 2044:

> Our global civilization came at a huge cost. [...] We call this the Global Energy Crisis [...]. Basically, kid, what this all means is that life is a lot tougher than it used to be, in the Good Old Days, back before you were born. Things used to be awesome, but now they're kind of terrifying. To be honest, the future doesn't look too bright. You were born at a pretty crappy time in history. And it looks like things are only gonna get worse from here on out.
>
> (17–18)

Indeed, the text is rather reluctant to give too many details as to how such a dystopia has come about, instead choosing to focus on the utopian potential of a nostalgized existence made possible through virtual reality technology.

To some extent, *Ready Player One* becomes a mere vehicle for Cline's own nostalgia for the 1980s, a meticulous recreation of the gaming, film, television, literature, and music culture of the decade set against a futuristic backdrop that, perhaps, befits a time itself particularly obsessed with futurism. This leads to what Nordstrom describes as "overlapping paradoxes" since the novel manages to represent "a utopia within a dystopia, a futuristic setting obsessed with the past, and characters playing elaborate games within the broader gaming environment of the OASIS itself" (244). But these paradoxes lie at the heart of the failings of Cline's utopian vision and, more broadly, the problems with retrofuturism that, while evidently desirous of a future utopia, can only render this imaginable by looking to the past.

In "Public Memory and Gamer Identity: Retrogaming as Nostalgia," Heineman documents the rise in popularity of so-called retro games over the last decade. He cites this as a peculiarly contemporary phenomenon, arguing that "it was not until the early part of the 21st century that retrogaming started to pick up steam as a marketable, profitable part of the gaming industry." It is worth at least pausing to consider the social conditions that might be responsible for such growth. In the 21st century, gaming has clearly become more affordable and accessible, and thus a proliferation of gaming styles and preferences are, perhaps, inevitable. However, over the past decade, despite the fact that advances in digital technology have seen the virtual world become increasingly sophisticated and high definition, there has been a parallel and somewhat contradictory revival of retro culture, which seems to revel in the celebration of the pixel. Sloan highlights that, "today, consumers have access to a

wide range of original videogames that build upon nostalgia for past vid-
eogame series, styles, forms, and mechanics" (526). But the trend toward
retro gaming seems to go beyond nostalgia. Take the hugely popular
children's game *Minecraft* (2011), for instance, a game that intention-
ally makes use of heavily pixelated graphics as a stylistic and aesthetic
*choice* rather than a necessity. *Minecraft*'s popularity amongst children
cannot possibly be accorded to nostalgia since players will likely have
grown up in the pixel-lite 21st century (although it is worth noting that
some nostalgia may play a part in the parents' decision to purchase the
game for their child), which means that it is more likely that it is the
retro style itself that has made the game so attractive to its younger au-
dience. A similar, although less phenomenally successful, console game
for children released the same year, *Terraria*, re-exploits the popular 2D
graphics of 1990s platform video games.

Online auction websites like eBay and Gumtree in the UK, along with
the rebirth of second-hand shops for DVDs, CDs, and video games such
as CEX—which now has in excess of 300 stores in Britain and is still
growing at a time where high-street branches are going into liquida-
tion left, right, and center—have reinvigorated the retro gaming market.
Old gaming consoles and obscure games can fetch good money online
and so have been interesting for those looking to sell off their child-
hood memories and those who want to relive them. The miniaturization
of gaming platforms due to the explosion of mobile gaming has also
opened up opportunities for small independent game makers who can
create overnight hits with quick-fire games that sacrifice graphics for
player enjoyment and levels of addiction. Larger tech companies like
Microsoft and Sony have also attempted to cash in on the market by
offering repackaged retro games through their online stores. New con-
tent is even being added to many of these older games so as to add resale
potential to collectors and more hardcore fans. As Heineman suggests,
"retrogaming is very much a personal hobby that involves participation
in a larger community and culture of like-minded aficionados of older
games." Thus, this same culture has expanded into areas beyond the
simple playing of games. For example, T-shirts referencing older games
are now relatively commonplace, and these are often worn as a kind of
'nod and wink' to anyone who might have shared that childhood experi-
ence. Similarly, board games and older forms of gaming have also come
back into fashion. And it's not just new and innovative designs; classic
board games such as Monopoly and Risk, for example, have recently
leant their names to a large number of popular culture sources such as hit
U.S. TV series *The Walking Dead* and *Game of Thrones*. Even *Fallout*
is now available as a Monopoly collector's edition. A 'Monopoly Nos-
talgia' edition is available and comes in a wooden box with the graphics
from the Parker Brother's original 1935 version of the game. In the world
of cinema, Disney was able to cash in on this trend in 2012 with *Wreck*

*It Ralph,* the story of an old arcade game 'bad guy' (Ralph—voiced by John C. Reilly) who wants to be the hero. Another success story was 2014's *The Lego Movie,* which animated the classic building blocks for another stint as one of the world's most popular toys. *Pixels* (2015), an Adam Sandler comedy vehicle, again riffs off the idea of re-energized arcade games as classic game characters such as PacMan, Donkey Kong, and Space-Invaders descend on Earth from outer space. Even classic 1980s science-fiction VR narrative *Tron* was given a dust off by Disney and remade in 2010.

But where has this explosion of retro gaming culture come from, and what does it actually mean? For Sloan, gaming, and in particular video gaming, is a primary portal for nostalgia. It is "the active and partici-patory nature of videogames [that] both strengthens our memories of past media and facilitates more powerful satisfaction of nostalgic desires through nostalgic play" (532). But this nostalgia is "more than simple recollection" according to Heineman because "to think nostalgically is to recognize the past as intrinsically better (e.g., simpler, healthier) than the present, but it is also to feel fear and sadness that what was lost cannot be regained" (37). That retro games might seem better to some users because they are simpler is understandable. In fact, on some level this has been recognized by designers of the current next generation Xbox and PlayStation consoles who have repeatedly resisted the urge to add further buttons to controllers. The sense of loss, however, argues Heineman, is at least partially negated by retro gaming culture since re-released games allow players to revisit the same "virtual environment [which] persists in an unchanged state." Thus,

> because of the technologies associated with the medium, gamers can return to the same virtual spaces that they occupied at an ear-lier time, [...] allowing their nostalgia to be addressed in ways that would be difficult to duplicate in non-virtual environments.
>
> (38)

For Heineman, then, games offer a more satisfying nostalgic experience since the player can become completely immersed in an unaltered past world from childhood. Thus, retro gaming negates the feeling of loss associated with nostalgia.

The yearning for the materiality of the past is ultimately a utopian de-sire predicated on the tragic nostalgia of the loss of the 'real' Baudrillard wrote of in the early 1980s in "Simulacra and Simulations." Sloan argues that certain nostalgic video games, he cites *Far Cry 3: Blood Dragon* (2013) and *Gone Home* (2013), "are part of a body of contemporary gaming products that seek to remediate the past and appeal to our desire to connect to our younger selves." The appearance of such games echoes Baudrillard's statement, as cited by Sloan, that "it is the real that has

become our true utopia—but a real that is no longer in the realm of the possible." This is because, as Sloan puts it, they are indicative of "the melancholic realization that the reality which we seek is now lost to us" (547). When placed in this context, it seems to matter little whether or not the past, as seen in the games or retro culture discussed in this chapter, is a past actually *experienced* by the consumer. These products are the mournful expression of an absence of the *real* past rather than any specific memory on which the gamer can draw. Thus, retro gaming and retrofuturism are examples of a desperate search for the sublime through a connection with past technology. It abjects the entirely super-ficial sublime of the digital infinite in search of the physical. This is, per-haps, the real power of *Fallout*'s retrofuture, since it evokes the power of the atom bomb, the last truly sublime and terrifying technological development: a destructive force that challenged perceptions of technol-ogy as benevolent and utopian and instead reminded us of the terrifying reality of life and death, where death is Game Over and there are no Extra Lives.

# 5 Sublime Special Effects in Contemporary Cinema and Nostalgia for Physical and Mechanical Special Effects

As a new millennium dawned, American culture was awash with predictions and dreams of a cyber utopia built on the back of a new Internet age. However, for just as many this moment brought in equal measure the fear (or undoubtedly fantasy for some) of destruction. Pronouncements of a technological apocalypse, often fueled by the 'threat' that the Y2K millennium bug would down the world's computers, abounded. One such proclamation was issued in 2001 by Paolo Usai who announced that the Digital Age would usher in 'the death of cinema' as we knew it. In hindsight, it is easy to point to such prophecies as naïve, but predicting the future is always fraught with potential for embarrassment. Besides which, on many levels Usai was right to focus on the ephemerality of the image in a contemporary digital world and to expose how much of the magic of cinema is lost with the production of such vast quantities of 'film.' Thus, whilst a number of developments, like the reintroduction of 3D and the monetization of avenues previously considered a threat to the industry such as downloading and streaming, have enabled cinema to defy expectations of its demise, since 2001 the effect Usai describes has only increased. The ubiquity of *personal* film, disseminated via social media platforms like Facebook, YouTube, Snapchat, and Instagram, means that many of us now capture even the most mundane moments of daily life in the medium. Our confrontation with the sheer volume of film at our fingertips—capable of generating an effect Richard Grusin calls "the YouTube Sublime"—has produced a distinctive side effect, however, leading many consumers to experience a sense of nostalgia for the perceived authenticity and originality of older films and filmmaking techniques.

In this chapter, we focus on two particular ways in which the melancholic sublime has been expressed in 21st-century cinema and keep one eye on the role that terror has played in shaping the form of these films. In the first section, this is explored in a literal sense through the examination of contemporary apocalyptic film. The disaster movie is, perhaps, the most natural cinematic vehicle for the sublime as it considers the grand themes of terror and death, packaged up in special effects sequences aimed specifically at eliciting the awe associated with

its sensations. It has also become the site of a curious nostalgia for a time *before* disaster; a yearning for that pre-9/11 invincibility encountered earlier in this book. Thus, recent apocalyptic films have sought to reverse a descent into the melancholia provoked by that pervasive sense of doom felt by many immediately after the 9/11 attacks by repackaging a formula for the apocalypse made popular in the 1990s.

From this, we move on to consider contemporary film at both a broader and a more technical level. While disaster films, interesting in their own right, are often made popular by their special effects sequences, the nature of these special effects in movies becomes our focus and the point of departure in order to explore a nostalgia that has developed for predigital forms of filmmaking. In later sections, I examine our critical reverence for older special effects techniques and explore how the films of today might inspire a nostalgia for the physical and mechanical effects seen in earlier periods. Is it possible that the closer digital special effects come to perfection the more they leave audiences yearning for authenticity? Why is it that we often underappreciate the talents and skills of those working for labor-intensive digital effects companies? The chapter culminates in an analysis of Stephen Spielberg's *Jaws* (1975) and its enduring appeal, arguing that our appreciation of its somewhat dated special effects are an example of the way in which the melancholic sublime, elicited by contemporary filmmaking processes, leads to a nostalgia for the blockbusters of the 1970s and '80s.

## Remaking the Past

"It is easier to imagine the end of the world than the end of capitalism," writes Fredric Jameson in *Archaeologies of the Future* (199). This simple idea, propped up by the volume of fictions that seem to evoke apocalypse over those that envision postcapitalist utopias, is, perhaps, more complex than at first it appears. On a basic level, to imagine the end of the world is also to imagine the end of capitalism, giving apocalyptic scenarios at least some cause to be considered anticapitalist. On another, more interesting, level, however, to imagine the end of capitalism, particularly after 9/11, is also to imagine the end of the world. This connection, while far less obvious, is predicated on two ideas. The first is that America's relationship with capitalism is so enshrined in national and personal identity that its destruction is akin to an Armageddon moment in which, even if the world is not destroyed by the end of capitalism, it is so radically altered as to no longer be recognizable as 'our' world. The second is that 9/11, America's own personal *apokalypsis*, was at once an attack on capitalism and a brief glimpse into a future without its structural logic. Indeed, this latter observation is borne out by the turbulence seen in the financial markets after the attacks that included the suspension of the New York Stock Exchange, the NASDAQ, and

other global markets; $40 billion in losses for insurance companies; and a trading crash. As always with terror attacks, however, and as was evident in President Bush's appeals to the nation to get on with its business, we were told that the best response is to carry on with our lives—to let it impact on our routine is to 'let the terrorists win'—and by this what is meant is the continuation of our day-to-day consumption of goods and services.

Many post-9/11 apocalyptic films played specifically with ideas about the end of capitalism. So, in Danny Boyle's *28 Days Later* (2002), we see a group of survivors on a shopping spree in an empty supermarket. The scene stands out as a moment of joyous freedom for the characters in an otherwise bleak film and as they gleefully grab whatever they wish from the shelves before leaving, the camera lingers playfully on the credit card left behind on the counter as a symbol of a defunct system of payment and governance. In *I am Legend* (Francis Lawrence, 2007) the film opens with Will Smith's character, Dr. Robert Neville, speeding through the streets of a desolate New York City hunting deer from the driver's seat of a shiny red sports car. The fantasy of having access to any luxury, the dream of unfettered capitalism, is rendered obsolete by the return of nature to the streets; the sports car, the ultimate in capitalist excess, acting as it does, almost solely as a status symbol and an aesthetic flourish, becomes a tool rather than a luxury for the hunter-gatherer whose essential need is to eat. In John Hillcoat's *The Road* (2009), the scarcity of items of luxury, and in fact almost any consumable products at all, means that capitalism has become an irrelevance, replaced by systems of scavenging, stealing, bartering, and even cannibalism. Thus, a key scene shows Viggo Mortensen's character (referred to simply as 'the man') giving his son (Kodi Smit-McPhee) a can of Coca-Cola as if it represents the very height of decadence.

When we consider 1990s films alongside those of today, however, the world is often *saved by* capitalism, or at least a combination of capitalism, bravery, and scientific ingenuity. Hence, in the 1990s humanity relied upon serious finance as a means to defend itself from an alien invasion in *Independence Day* (Roland Emmerich, 1996), and to orchestrate an advanced space mission in order to protect the planet from an asteroid in *Armageddon* (Michael Bay, 1998). Similarly, in *2012* (Roland Emmerich, 2009) humanity is saved from a biblical flood by the financing and building of extravagant arks that will carry the seeds of new life on earth; in *Pacific Rim* (Guillermo del Toro, 2013) alien monsters who appear from under the sea are defeated by expensive giant robots that become the last line of defense, and in *Independence Day 2* (Roland Emmerich, 2016), the world (specifically the U.S. military) has been preparing for a second attack since the climax of the first film with what appears to be an impossibly inflated defense budget—even by U.S. standards.

As a result of a change in tone between pre- and post-9/11 apocalyptic films, in "Melancholic and Hungry Games: Post-9/11 Cinema and the Culture of Apocalypse" I characterized post-9/11 cinema as "respond[ing] to a cultural pessimism imbued by the events of 9/11." This included a pessimism not only toward the stability of capitalism and its concurrent logics, but also toward the longevity of contemporary society more broadly. "When we sit down to watch *Armageddon*, *Independence Day*, or *The Fifth Element*," I argued,

> we already know that, come the eleventh hour, humanity will save itself. Redemption is the point of these films: the world must be saved so that in films to follow it can be blown up all over again. In the current post-9/11 environment as seen onscreen it is the end of the world itself that is inevitable, so taken for granted that the cause has become almost irrelevant.
>
> (329)

Thus, post-9/11 films displayed an innate nostalgia for a pre-9/11 invincibility by offering spectators little more than survival in the toughest of postdisaster environments. Indeed, the apocalypse genre, often chastised after the attacks for having purportedly inspired the actions of Mohammed Atta and the other 9/11 terrorists, became central to interpretations of the attacks themselves. Aside from Robert Altman's famous admonishment of the film industry for its role in preparing the imagination for the attacks mentioned earlier, Baudrillard suggested of 9/11 that,

> in this singular event, in this Manhattan disaster movie, the twentieth century's two elements of mass fascination are combined: the white magic of the cinema and the black magic of terrorism; the white light of the image and the black light of terrorism.
>
> (*The Spirit of Terrorism*, 29–30)

In so doing, he makes no distinction between the attacks and the disaster movie. For Baudrillard, Altman, and many others, 9/11 *was* a disaster movie. The public reaction to 9/11, as Max Page has revealed, would have consequences for the disaster film. "In the wake of 9/11", he highlights,

> journalists and theorists, news commentators and politicians realized that the language of the disaster movie had shaped the initial, unscripted response to 9/11, and they were appalled. "This is not a movie," argued Anthony Lane, a film critic for the New Yorker, in an impassioned essay just two weeks after 9/11. "What happened on the morning of September 11th," Lane argued, "was that imaginations that had been schooled in the comedy of apocalypse were

forced to reconsider the same evidence as tragic." Perhaps, he suggested, "the disaster movie is indeed to be shamed by disaster".

(207)

But, as time has passed, a return to the 'comedy of apocalypse' has seemed more acceptable. The arguments I made in 2012 can now be revised in light of the films that have since arrived on the big screen. In my original piece I considered films such as *28 Days Later, The Day after Tomorrow* (Roland Emmerich, 2004), *Children of Men* (Alfonso Cuarón, 2006), *I am Legend, The Road,* and *The Book of Eli* (Albert and Allen Hughes, 2010) alongside popular 1990s films *Independence Day, The Fifth Element* (Luc Besson, 1997), *Armageddon, and Godzilla* (Roland Emmerich, 1998) as prime examples of the way in which post-9/11 apocalyptic films moved away from the escapism seen in the late 1990s, an escapism predicated on the seeming impossibility of destruction. Today, and with films like *Olympus Has Fallen* (Antoine Fuqua, 2013), *White House Down* (Roland Emmerich, 2013), *Pacific Rim, San Andreas* (Brad Peyton, 2015), and *Independence Day 2* in mind, we see a return to the style, substance (or lack thereof), tone, and tropes of the fun disaster flicks of the 1990s. In these films, we see not an acceptance or overcoming of disaster, but rather a nostalgic remaking of the 1990s in celebration of a moment now passed and in need of recapture. Thus, these films directly recycle core elements of the 1990s films.

Comparing the opening of *Godzilla* (1998) with that of del Toro's *Pacific Rim*, both begin in token fashion by taking the audience around a number of 'exotic' locations in order to orient their disaster as global, rather than merely local. In so doing, while both films imply a kind of melting pot culture, celebrating (American) cultural diversity, primarily American characters save the day. It is notable, however, that both films rely on teamwork in a way that the films immediately following 9/11 do not, concerned as they were predominantly with the fates of lone survivors. In the 1990s, humanity worked together in order to thwart the end of days. One could cite *Armageddon* and *Independence Day* as offering the most overt messages about the power of such a coming together, but it is a trope that runs throughout the wave of films. Thus, as Stephen Keane notes in his analysis of *Armageddon*, although "repeatedly throughout the film [Harry] Stamper is referred to as a Red Adair, "the world's best deep core driller," [...] fundamentally his leadership principle is tempered with the value of teamwork: "I'm only the best because I work with the best"" (*Disaster Movies*, 93). In comparison, immediately after the attacks, films focused on the exploits of lone survivors almost as if they too were like the dazed and confused victims of 9/11 as they staggered out of the dust cloud, separated from their families and their co-workers (many of whom may well have been dead), thinking only how lucky they were to still be alive. Lone survivors dominate the

films in the first decade of the 21st century, exploring apocalyptic wastelands in *I am Legend, The Road,* and *The Book of Eli,* among others.

Further similarities between 1990s apocalyptic films and recent movies in the same genre can be seen on the level of narrative tropes. Films like *Independence Day* and *Godzilla* established a kind of formula in which brawn must team up with brains in order to solve the impending crisis. Thus, in *Independence Day,* Will Smith's Captain Hiller, a man who displays his masculine physicality by punching an alien directly in the face in one comic scene, needs the help of the socially awkward scientist David Levinson (played by Jeff Goldblum). Similarly, in *Godzilla* Jean Reno plays French hard man Philippe Roaché who must learn to cooperate with the scatty Dr. Niko Tatopoulos to bring down the legendary Japanese beast. Fast forward to 2013, and in *Pacific Rim* we find this same formula in operation only (like almost everything in the movie) doubled. Thus, the brawn comes from the pilots of the massive fighting machines who must synchronize their minds and bodies, forming a "neural bridge" in order to do battle with the alien monsters, and the brains come from an English and American scientist who eventually figure out how to subvert the terrible odds against humanity (notably, it is the American scientist who disproves his counterpart's theory to become one of the heroes of the story).

The similarities do not stop there. In fact, *Pacific Rim* seems exacting in its remaking of the 1990s version of the apocalypse genre (although it is worth noting that it also incorporates older ideas alongside themes from Japanese anime). Thus, *Pacific Rim* follows the tendency to brazenly employ spectacle over meaning, which lies firmly at the center of the 1990s apocalypse mode. The idea that anything should make sense in this movie is treated with the least importance. So, when convenient, Raleigh Becket (Charlie Hunnam) and Mako Mori's (Rinko Kikuchi) fighting robot, named Gypsy Danger (one of the most sophisticated machines ever built by mankind) is described as 'analogue' rather than 'digital' like the others, the championing of this robot sending a signal that the old-fashioned ways were always the best. Again, when convenient, the pilots of Gypsy, at the very point of destruction, suddenly remember that their robot has a rather overpowered sword function that saves the day but leads the viewer to question why they didn't use it much earlier. What is more, in a fairly crude rip-off of Bill Pullman's rallying speech in *Independence Day,* Idris Elba's character, Stacker Pentecost, stands at the foot of his war machine and addresses a crowd of pilots and bit-part engineers as they prepare for the final showdown. In a speech remarkably reminiscent of that famous scene from *Independence Day,* Pentecost emphasizes their solidarity, suggesting that the crew has chosen to believe not just in themselves but in each other, before bullishly declaring "today, we are canceling the apocalypse." And this is where the truly fundamental similarity between the 1990s films and

those of today lies: in *Pacific Rim, Olympus Has Fallen, White House Down, San Andreas,* and *Independence Day 2,* apocalypse is canceled (or at least postponed until a sequel). For all their emphasis on sublime special effects, action, and explosions, the world is saved by a nostalgia that sweeps away the cultural pessimism of the previous decade and insists that the 1990s were indeed the time of American invincibility, encouraging the audience to relive them once more before returning to their own time of terror.

On some level, at least, this new wave of films comes as a relief. While the post-9/11 apocalyptic movies may have been better made than today's counterparts, eschewing as they often did a gritty realism, they all too frequently left spectators with a feeling of hopelessness and despair. Take Lars Von Trier's 2011 film *Melancholia,* which is centrally concerned with protagonist Justine's (Kirstin Dunst) clinical depression. In the film, Justine's astronomer brother-in-law, John (Kiefer Sutherland), continually repeats his belief that a collision event between the earth and another planet will not occur. John believes, along with many other scientists, that the two celestial bodies will pass harmlessly by each other and will in fact generate the most spectacular astrological event ever witnessed. However, during the film's climax, when it becomes clear that science is mistaken and that the world is destined to be destroyed in this collision, John is found dead having committed suicide. That the character is played by Sutherland, best known for his role as near-invincible antiterror agent Jack Bauer in the hit TV show *24,* makes this ending somewhat ironic and doubly bleak. Indeed, this wave of films more generally was pessimistic to such a degree that many titles flopped on cinematic release despite the genre's suitability to today's effects-hungry market. However, the current more optimistic tone comes at a cost. Rather than marking a shift forward, as demonstrated, these films attempt to remake the 1990s for today's audience. They are nostalgic for a not-so-distant past in which a multicultural American utopia still seemed possible. We can enjoy these films for their escapism but, ultimately, come away with that hollow feeling that it is all a little too familiar, the relic of a more naïve time when disaster was averted, when life carried on, and when the 'good' guys always won.

## An Uncanny Nostalgia for the Real

Apocalyptic films, of course, are often known for their dramatic and spectacular special effects sequences. In fact, it is not uncommon for these films to feel like the narrative is secondary—an excuse to dazzle the spectator with their visualization of destruction. These effects, however, can interrupt viewing pleasure simply because they are, at times, poorly executed or overly ambitious. Take films like *2012, San Andreas,* and *Independence Day 2,* for example. In these films, whilst the effects

budgets are clearly large and the money is materialized on the screen, the repeated grandeur of the destruction scenes seems to ask too much of the audience, and the overall effect appears flat. In such cases, too much CGI—which in these films draws attention to itself—has served to undermine the viewer's faith in the fidelity of onscreen images. This is just one of the ways in which spectators can be 'turned off' by CGI. Others include the knowledge that actors are simply not located in the diegetic space. For example, in documentaries about contemporary filmmaking (often found as extras on DVDs that make use of impressive special effects sequences) I am repeatedly struck by how the appearance of actors in front of green screens, or with their faces covered in motion sensing dots, ruins the magic of cinema. In this way, the use of CGI seems to directly undermine the impressiveness of the effects, even if the result in itself is successful. Furthermore, the increased ubiquity of CG effects has, in some instances, led to lazy filmmaking and an overreliance on the technology. Rather than being driven by the narrative, special effects all too often appear to be used as its replacement—just take any of Michael Bay's hugely/bizarrely popular Transformers movies for example.

Sometimes 'perfect' effects aren't really what we want, either. When watching some of the epic fantasy films of the 21st century, from *The Lord of the Rings* (Peter Jackson, 2001–2003) and *The Hobbit* (Peter Jackson, 2012–2014) trilogies to the *Harry Potter* films (2001–2011), James Cameron's 2009 *Avatar*, and even *Warcraft* (Duncan Jones, 2016), you could be forgiven for thinking that there's nothing that cannot be achieved with today's special effects. Whether it is the creation of hordes of troops and CG armies, lifelike monsters, or fully interactive fantastical environments—all of which have become commonplace in contemporary fantasy blockbusters—the power of CGI has seemed near limitless. Not a summer goes by without at least a handful of epics that seem to push the boundaries of effects-based cinema. Not only this, but it also all seems rather easy—perhaps a little too easy. Today's effects sit so comfortably within the filmscape as to seem naturalized: "it's all done on computer," we might say, as if we ourselves could produce such effects on our laptops at home. The question that springs to mind is this: why do we appreciate art that isn't photo real? The answer is relatively simple. We appreciate both vision and the technical skill required to bring vision to life. There are many people that *like* to see the stamp of the creator on the creation, like seeing the brush stroke of a painter. More specifically, I want to focus here on the ways in which the exclusion, or obfuscation, of the work/labor of production has led some audience members to feel alienated from today's effects-laden movies: the idea that excessive use of CGI leads audience members to appreciate contemporary films less and older films more, producing within these sublime effects sequences a nostalgic reverence for the 'original.'

There is one problem studios have repeatedly found difficult to solve: generating a single, believable, CG human character tests filmmaking techniques to their limits. Considered the final frontier in special effects, the replacement of actors with photorealistic CG characters has thus far proven more challenging for effects studios than any other task. Karl MacDorman asserts that studios have successfully been able to convince spectators that monsters are real, or rather have been played by actors in suits/with prosthetics, citing Davy Jones in *Pirates of the Caribbean: At World's End* (Gore Verbinski, 2007) as an example, but that convincing viewers of the physicality of CG humans has proven far more difficult, describing it as the "holy grail of computer graphics" (695). There are a number of arguments as to why this is more problematic, but perhaps the most often cited makes use of a generalizing theory posited by robotics expert Masahiro Mori in 1970 termed the 'Uncanny Valley.' Drawing on Freud's term, Mori proposed that the closer a humanlike substitute was to perfection in its replication of the human form, the more disturbed we are by its flaws. Thus, while we might not notice such flaws in a CG monster—after all, there is no clear point of reference for imaginary creatures—CG humans, at least those interacted with in any real depth, remain unconvincing and even uncanny because of the imperfections in the technology that creates them.

Mori's concept was intended to apply to robots, but his ideas seem as applicable to images and have been taken seriously by the film industry: as MacDorman suggests, "the uncanny valley has even led studios like Pixar to shy away from human photorealism, choosing instead cartoony stylization" (696). Although such 'stylization' may not always be the result of a wish by studios to avoid producing uncanny effects (particularly on children or in areas that might impact spectator immersion), after all, Pixar is likely only following what could be considered a traditional style for children's entertainment, the attempts that have been made to replace human characters with entirely CG ones in films such as *Final Fantasy: The Spirits Within* (Hironobu Sakaguchi and Motonori Sakakibara, 2001) have only proven the inadequacies of the technology. Instead, today, what is often substituted for attempts to create virtual actors is a form of motion capture in which an actor must perform, their movements captured and then translated into a computer image that can be manipulated. In fact, videogames are in this instance leading the way by going in the reverse direction, i.e., taking what were always computer generated characters and having them played by actors as a kind of crossover between the two. For examples we could cite Kevin Spacey's performance in *Call of Duty: Advanced Warfare* (2014), or the Xbox One exclusive title *Quantum Break* (2016), which uses a rich cast of real-life stars including Shawn Ashmore, Aidan Gillen, Courtney Hope, and Lance Reddick and augments gameplay with real-life filmed 20-minute episodes that bookmark the end of each gameplay 'chapter.'

The mixed reception of Steven Spielberg's 2011 *The Adventures of Tintin* movie, like Robert Zemeckis' 2004 *The Polar Express*, in which critics often cited the 'uncanny valley,' shows that even in animation, straying too close to reality can have a detrimental effect. In his review of the film for *The Guardian*, Steven Rose highlights the debate between those who believe that the uncanny valley might never be bridged and those who believe that it already has been. David Fincher's 2008 *The Curious Case of Benjamin Button*, for example, uses CGI in order to make Brad Pitt's eponymous character appear progressively younger. The special effects in the film suffer from a number of weaknesses that give a slightly uncanny and rather awkward look to Button at various points. But only two years later in Joseph Kosinski's *Tron Legacy*, similar techniques are used to much greater effect in order to create a young version of the Jeff Bridges character (Clu). The CGI, although again imperfect, is strong enough to enable the older Bridges to converse with his younger self and convince some audience members of the latter's authenticity (although it is worth noting that minor flaws are made easier to cope with due to the fact that the film is set in a simulated computer environment). These two films, both supported by large budgets and a strong cast of actors, demonstrate the potential of such effects but also their weaknesses and inconsistencies: when it comes to the production of CG humans, there is a very fine margin for error.

As already intimated, one of the problems for effects companies seeking to create virtual actors is the abundance of real-life material with which the audience can compare. For a virtual actor to look real when stood next to an actual actor requires an incredible amount of detail. The same even applies to creatures when there is a handy example with which they can be compared. We could consider this the case with *Jurassic World*'s (Colin Trevorrow, 2015) velociraptors, which must compete with Spielberg's hugely popular original 1993 blockbuster and its own ground-breaking *animatronic* raptors. Indeed, even if when studied side-by-side *Jurassic World*'s entirely CG raptors appear to look as, if not more, 'realistic,' the CGI still seems to disappoint for its lack of physicality and because it generates in the spectator a nostalgia for the original. In short, the physical effects work on *Jurassic Park* seems more satisfying and the physicality of these effects gives audiences a greater appreciation for the skills of the team involved in their production. Reasons for this will be explored later in this chapter and particularly in the section on *Jaws* (1975).

MacDorman also suggests that the replacement of the humanoid with the artificial/mechanical serves to undermine our sense of identity; it could be further responsible for our experience of the uncanny when confronted with such machines or images. This is an argument, mirrored in discourse, more broadly about the uncanny effect exhibited by robots or clones but is of less use to us in a discussion about the nostalgia for old

special effects. For example, we shouldn't attribute all the problems with contemporary CG effects to the uncanny valley. Instead, here, I would like to maintain a focus on aesthetics and why contemporary special effects, most notably the replacement of the mechanical effects prevalent in the earlier blockbuster years of Hollywood cinema with CGI, have led to a nostalgia for, and reverence of, these older films.

The digital image itself has secured its position at the heart of contemporary filmmaking for its malleability, convenience, and cost effectiveness. But it has also attracted criticisms for being lifeless and flat. Wheeler Winston Dixon argues that, "the 'coldness' of the digital image, stripped of any of the inherent qualities of light, plastics and coloured dyes, betrays a lack of emotion, a disconnect from the real in the classical Bazinian sense" ("Vanishing Point: The Last Days of Film"). Yet Winston Dixon also argues that there is no superiority of the 35 mm filmic image over the digital, and his argument, made in 2007, was more nuanced than to simply denounce the digital image. Instead, he suggests that cinema today is a different medium from that with which he grew up. Perhaps, the differences in these two types of filmmaking, however, are less stark than most are prepared to accept. Julie Turnock, in her fine book *Plastic Reality*, offers a counter-narrative that foregrounds earlier film production ideals and techniques as foundational for the contemporary CG films of today. Linking back specifically to the development of the Hollywood blockbuster in the 1970s, Turnock argues that while many point to improvements in digital technology and image creation being aimed at generating more 'realistic' cinematic presentations, in fact this look is heavily stylized and conforms to a type of aesthetic 'realism' that itself was introduced by ILM (Industrial Light and Magic) in the 1970s. "What is important to recognize is that the powerfully photorealistic style of contemporary effects is in no way objectively more 'natural' or 'realistic' than any previous style," she suggests. It is, in fact, "a historically specific style" (3). Furthermore, she attributes this confusion directly to the role played by technological innovation in Hollywood:

> Commonsense notions of computer-generated realism tend to assume that more advanced technology means more perfect realism. What might be characterized as a stop-motion approach to photoreal special effects, an approach that courts imperfection and the simulation of chance, gives lie to that assumption. It also demonstrates how the accepted aesthetic of photorealism does not necessarily dutifully replicate what the camera sees but instead involves a strong basis in stylization and caricature. [...] This counterintuitive approach (or what might be called "not *too* realistic") forms an important cornerstone of the overall ILM aesthetic as it exists today.
> (90)

It is certainly the case that during the development of contemporary CG special effects, both CG images and camera movements were manipulated in order to mimic the more rugged and imperfect styles of older classical filmmaking. This would make particular sense in relation to inadequate CG effects for which it might also represent an attempt to mask the imperfections of cheaper effects and those achieved through a limited and still-developing technology. However, what is interesting is that even today's filmmakers, considering the vastly improved consistency and affordability of the effects at their disposal—at a time when it can cost less than twenty million dollars to make a film that looks as slick as Alex Garland's *Ex-Machina* (2015) —still often seek to make use of older forms of special effects technologies (or attempt to imitate these within a manipulated digital image).

An example of this, what I'd like to term 'fusion-effects cinema'—a technique that combines the slickness of new digital effects with a retro styling mimicking older forms of effects—can be seen in J. J. Abrams *Star Wars* reboot (2015). Abrams has seemingly delighted most fans of the franchise (no mean feat considering the high levels of expectations for anything *Star Wars* related) by maintaining continuity with the aesthetics of the original trilogy films whilst vastly updating and improving special effects sequences. Thus, many of the alien species seen in his film closely resemble the 'man-in-a-suit' appearance carried by Lucas' films, and yet this appears to sit happily alongside the more slick aesthetics of a contemporary super-budget action movie. It is interesting that Abrams also chose to use the unconventional wipes, fades, and transitions of the original trilogy as visual cues, much as he used repeated lens flares in his similarly highly rated *Star Trek* (2009) reboot in order to imply an imperfect and, therefore, retro filmmaking style. Indeed, it could be surmised that the real disappointment of the *Star Wars* prequel films, which appeared in the late 1990s and early 2000s, was exactly the failure to recognize the nostalgic appeal of the Lucas aesthetic encapsulated by the fans' ire directed toward CG character Jar Jar Binks.

The special effect is a tool that *can* be used to draw the spectator into the film, although, as Binks demonstrated, this is not always the case. Murray Pomerance makes the telling observation that "the theater space is designed and architected to disappear, to offer a tentative foreground that can be instantaneously withdrawn when the presentation begins" (*The Horse Who Drank the Sky*, 215). So the theater acts to extend the space of the screen into the real space of the spectator. Thus, whilst the comforts and convenience of home viewing may be alluring, film is still a theatrical medium that is, without doubt, more impactful when seen in its intended environment. In particular, as Grant argues, "the scopophilic pleasure of cinema is mobilised most intensely in special effects images, as viewers are swathed in their power" (22). However, Stephen

Keane highlights that, if there has been an attempt to naturalize CGI, then in large part it has failed since,

> whilst steps are often taken to try to ensure that effects sequences seem realistic and in keeping with the film's aesthetics there is commonly one of two possible responses: 'that's obviously a special effect' or 'what an amazing special effect'.
>
> (58–59)

The suggestion that effects, whether intentionally or not, announce themselves as such, implies that the mastery of special effects technology and the realism of CGI is still lacking, that the human mind cannot fully bridge the gap required for total immersion, or that there is a perceived benefit in breaking the spectator out of the immersion of the film at least temporarily enough to appreciate the artistry of the effects sequence. This third option is, perhaps, what Richard Maltby refers to when describing film's *commercial aesthetic*, which dictates that all the money should be on the screen, accounting for the increased visibility of special effects in contemporary cinema (cited in Turnock, 109).

Although not all effects draw such clear attention to themselves, often sitting comfortably within the verisimilitude of the particular genre of the film in which they appear, they are often greeted as expected and eagerly anticipated elements of the filmic production. It is, therefore, unclear whether spectacle enhances a film's immersive qualities or it hinders total immersion. Whilst it could be argued that the cinematic spectacle momentarily halts the narrative, it is also capable of stirring emotion in an audience and can hold powerful sway over an audience's experience of the film. Spectators will usually remember the special effects of a film, whether because they stood the test and were able to impress or because they failed to live up to their billing. As Carl Freedman argues, special effects tend to "overwhelm the viewer, to bathe the perceptual apparatus of the filmgoer in the very 'filmicness' of film" (cited in Grant, 21). It is this ability to 'overwhelm' that makes cinema a form of expression naturally tuned to the frequency of the sublime.

It is well documented in accounts of audience response to early films such as the Lumière Brother's 1895 *Arrival of a Train at La Ciotat* that spectators experienced a vast range of emotions from wonderment to outright terror. That cinema, in its infancy, was focused on spectacle rather than narrative has been enshrined in theory since Tom Gunning's influential designation of the work as the cinema of attractions. What was, perhaps, lost for a time in the intervening period between the birth of narrative cinema and the coming of later special effects based Hollywood blockbusters, was the very aspect that most connected cinema to its roots in the sublime: the objective of motion capture. When the train pulls into the station at La Ciotat it is exactly this *motion*

that startles its audience, and when we rightfully place cinema alongside other forms of image-based art we can see that it is preempted by much older mediums. Even before the advent of cinema, artists sought to capture the sublime through movement and dynamism. What makes, for example, Van Gough's *The Starry Night*, or a Turner seascape special or sublime if not the way it captures movement, anticipates motion and the most unpredictable form of energy? For cinema this struggle has always been technological. Motion capture is a process that is mechanical in nature, and its evolution has been entirely dependent upon the advancement of various technologies and filmmaking practices.

One such technology, designed in the 1970s specifically for George Lucas' *Star Wars* project, was motion control. As elucidated by Turnock, motion control was the first computer-controlled camera system to allow the filmmaker to recreate camera movements on a virtual level through matching sweeps. However, there was a cost attached to this method. According to Turnock,

> the technique's computerized perfection was also seen as something of a shortcoming, since it gave the camera's movement such mechanical perfection, as if shot by a robot. The effects team felt the computerized movement needed flaws added in (so as to read as more handheld).
>
> (90)

Returning, then, to Abrams' more recent *Star Wars* film, we see that this struggle is still apparent but, perhaps, for differing reasons. Whilst Lucas' film needed these flaws added, in order to seem more 'real,' Abrams' *Star Wars* intentionally uses retro-filmmaking cues despite the fact that such cues, when placed in the context of the glossy effects presented in the majority of the film, draw attention to the discord between these effects and the more contemporary CG verisimilitude in which they appear. The conclusion must be, therefore, that these effects are aimed at promoting a sense of nostalgia rather than at enhancing any objective sense of 'realism' and, thus, his film serves as a useful example of attempts to evoke such nostalgia through the sublime of special effects sequences.

In the next section, I would like to pause to consider this effect not just as relating to contemporary filmmaking practices, but as a social phenomenon that involves a nostalgic *devotion* to older types of filmmaking, specifically represented through a case study of the continuing popularity of Steven Spielberg's *Jaws* (1975)—adapted from a paper given at a recent symposium marking the fortieth anniversary of the film. It is, nonetheless, important not to see the two as entirely separate. This case study offers a chance to explore and help make sense of the decisions made by those contemporary filmmakers who return

to retro-filmmaking styles in an attempt to evoke nostalgia and to re-establish the emotional *attachment* of the spectator to the physicality and labor of filmmaking, aimed at overcoming the emotional *detachment* promoted by formless CGI.

## "Staring into those Black Eyes": *Jaws* and Nostalgia for the Mechanical Sublime

More than forty years after its initial release, Steven Spielberg's *Jaws* (1975) offers a nostalgic fantasy, returning to a period we might best categorize through Walter Benjamin's 1936 treatise on 'the Work of Art in the Age of its Technological Reproducibility' or through the ascension of what David Nye (1994) has termed the 'American Technological Sublime.' Benjamin writes of the religious fervor behind the celebration of traditional works of art, suggesting that "technological reproducibility emancipates the work of art from its parasitic subservience to ritual" (24). For Benjamin, then, the fact that the age of technological reproducibility has eradicated the artwork's 'aura' liberates it from an overzealous form of worship. What I would like to suggest, here, is a link between this very same kind of worship and *Jaws*, manifested specifically in the contemporary spectator's identification with the film's mechanical antagonist. Although, in theory, Benjamin's work speaks of mechanical reproduction, of which the *Jaws* shark (Bruce) must surely be an example, what I wish to propose is that we feel the same nostalgia (that Benjamin argues was once held for the aura of an authentic work of art) toward the somewhat hokey *Jaws* shark *because*, rather than in spite of, the fact it is a mechanical reproduction of nature. Cinematic technology has, since its beginnings, been the showcase for technological advancement with the 1960s and '70s, in particular, representing a golden period for films that echoed the replacement of the natural with the mechanical. Films such as *2001: A Space Odyssey* (1968), *Star Wars* (1977), *Close Encounters* (1977), and *Jaws* itself actively sought to demonstrate just how far such technology had come. The replacement of the mechanical with the digital, as glimpsed through the similarly nautical-themed James Cameron epics *The Abyss* (1989) and *Titanic* (1997), encourages the continued enjoyment of *Jaws* at least in part because the film offers us a nostalgic trip back to a time in which human technological progress was measurable by the largeness of our machines rather than their miniaturization and invisibility. Thus, the nostalgic appeal of *Jaws* is driven as much by the film's narrative—encapsulating a period of replacement of the natural by the mechanical, alongside the film's timing immediately prior to the transformation toward a more abstract and virtual technological visual economy—as it is any aesthetic advantage of physical special effects over the digital.

*Jaws*, alongside many other films in its celebrated era, is often referred to nostalgically in connection with the big summer blockbuster these films,

in particular, helped to establish. But just what is it about the films of the 1970s that cause cinephiles to go weak at the knees? Whilst it is not the only aspect for which the films are admired, their bombastic use of technology to create spectacular visual effects can never be fully disassociated from this nostalgic appeal. In order to get to the core of *Jaws*' continued popularity, then, we ought to consider the film in terms of its aesthetics and how the technology involved in the production of these aesthetics has come to say something definitive about the period as a whole. David Nye's application of the sublime to technology, to articulate the dominance of technological development over the landscape of the 20th century American imagination, is particularly useful here. Somewhat like Benjamin's description of the "aura" of a work of art, Nye refers to the sublime as "an essentially religious feeling," which "can weld society together" (xiii). Furthermore, the shift of the sublime from its traditional association with natural vistas such as mountains, oceans, and storms toward technological constructions such as bridges, skyscrapers, and the bomb suggests that what is at stake during this period is a sense of human mastery over nature. In essence, what we could suggest here is that the technological sublime's 'religious feeling' can be seen to coincide with a period of increasing secularization in which the advancements of such technology encouraged humanism and a reverence for human potential that was only just beginning to be tapped.

For Nye, the technological sublime separates "those who understand and control machines [from] those who do not" since it is a "sublime made possible by the superior imagination of an engineer or a technician, who creates an object that overwhelms the imagination of ordinary men" (60). Ultimately, however, what most impresses about technological constructs is not just the imagination of the designer or engineer, or simply their scale in comparison to the individual; it is also the work evident in their production. What strikes us as sublime when we contemplate a skyscraper is its sheer overwhelming size, yes, but also the building process itself that contributes to the transcendence of the technological sublime over the natural. This, however, when considered alongside cinematic innovation presents a less straightforward example. Sherryl Vint and Mark Bould determine that, "Nye's account [emphasizes that] the rise of the technological sublime" is predicated on "the continual erasure of labour from the public display and experience of technology, which is increasingly presented as if its capacities and effects spring from it alone" (273). Going further, they argue that

> [films which rely on CGI] also appear to create their own effects, without the intervention of human hands. Thus CGI is the perfection of the technological sublime, seeming solely to be the creation of computer programs, obscuring the human labour, such as coding, actually involved.
>
> (273–274)

But, if cinematic history since the Cinema of Attractions (which according to Gunning dissipated around 1907) has been a journey toward effects becoming increasingly *in*visible, not in terms of their on-screen impact but in terms of the lines of their labor or manufacture, and CGI represents the "perfection of the technological sublime," then why does the use of CGI still generate such high levels of debate, and why is it that films such as *Jaws* are still able to offer such entertainment and sublimity, providing a strong sense of nostalgia and fascination? Can it simply be that the film reinforces our own inflated sense of progress, or has the sublime, in fact, been reconfigured with the estrangement of CGI from its labor? Can the sublime be recaptured through our watching of *Jaws*, a film that makes such labor awkwardly visible in its effects?

Debates surrounding the effectiveness of CGI will likely persist. Simply put, when spectators know that what they are seeing on screen has no physical form, it is more difficult to suspend disbelief no matter how expert and accurate a rendering is achieved. We need only cite the fans' disgust at Spielberg's use of CGI in *Indiana Jones and the Kingdom of the Crystal Skull* (2008) or the vociferous reaction to the CG character Jar Jar Binks in the *Star Wars* prequels (1999, 2002, 2005) by way of illustration. In an interview on BBC Breakfast in 2012, Spielberg himself stated that he would probably use CGI if he were filming *Jaws* today, but he also admitted that audiences will always be able to tell the difference between the physical and the computer generated, saying

> The second you see a million soldiers charging, you know no-one hired a million soldiers charging any place in the world, and you know that it's artificial. [...] I think one of the reasons *Jaws* was so effective was it was authentic.
>
> (Nissim and Goodacre)

We can also see the flip side of this, evidenced in the critical acclaim received by George Miller's *Mad Max: Fury Road* (2015), which was lauded for its 'authentic' stunts rather than CG effects. Finally, and perhaps in a more abstract sense, it is also evident in that popular saying "they don't make them like they used to," which is interesting in as much as it emphasizes the act of creation rather than necessarily the quality of the outcome itself. The difficulties of *making Jaws*, of course, and in particular its infamous villain, are well documented; thus, it has become an even more attractive target for such a nostalgia that relies upon the visibility of the labor of the artist, in this case the mechanical effects team supervised by Bob Mattey.

To refer back to Benjamin, it may be that the replacement of the mechanical by the digital has instigated a nostalgia for the mechanical because of its apparent originality in the face of the digital's overwhelming capacity for infinite reproducibility without any clearly visible lines of

labor. In comparison to CG sharks seen in films such as *Deep Blue Sea* (1999) or comedy/b-movie spoofs like *Mega Shark vs. Giant Octopus* (2009) and *Sharknado* (2013), Bruce appears unique and, thus, subsequently acquires the 'aura' of the original. Vivian Sobchack argues in her article "Sci-Why? On the Decline of a Film Genre in an Age of Technological Wizardry" that science fiction cinema no longer appears to be at the forefront of technological spectacle innovation as a "result of the exponential increase in the use of CGI cinematic and televisual effects and their diffusion across a variety of genres." She continues, "'Special effects' have become naturalized and are no longer quite so special" (284). She even makes use of Benjamin's key term, stating that "sf spectacles have lost much of their aura," citing *Avatar* (2009) and *Gravity* (2013) as notable exceptions (284). Perhaps it is not that Bruce is really any more than a mechanical reproduction but that, in comparison to the infinite simulation produced by contemporary CG films, the shark comes to take on the properties of the original, since CGI appears only to offer infinite homogenization the likes of which we see in the famous *Matrix Reloaded* (2003) scene in which Neo fights the multitude of Agent Smiths. We could recall, here, Baudrillard's influential treatise on the image in "Simulacra and Simulations" in which he highlights that philosophy has always been concerned with "the murderous power of images," (173) by which he is referring to the idea that the image does not simply represent the 'real' but that it violently empties and replaces it. Interestingly, Baudrillard also links this to a kind of nostalgia for the 'real,' stating that "when the real is no longer what it used to be, nostalgia assumes its full meaning. There is a proliferation of myths of origin and signs of reality; of second-hand truth, objectivity and authenticity" (171). Since *Jaws* is the defining shark attack film, on some level at least, it is possible to see later CG sharks as images of Bruce, a copy of a copy the likes of which would leave Plato, who famously distrusted art and poetry because of their mimetic nature, particularly suspicious. We might also note that Bruce's uniqueness, in comparison to later CG sharks, is only enhanced by its naming, which confers a single coherent identity on the shark despite the reality that *Jaws* was, in fact, filmed using three different mechanical models.

Whilst Scott Bukatman claims in *Matters of Gravity* that the spectator of science fiction films clearly experiences "pleasure [...] derived from responding to these entertainments as if they were real" (81), it could be argued that the pleasure in watching *Jaws* is brought about through the understanding that what we see on screen falls somewhat short of our expectations of reality, something played out in the narrative when two children are caught with a cardboard fin pretending to be the shark in order to scare tourists from the water. However, in doing so, the film highlights the work of the artists whose struggles are made visible, thus allowing spectators to celebrate what is now often interpreted as a

romantic past attachment to physical effects. In some way, in fact, Bruce is made to seem all the more real by the knowledge of the difficulties suffered shooting the film and the inadequacies of the physical model.

If we wish to further consider *Jaws'* relationship to the spectator in an age consumed by what Vincent Mosco calls the 'digital sublime,' we can do so by analyzing its plot. *Jaws*, after-all, also figures these ideas of technological evolution, struggle, and progress on the level of narrative. As the three central characters, Brody, Hooper, and Quint, attempt to get the better of Bruce, the film represents the clash between nature and technology. The stand-off between the highly educated marine scientist, Hooper—with his extravagant, futuristic, and mystical gear—and the old-fashioned, technophobic fisherman, Quint, ends in Hooper's redemption and Quint's demise. On a symbolic level, then, Hooper's victory suggests a shift away from the natural toward the mechanical. Whilst on the surface this is a film in which nature in large part bares its terrible teeth, this is a nature that is not only, as we have already seen, constructed through mechanical technology, but is also eventually defeated through that same technology. And, as if we had not already grasped the significance of the explosive finale in which Brody shoots a canister lodged in the beast's jaws, detonating it and blowing the shark into smithereens, we even have this preempted in the film's dialogue as Quint recalls his experiences of delivering the Hiroshima bomb. Perhaps the most telling aspect of Quint's speech is just how wrong he gets it. If we see Quint's death in the jaws of a (mechanical) shark as a sign of the replacement of the old guard, who still cling to the primacy of the natural over the technological, by the power of a new generation of the technologically gifted, then we also see a horrific lopsidedness in his account of the mission aboard the USS *Indianapolis*, in which his focus on the deaths of the rest of his crew taken by sharks glosses over, in mysterious silence, the deaths of well over 100,000 Japanese men, women, and children in the most destructive use of technology in human history.

Spencer Weart asserts, as cited by Nye, that the Atomic bombings of both Hiroshima and Nagasaki "seemed less like a military action than a rupture of the very order of nature" (Nye, 232). It is telling, then, that *Jaws* refers so explicitly to this moment since "Atomic power reaffirmed man's control over nature" (Nye, 235). Just as the shark is blown up, sparing the two characters we most associate with a technological future, the natural sublime too is in this same moment viscerally shredded by the power of the bomb. This is a moment that makes the appreciation of the classical sublime defunct. For Gene Ray, "After Auschwitz and Hiroshima [...] human-inflicted disaster will remain more threatening, more sublime, than any natural disaster" (*Terror and the Sublime*, 19) and, as Nye suggests,

> At the deepest level, the existence of atomic weapons has undermined the possibility of the sublime relationship to both natural and

technological objects. The experience of the natural sublime rests both on the sense of human weakness and limitation and on the power of human reason to comprehend the infinitely large and powerful. But when human beings themselves create something infinitely powerful that can annihilate nature, the exaltation of the classic sublime seems impossible.

(255)

Just as Brody begins his journey by researching scientific books about sharks in order to attempt to better understand his foe (notably he struggles with this, implying the primacy of the natural sublime, which goes beyond the limit of human comprehension), Quint shares a similar inability to comprehend Hooper's technology. As Bukatman suggests, when citing Douglas Trumbull's effects sequences in *2001*, *Close Encounters*, *Star Trek* (1979), and *Blade Runner* (1982), "it is technology that inspires the sensations characteristic of sublimity; therefore, it is technology that alludes to the limits of human definition and comprehension" (82). Ultimately, what we see in Bruce's spectacular end, then, is no less than the annihilation of the natural sublime by the technological.

Never does the mechanical shark seem more alive than in its moment of destruction, as it sprays its lifeblood over an ecstatic Brody. In his lengthy speech about the shark attack that wiped out over half the crew of the *Indianapolis*, Quint says "the thing about the shark is it's got lifeless eyes, black eyes, like a doll's eyes. When he comes at you, he doesn't seem to be living, until he bites you, and those black eyes roll over white." In this way, the mechanical shark strikes the perfect balance. The machine, like the doll Quint references, stands as a mystical being. The enduring appeal of science fiction narratives concerning artificial intelligence, or horror narratives about the living doll, is testament to the long-standing belief that our machines are inhabited by a soul or a spirit. We might see something of Freud's 'uncanny' alive and well in the body of this mechanical shark as it drags its victim, kicking and screaming, in its eager jaws. In this way, the machine appears to us to be more alive than any computer generated image, especially when placed in the context of a narrative that concerns itself with the power of technology, a narrative that revels in the brilliance and the flaws of its mechanical star. Thus, when we return to a film like *Jaws* it is the feat of engineering that astounds, an appreciation for the work of the effects team, who had to struggle to build something physical, something real. But most of all, we finish the film with an appreciation for the role that such machines have played in the development of recent human history, machines that seem to bring the screen to life in ways rarely seen in today's world of ephemeral and lifeless CGI. *Jaws*' enduring appeal is forged through its intimate connection to a moment in human history celebrating the ascension of the machine, and the accomplishments of those who build

them, and as we move further into the abstracted technological advances of the future, destined to change the face of cinematic entertainment still further, we look back with nostalgia at a film that made it all possible.

Yet, ultimately, this nostalgia is debilitating and masks the digital mastery experts in the film industry have come to wield with contemporary digital effects. As Spielberg himself suggests, if he were to make *Jaws* today, he would use CGI. Is this simply because the expectation levels of spectators for contemporary Hollywood film have changed so much? The fresh enjoyment of mechanical-based effects films would suggest not. Is it simply naivety on the part of filmmakers who are so deeply engrained in the ways of their craft—traditionally a kind of technological arms race—that they cannot see the authenticity that spectators seem to crave? Again, I would suggest not, since the film industry is ultimately driven by profit. It is simply because CGI is inherently less flawed and allows for a much greater manipulation of the image than physical effects. It is, at least in part, the sanctity of the original that is responsible for this nostalgia, and even as far back as 1936, Benjamin was warning us of the dangers of the reverence of the original. His account of the 'aura' is often mistaken for a bemoaning of its loss when, in fact, Benjamin celebrates the technological future to come and the liberation attached with freeing ourselves from the binds of the original as a privileged site. Thus, the nostalgia we may feel for our favorite old films and for their hokey special effects should not be taken as a call to retreat backward into film history—bringing back mechanical models, actors in suits, and even stop-motion. We should not, as critics, complain of new films that they are less crafted or lazily produced. Nor should we yearn for the days when mechanical sharks actually needed to be built. Instead, we should appreciate the old alongside the new and revel in the progress made by digital special effects. While contemporary effects-based films may not always get it right, we should try to recognize that when looking back we tend only to focus on the masterpieces of respective eras with the rose-tinted glasses of a nostalgia for the visible work and struggle associated with cinema of an earlier time.

# Conclusion
## "Show Me the Way to Go Home":
## Sublime Apathy and Nostalgia

"Show me the way to go home," sing Brody, Quint, and Hooper, our unlikely band of heroes in *Jaws*. "I'm tired and I want to go to bed." The song that brings them together, a 1925 Irving King hit; their nostalgia, the culmination of a night of drunken revelry in preparation for their final showdown with death. Staring quite literally into the jaws of defeat, somehow Brody and Hooper find the last ounce of strength to keep fighting and are able to face down terror, emerging glorious in victory. In the final shot of *Jaws,* we see the infinite expanse of the ocean and ponder what demons still lurk below its churning surface. We know that the end is yet to come, that the battle that has been won here is likely only the first of many. And yet there is a hopefulness in this; having faced their fears and triumphed, who is to say that such an open horizon is not Brody and Hooper's as well? While the party sings of home and their tiredness, they do not succumb to the warm embrace of its nostalgia. It is in their small, yet significant, victory over the monster of the deep that a new future is born. But if the nostalgic lure of "Show Me the Way to Go Home" is appropriate to any era, it is our own. In the opening scene of Alexandre Aja's *Piranha 3D* (2010), Richard Dreyfus, reprising his role as a now aging and vaguely incompetent drunk Hooper, meets his grizzly, visceral, and overly CG demise at the hands (or rather teeth) of piranhas. As the camera tracks in on Hooper's small fishing boat, we hear his gentle crooning of that very same song, and to some extent it is to home that he returns as his eviscerated corpse sinks to the depths he seemed to claim as his own in Spielberg's iconic movie. There is no victory here. Hooper is a relic celebrated but not mourned in this bloodbath; his significance as a figure of hope drained dismissively, hollowed out to make way for the emptiness of a CG future destined to recreate the past in pixels.

"Show me the way to go home. I'm tired and I want to go to bed." If anything can underscore the sense of nostalgic apathy operating within today's culture it is, surely, these two lines. The continual desire to return home to a mythical past is debilitating. "Yes we can!" chanted former President Barack Obama's starry-eyed supporters on the evening of his electoral victory back in 2008. "Change we can believe in" read

the slogan that swept him to power, a shallow optimism that evaporated within months of his inauguration and now a painful reminder of the inadequacies of the political system of today's superpower; a system built to resist change at any level. Was not the same nostalgia evident in Donald Trump's nomination and electoral run slogan "Make America Great Again"? If Obama couldn't turn the ship in a new direction then what hope can his successor have? Set against the backdrop of divide and conquer politics, inwardness, and conservativism, the melancholic sublime and the nostalgia it produces has become particularly significant. A healthy respect for history is the bedrock of social change and progress, but by locating the answers to all our problems in the past, we cripple our imaginations and our capacity for change. The melancholic sublime pacifies us in the face of the overwhelming magnitude of today's geopolitical landscape, stacking our problems up for future generations, and nostalgia simplifies politics. Let's take today's television, for example.

Over the last few years, there has been a trend toward Cold War nostalgia in television series. 1960s, '70s, and '80s in America are the locations in which television's time machines have often landed. But what is the purpose of the Cold War as a political framework? It is a nostalgic simplification of geopolitics and power. In the Cold War, there were good guys and there were bad guys. There was capitalist *free*-enterprise, and there was the 'Red Menace,' Reagan's "Evil Empire." This is the world that George W. Bush and his counterparts, like Tony Blair, attempted to return us to after September 11, 2001. In his address to the nation following the attacks, Bush used the term "evil" to describe the perpetrators no less than four times in as many minutes. As Richard Bernstein highlights in his timely book *The Abuse of Evil*,

> overnight (literally) our politicians and the media were broadcasting about evil. We were flooded with headlines about evil and images displaying evil [...]. Suddenly the world was divided in a simple (and simplistic) duality – the evil ones seeking to destroy us and those committed to the war against evil.
>
> (10)

The return to Cold War narratives in a world in which terrorism is reduced in such a way, a way that drastically oversimplifies the complex political and socioeconomic climate in which terrorism is fostered, is indicative of a culture trying to make sense of such a duality and how it can possibly apply to today's globalized malaise. "What is disturbing," continues Bernstein, "about the post-9/11 evil talk is its rigidity and popular appeal. Few stop to ask what we really mean by evil" (10). The term is so emotive that it effaces debate, "it is an abuse because, instead of inviting us to question and to *think*, this talk of evil is being used to stifle *thinking*" (11).

On some level, today's Cold War television series—*The Americans* (first season in 2013), *The Man in the High Castle* (2015), and *Deutschland 83* (A German language series originally made for an American audience in 2015)—seem to place the viewer in the uncomfortable position of having to relate to the *other* side. In *The Americans*, we follow the lives of two deep-cover KGB spies who have infiltrated America in the 1970s and '80s. *The Man in the High Castle* imagines an alternative history in which the Nazis *win* World War II, with the action taking place in an occupied America in the 1960s. Here, while generally it is the resistance we follow, at a number of points during the narrative the spectator is asked to sympathize with Nazi characters. And in *Deutschland 83* our protagonist is East German Soviet spy Martin Rauch. While this would seem to challenge the idea that the Cold War functions as a nostalgic means to simplify politics, reducing conflict to the level of grand narrative, good versus evil, even a brief analysis of the content of these shows serves to demonstrate that they are far less radical than they appear on the surface. In fact, not one of *The Americans*, *The Man in the High Castle*, or *Deutschland 83* is effectively able to question the complexity of the ideological positions held by their characters or even audience. At best, the viewer is asked to understand the principles of serving your country at any cost and very little attempt, if any, is made to critique U.S. free-market capitalism. All three shows provide a distinctly American perspective, even if otherwise packaged, and assume the superiority of the American 'model.'

Some examples demonstrate how the television shows discussed here choose to value and reinforce American ideological assumptions from positions that should naturally oppose them. In *The Americans*, we are told that the two deep-cover KGB agents, identified by their American names Elizabeth and Philip Jennings (played by an American actress and a Welsh actor, respectively) and who operate as a rather traditional nuclear family with their two children Henry and Paige, are so highly trained that they appear to everyone as wholehearted American capitalists. While both Russian born, they moved to America in the 1960s and began working together as a couple at a travel agency. As befitting their financial security and middle-class American life style, they own a rather nice property in a quiet and idyllic suburban neighborhood of Washington DC. This is not only appearance, however, as in the show's pilot Philip actually decides that he'd rather work for the Americans and threatens to play turncoat, establishing a tension that will run throughout the series. Philip recognizes that his life in America is better than any he could have back in mother Russia and argues with Elizabeth about the merits of making a deal with the CIA. For all intents and purposes, Philip not only acts American, but he feels American too.

Although not technically set in the Cold War, since *The Man in the High Castle*—based on the 1962 Philip K. Dick alternative history

novel—imagines a past in which the Nazi-Japanese alliance won the second World War, the television show's narrative follows the escalation of an arms race between the Japanese Empire and Nazi Reich in which development of the Heisenberg Device (effectively a nuclear weapon that will tip the balance of power in favor of the Germans) is at the center of a conflict brewing behind the scenes. In essence the show, set in a retrofuture 1960s America, reconfigures the Cold War transposing Americans and Soviets for Japanese and Nazi cultural forces. Like *The Americans*, the series encourages spectators to identify with a range of different characters on either side of the battle. In so doing, it at least accepts the complex morality of the decisions those living under occupation must make. The problem is that, in its premise, it makes the automatic assumption that American capitalism and democracy are superior to any alternative. The past as it was is therefore valorized by the show and, thus, nostalgia and celebration are the underlying sentiments of *The Man in the High Castle*'s attempts to rewrite history. Instead of liberating us from the past, this rewriting of history seems only to allow a glimpse of the nightmares that could have befallen us, binding us closer to our own historical narrative.

Anna and Jörg Winger's *Deutschland 83* offers a final example. In the show, Martin Rauch is forced into spying on his West Berlin military counterparts and becomes embroiled in a set of tense scenarios and miscommunications that bring the competing American and Soviet superpowers to the brink of nuclear war. Martin is, in many ways, a sympathetic lead. Used as a pawn by various members of the East German spy network, including his Aunt Lenora, he is, at point of contact, drugged and kidnapped before becoming a reluctant spy posted in the West Berlin military barracks as an aide to General Wolfgang Edel. While in one early scene the General, during a reflective moment at a house party, turns to the protagonist and says "From 3,500 miles away it's easy for Reagan to call the Soviet Union the evil empire. The SS-20s won't be hitting his house," to which Martin responds, "They'll be hitting yours though"; more generally, the show *celebrates* American consumer culture. On duty in West Berlin, Martin discovers the relative luxury of the West versus the East. In fact, in an early scene, the protagonist is made to dress in a new pair of jeans in order to blend in. The jeans, a symbol of American influence, were a high-value commodity item in the Soviet Union with genuine denim pairs expensive, hard to come by, and often obtained through illegal trafficking. In another scene, as Martin is being assimilated into Western culture the audience is confronted with a series of images that contrast the availability of items in the two halves of the divided city. On the left of the screen, we see recognizable and Americanized cultural products, all of which are in some way superior to their East German equivalents on the right. First, we see a two-in-one hair product played against two cheaper looking

sprays; then some washing powder—not only is the packaging of the West Berlin powder more attractive, it also goes to 95 degrees rather than 90 and is suitable for colors as well as whites. Another shot shows water and a kind of orangeade contrasted with a bottle of Pepsi and a can of Fanta; the final comedic flourish reveals the lack of fresh fruit in East Berlin with bananas and an orange pictured on one side of the screen and an empty desk on the other.

In another episode, Martin goes to some lengths to buy a Walkman, a symbol of Western freedom and affluence. The first Sony Walkman went on sale in 1979 and by '83 they were still prominent items on the tech scene. For Martin, this is an important moment. Clearly the first time he has seen such equipment, the look of pleasure and astonishment on his face as he listens to a track signifies the moment as *liberating*. What is more, the series delights in putting 1980s pop music at its center. Notable tracks include Phil Collins' "In the Air Tonight," "Blue Monday," a track by New Order, The Eurythmics' "Sweet Dreams (Are Made of this)" and Nena's "Neunundneunzig Luftballons" (also known by its English translation "99 Red Balloons"—although it's worth highlighting that the German language version of the song topped the charts in America). This music serves to highlight an underlying Western cultural dominance. Indeed, by telling the story through 1980s music, *Deutschland 83* recreates the 'feeling' of the 1980s as glamorous without complicating this sensation with any acknowledgments of the hardships of the period that are, instead, papered over through the cultural excitement of Martin's stay in the West. By comparison, back home in East Berlin enjoying culture is much more dangerous. One plot line involves the questioning of Martin's girlfriend and mother over their involvement in an underground collection of banned books including a copy of Orwell's *1984*. Finally, and crucially, while Martin remains loyal to the East, and it is clear that both sides fear the escalation of the arms race and the possibility of nuclear conflict, it is the manipulations of evidence by one particular member of the *East* German establishment that brings the two nations to within minutes of an annihilation Martin must ultimately prevent.

A notable mention should also go to two 'Netflix exclusive' shows that evoked the Cold War: *House of Cards* (2013- )—which saw Season Three introduce a Putin-like Russian president, Viktor Petrov, as a key character, and spent much of the season exploring the frosty relationship between the American and Russian politicians—and Guillermo del Toro-esque sci-fi horror *Stranger Things* (2016)—another show set in the 1980s that seems fascinated with Cold War technology. But while the examples used so far have all been televisual, this nostalgia for the Cold War does not begin and end with culture but rather seems to have real political resonance. Cold War rhetoric has bled into national political debate. For example, Mitchell argues that whereas before his election

in 2008 the right had emphasized former President Obama's ethnic *difference* "since the election the tactic has shifted to Cold War imagery, and Obama is now routinely portrayed as a socialist or communist" (8). On the international scale, over the last few years, the increasing tensions between the U.S. and Russia, an idea that seemed virtually impossible at the beginning of the 21st century, has reached worrying levels with talk of a new Cold War now commonplace. What began with Putin's invasion of Georgia in 2008 has seen a number of recent flashpoints from the coup in Crimea and violence in the Ukraine beginning in 2014, the downing of flight MH17, to Russia's continuing involvement in Syria despite both sides insisting that they have the same goal (the defeat of Islamic State). The war of words itself has been central to this, culminating in Russian Prime Minister Dimitri Medvedev's statement at the Munich Security Conference in 2016 that, "we are rapidly rolling into a period of a new Cold War." In a rather bizarre turn, Medvedev continued by stating that, "I am sometimes confused. Is this 2016 or 1962?" Considering the prime minister was not born until 1965, the comment seems particularly resonant of a nostalgia stretching beyond personal memory.

What, then, can we make of the controversy surrounding the possible involvement of the Russian government in the 2016 presidential election? It is difficult to tell whether this represents the 'ramping up' or the 'winding down' of tensions with Russia without being able to predict the outcome of Trump's extremely unpredictable presidency. What Mitchum Huehls shows, however, is precisely why a return to Cold War rhetoric seems out of date today. For Huehls, the Cold War era was fundamentally different from the War on Terror because it "sought to control territory (Berlin, Korea, Cuba, Vietnam, Central America, and even outer space)" through the "spatial metaphors of dominoes, walls, and curtains" whereas the "'war on terror' needs to control time" (46). Huehls, therefore, makes *pre-emption* the defining feature of the War on Terror "from the war against Iraq to curtailing civil liberties under the Patriot Act and detaining 'enemy combatants' at Guantanamo Bay without due process" (46). The change in emphasis from space to time was not just appropriate because of the differences between the two enemies (terrorists accountable to no state compared with a clearly marked Russian aggressor seeking to control countries within spheres of influence) but also because of the nature and packaging of a war on 'terror,' the very concept of which determines it as an endless and unwinnable war. The nostalgia for the Cold War is not simply predicated on the war's reduction of the complexities of moral values and ideological positions, then; it is also about the solidity of borders and territorial boundaries: it is a rejection of the integration of the world under globalization.

It is no coincidence, then, that the central planks upon which Trump ran for the Republican Party nomination in 2016, and later the presidency—the

notion that America could build a wall between its southern states and Mexico, and the threat to ban Muslims from entering the U.S.—also articulate this nostalgia for nationalism and solidity in the face of a growing wave of multiculturalism and fluidity of movement, identity, and their relational constructs. Similarly, Britain's exit from the EU came on the back of a debate fought along these same political lines and a nostalgic yearning, by large swathes of the nation, for a *Great* Britain of past eras. Many, in fact, argued that Europe was holding Britain back. What became known as "Brexit"—led by a group EU Commission President Jean-Claude Juncker aptly described as "retro nationalists"—was fueled by a similar anti-immigration, anti-globalist nostalgia. Indeed, one high-profile Brexit advocate, Michael Gove MP, summed up the mood of many in the country with his response when confronted in an interview with the long list of authorities who opposed leaving the EU. "I think people in this country have had enough of experts," argued the former Education and Justice Secretary. It is, perhaps, this sentiment that is behind the recent popularity of right-wing conservatism in both the U.S. and Europe. Indeed, with the Brexit campaigners winning out, their dream of restoring Britain to times gone by was literalized. Britain really did take a trip back to the past when, with the results of the vote rolling in, the value of the pound plummeted to its record low since 1985.

This "retro-nationalism" is dangerous, however, and politically misguided. We do not live—thankfully—at the highpoint of the British Empire. Nor is it possible to turn back the tide of globalization even if such an outcome were desirable. The world and its hierarchies work in fundamentally different and more complex ways. Interdependence and interconnectivity mean that nations, no matter how wealthy, simply cannot ignore global ramifications. Isolationism cannot possibly work when Western powers and affluence are so heavily dependent on cheap foreign imports, labor, and exploitation. As Arjun Appadurai neatly puts it, "the new global cultural economy has to be seen as a complex, overlapping, disjunctive order that cannot any longer be understood in terms of existing centerperiphery models" (29). Hence, the binary relationships of East and West that existed during the Cold War are no longer valid with internal stratification intensified by globalization. Even space does not operate in the same manner. The authority of maps as indicators of territory, collective cultures, and definitive nationalities has been under threat from aggressive agents who do not recognize borders (including the Islamic State group who uploaded a YouTube video in which they effectively announced the end of the Sykes-Picot line drawn up in 1916 that divides Iraq and Syria), migration flows as a result of the geopolitical forces and pressures associated with globalization (the European migration crisis) and the increasing impact of virtual spaces.

Just as national and territorial identity is constructed, so, too, is the past to which our political leadership seeks a return. The underlying

principle is that beneath all this confusion lies a 'natural' state, but this is a dangerous way of thinking. Timothy Morton, in *Ecology without Nature*, suggests that, "the idea of nature is getting in the way of properly ecological forms of culture, philosophy, politics, and art" (1). For Morton "putting something called Nature on a pedestal and admiring it from afar [...] is a paradoxical act of sadistic admiration" (5). Nature is simply a nostalgic construct, a state to which we appeal when confusion reigns. In *Living in the End Times* Slavoj Žižek highlights the utopian qualities of animal documentaries. For Žižek,

> we can [...] explain why we obviously find it so pleasurable to watch endless animal documentaries on specialized channels (*Nature*, *Animal Kingdom*, *National Geographic*): they provide a glimpse into a utopian world where no language or training are needed, in other words, into a "harmonious society" (as they put it today in China) in which everyone spontaneously knows his or her role.
>
> (83)

Is this not a simplifying effect similar to the one expressed in the nostalgic political rhetoric of today? The nostalgia for simple solutions to complex problems is both a reaction to this fragmentation and rendered simultaneously powerless in its face. We live in a world in which mega-corporations often appear more powerful than governments, in which a foreign policy initiative to provide citizens with access to the Internet might be as effective in toppling dictatorial powers as military intervention, and in which nomadic cyber criminals can target countries from their basements half the world away. In this environment, nostalgic politics offers people solutions they can understand. That these solutions are destined to fail seems to make little difference. And thus, we have entered the age of 'post-truth' politics in which the simpler (and dumber) the solution (building a wall, banning all people of one religion, leaving the EU), the louder the cheers.

So where does this leave us, and how can we move beyond the pull of nostalgic politics? First, we must begin to recognize it when we see it, and we must also attempt to understand its origins. The success of 'dumb and dumber' politics does not, as it might seem, imply a dumb and dumber public. Rather, today many voters are simply under the thrall of the melancholic sublime. On some level, there are distinct similarities between the effect of this and what Bruce Robbins termed 'the sweatshop sublime.' For Robbins, what was most important about the sublime we experience when confronted with the overwhelming intricacies of the global was not the feeling itself but the resultant passivity and helplessness. Robbins states that,

> to contemplate one's kettle and suddenly realize, first, that one is the beneficiary of an unimaginably vast and complex social whole

and, second [...] that this means benefiting from the daily labor of the kettle-and electricity-producing workers, much of it unpleasant and underremunerated, is not entirely outside everyday experience. What seems special about [this] is a third realization: that this moment of consciousness will not be converted into action.

(84)

Instead, Robbins worries that any action generated by the sweatshop sublime is precisely the wrong type of action, tending to favor right-wing politicians. This can be seen in the recent surge in anti-politics/anti-establishment voting in America and the European Union nations. During the first televised debate in the run up to the 2016 Presidential election Hillary Clinton described Trump's economic policies as "Trumped up trickle down," but Trump himself actually boasted about his tax cut, saying that it would be the largest since Ronald Reagan's in the early 1980s—conveniently glossing over the abject failure of Reaganomics, or neo-liberal trickle-down economics, for the middle-classes as crystalized with the later policies of George Bush Jr. and the 2008 financial crisis. But why is it nearly always the Right that wins out in these cases? Socialist and liberal agendas should be the traditional paths for anti-establishment voting, but these causes seem to have benefited relatively little from the phenomenon. Trump's confidence in his own economic policies is what appeared to override the more obvious flaws in their content since, in an era in which the global landscape confounds us in its sublime complexity, many voters are happy to latch on to any politician who exudes personality and passion and offers simple solutions.

Another possible reason for the comparative weakness of the Left today could be the effects of 'slacktivism'/'clicktivism' on the potency of left-wing political movements, particularly for younger generations. 'Slacktivism,' or "[...] feel-good online activism that has zero political or social impact [and which] gives those who participate in 'slacktivist campaigns' an illusion of having a meaningful impact on the world without demanding anything more than joining a Facebook group" (Morozov, 2009), is, according to Jocelyn Brewer, "the lowest common denominator in terms of action." "The challenge," she writes, "is to get people to step up beyond a simple 'like' and turn that into something more substantial" (quoted in Ayoub). Additionally, this new economy of protest represents what Micah White calls "the marketisation of social change" as charities and other causes often analyze meta-data with the aim of achieving maximum coverage. While exposure is important for these campaigns, a devotion to it often favors superficial engagement because this is easier to track through social media. White suggests that "the exclusive emphasis on metrics results in a race to the bottom of political engagement." While the general effectiveness of online petitions and campaigns is difficult to measure, and there are certainly some overt

benefits to the way in which people have used the Internet to garner support and awareness for, and of, various causes, 'slacktivism' has also produced a cacophony of voices all competing for the limited attention of a specific type of online user. This is a dilution rather than an intensification of political momentum in favor of the Left.

On the Right, however, Robbins, writing in 2002 before the huge growth in online political activity, notes that the common reaction to the sweatshop sublime is misguided, tending toward a nationalistic desire to relocate labor within our borders rather than to address the appalling conditions of those who work out of sweatshops in foreign countries (ultimately workers being exploited by Western companies for their own—and our—profits). Hence, the commandment to *buy* American, or *buy* British, even as the two formerly industrial power-houses continue to produce fewer and fewer of their own commodities, is the manifestation of our distaste for foreign labor. This is, at least in part, the "irremediable tyranny of the close over the distant" (86). Thus, while the sweatshop sublime may temporarily engulf us as we consider the plight of the poor worker who must slave over our T-shirts so that we can enjoy the prices to which we have become accustomed, we are subsequently squeezed out of action by both the seeming impossibility of our own intervention and by the pressing closeness of our existence. The problem is that this, of course, does nothing to improve the conditions of those working in factories overseas.

While this may be true of the sweatshop sublime, the opposite seems to be the case with the melancholic sublime. After all, the yearning for the past is surely about selecting the distant over the close, choosing to defer action not because of the pressing weight of immediacy but rather because of the very desire to defer the present itself in the preference of dwelling in that past. This nostalgia stretches beyond our consumption of cultural texts. There has, for example, been a renewed interest in retro-technology through increased sales of instant polaroid cameras, oversized headphones, 1990s-style Cassio wristwatches, and chunky Vinyl LPs. Phones are getting larger again too (although they admittedly have so many functions now that they basically run our lives). Is it not also the case that living out our lives online promotes nostalgia? Social media actively endorses the reliving of past memories and histories meaning that our lives can be consumed as a series of images, documented, filed, and stored on the Cloud.

Throughout this work I have drawn on a large number of textual and contextual examples in order to demonstrate that our contemporary culture is inflected with nostalgia, preferring to look backwards to the presupposed 'simpler times' of the past as a coping mechanism to manage the difficulties of an increasingly complex and terrifying present. The melancholic sublime can, therefore, be read in two ways, neither of which excludes the other. First, our culture and our politics

are retrospective as a response to our sublime confrontation with the globalized world, i.e., this nostalgia is a longing for a time perceived of as coherent and whole(some), even more *natural* than our own. And second, that our nostalgic culture and politics are themselves sublime since they overwhelm our senses and cripple our ability to think beyond our present moment.

Within this, I have also argued that, at least in some regards, we should consider the melancholic sublime and our resultant nostalgia as a flight from terror. In the aftermath of 9/11, DeLillio wrote that, "whatever great skeins of technology lie ahead, ever more complex, connective, precise, micro-fractional, the future has yielded, for now, to medieval expedience, to the old slow furies of cut-throat religion" (Ruins, 54). Although the addition of 'for now' highlights this as a temporary shift, the evidence in this book suggests that not only is such a nostalgia still prevalent today, nearly two decades on from those attacks, if anything our retreat into the past seems more earnest than ever before. Fueled by a terror that has been given power and legitimacy by Western responses and interventions and that is itself a force nostalgic for a world of patriarchal rule through violence, our own retrograde actions leave us ill-equipped to use the very advantages that the 21st century has proffered in order to fight its various crises. Today's crises, then, cannot be reduced to any coherent vision or narrative. Neither can they be remedied by a return to the old ways, or, as so many politicians have advised us, condensed into any single root cause. There is no silver bullet that will solve climate change, defeat terrorism, eradicate bigotry, alleviate world poverty, or bring peace to the war-torn regions of our planet. If we want to begin to navigate beyond these problems we need to recognize that any starting point for such solutions lies in our future rather than our past. Thus, we must begin to resist the cultural and political nostalgia generated by the melancholic sublime and fix our eyes once again on the horizon, lest we risk leaving it far too late to tackle the problems that *might* just engulf tomorrow.

# Bibliography

4 News. (2015). Two Billion Miles. Available at: http://twobillionmiles.com/.

Adorno, Theodor. (1983). Cultural Criticism and Society. In: *Prisms*. Trans. W. Samuel and W. Shierry. Cambridge: The MIT Press, pp. 17–35.

Aldred, Jessica and Brian Greenspan. (2011). A Man Chooses, A Slave Obeys: Bioshock and the Dystopian Logic of Convergence. *Games and Culture*. 6 (5), pp. 479–496.

Appadurai, Arjun. (2011). Disjuncture and Difference. In: N. Marsh and L. Connell, eds. *Literature and Globalization*. London: Taylor and Francis, pp. 28–36.

Arad, Michael and Peter Walker. (2003). Reflecting Absence. Available at: www.wtcsitememorial.org/fin7.html.

Auchter, Jessica. (2014). *The Politics of Haunting and Memory in International Relations*. New York: Routledge.

Ayoub, Sarah. (2014). Critics Say Slacktivism Can't Change the World But Supporters Say It's a Good Start. *The Daily Telegraph*. Available at: www.dailytelegraph.com.au/news/critics-say-slacktivists-cant-change-the-world-but-supporters-say-its-a-good-start/news-story/e57b54e17674eb0431169bc79afeef45.

Baudrillard, Jean. (1995). *The Gulf War Did Not Take Place*. Trans. P. Patton. Bloomington: Indiana University Press.

Baudrillard, Jean. (2001). Simulacra and Simulations. In: M. Poster, ed. *Jean Baudrillard: Selected Writings*. Stanford: Stanford University Press, pp. 169–187.

Baudrillard, Jean. (2003). *The Spirit of Terrorism*. New York: Verso.

Bauman, Zygmunt. (2006). *Liquid Fear*. Cambridge: Polity Press.

Benjamin, Walter. (2008). *The Work of Art in the Age of Its Technological Reproducibility, and Other Writings on Media*. Cambridge, MA: Harvard University Press.

Bernard, Doug. (2012). Does Social Media Help or Hurt Terrorism? *Voice of America*. Available at: https://blogs.voanews.com/digital-frontiers/2012/01/21/does-social-media-help-or-hurt-terrorism/.

Bernstein, Richard J. (2007). *The Abuse of Evil: The Corruption of Politics and Religion since 9/11*. Cambridge: Polity Press.

Bevan, Robert. (2006). *The Destruction of Memory: Architecture at War*. London: Reaktion Books.

Bierstadt, Albert. (1866). *A Storm in the Rocky Mountains, Mt. Rosalie*. Available at: www.brooklynmuseum.org/opencollection/objects/1558.

Bierstadt, Albert. (1870). *Storm in the Mountains*. Available at: www.mfa.org/collections/object/storm-in-the-mountains-33126.

Boddy, Trevor. (2008). Architecture Emblematic: Hardened Sites and Softened Symbols. In: M. Sorkin, ed. *Indefensible Space*. New York: Routledge, pp. 277–304.

Brottman, Mikita. (2004). The Fascination of the Abomination: The Censored Images of 9/11. In: W. W. Dixon, ed. *Film and Television after 9/11*. Carbondale: Southern Illinois University Press.

Bukatman, Scott. (2003). *Matters of Gravity*. London: Duke University Press.

Burke, Edmund. (2008). *A Philosophical Enquiry into the Origin of our Ideas of the Sublime and Beautiful*. Oxford: Oxford University Press.

Castle, Terry. (2011). Stockhausen, Karlheinz: The Unsettling Question of the Sublime. *New York Magazine*. Available at: http://nymag.com/news/9-11/10th-anniversary/karlheinz-stockhausen/.

Chanda, Nyan and Strobe Talbott. (2002). Introduction. In: N. Chanda and S. Tablott, eds. *The Age of Terror: America and the World after September 11*. New York: Basic Books.

Chollet, Derek, and James Goldgeier. (2008). *America between the Wars: From 11/9 to 9/11*. Philadelphia, PA: Public Affairs.

Cline, Ernst. (2012). *Ready Player One*. London: Arrow Books.

Cole, Teju. (2012). *Open City*. London: Faber and Faber.

Collin, Robbie. (2015). The Walk Review: Breathtaking. *The Telegraph*. Available at: www.telegraph.co.uk/film/the-walk/review/.

Cooper, Simon and Paul Atkinson. (2008). Graphic Implosion: Politics, Time, and Value in Post-9/11 Comics. In: A. Keniston and J. Quinn, eds. *Literature after 9/11*. New York: Routledge, pp. 60–81.

Crowther, Paul. (1989). *The Kantian Sublime*. New York: Oxford University Press.

Darlington, Joseph. (2016). Capitalist Mysticism and the Historicizing of 9/11 in Thomas Pynchon's *Bleeding Edge*. *Critique: Studies in Contemporary Fiction*. 57 (3), pp. 242–253.

DeLillo, Don. (1992). *Mao II*. London: Vintage.

DeLillo, Don. (2001). In the Ruins of the Future: Reflections on Terror and Loss in the Shadow of September. Available at: www.theguardian.com/books/2001/dec/22/fiction.dondelillo.

DeLillo, Don. (2004). *Cosmopolis*. London: Picador.

DeLillo, Don. (2007). *Falling Man*. New York: Scribner.

DeLillo, Don. (2016). *Zero K*. New York: Scribner.

Derrida, Jacques and Jürgen Habermas. (2003). *Philosophy in a Time of Terror*. London: University of Chicago Press.

Dixon, Wheeler Winston. (2003). *Visions of the Apocalypse: Spectacles of Destruction in American Cinema*. London: Wallflower Press.

Dixon, Wheeler Winston. (2007). Vanishing Point: The Last Days of Film. *Senses of Cinema*. 43 (1). Available at: http://sensesofcinema.com/2007/feature-articles/last-days-film/.

Duchamp, Marcel. (1917, replica 1964). *Fountain*. Available at: www.tate.org.uk/art/artworks/duchamp-fountain-t07573.Emin, Tracy. (1998). *My Bed*. Available at: www.saatchigallery.com/artists/artpages/tracey_emin_my_bed.htm.

Faludi, Susan. (2008). *The Terror Dream: What 9/11 Revealed about America*. London: Atlantic Books.

Fischl, Eric. (2002). *Tumbling Woman*. Available at: www.ericfischl.com/tumbling-woman/.

Fisher, Mark. (2009). *Capitalist Realism: Is There No Alternative?* Winchester: Zero Books.

Fisher, Mark. (2014). *Ghosts of My Life: Writings on Depression, Hauntology and Lost Futures*. Winchester: Zero Books.

Fitzsimmons, Phil. (2010). Little White Lies: 9/11 and the Recasting of Evil through Metaphor. In: N. Billias, ed. *Promoting and Producing Evil*. New York: Rodopi, pp. 3–18.

Foer, Jonathan Safran. (2006). *Extremely Loud & Incredibly Close*. London: Penguin Books.

Forsey, Jane. (2007). Is a Theory of the Sublime Possible? *The Journal of Aesthetics and Art Criticism*. 65 (4), pp. 381–389.

Foster, Mindi D. (2015). Tweeting about Sexism: The Well-Being Benefits of a Social Media Collective Action. *British Journal of Social Psychology*. 54 (1), pp. 629–647.

Fox, Jesse, Carlos Cruz and Ji Young Lee. (2015). Perpetuating Online Sexism Offline: Anonymity, Interactivity, and the Effects of Sexist Hashtags on Social Media. *Computers in Human Behavior*. 52 (1), pp. 436–442.

Franklin, Ruth. (2011). The Stubborn, Inward Gaze of the Post-9/11 Novel. *New Republic*. Available at: https://newrepublic.com/article/94180/september-11-the-novel-turns-inward.

Freda, Isabella. (2004). Survivors in *The West Wing*: 9/11 and the United States of Emergency. In W. W. Dixon, ed. *Film and Television after 9/11*. Carbondale: Southern Illinois University Press, pp. 226–244.

Freud, Sigmund. (1950). Mourning and Melancholia. In: *Collected Papers volume 4*. Trans. J. Riviere and A. Strachey. London: Hogarth Press and the Institute of Psychoanalysis, pp. 152–170.

Frost, Laura. (2008). Still Life: 9/11's Falling Bodies. In: A. Keniston and J. Quinn, eds. *Literature after 9/11*. New York: Routledge, pp. 180–206.

Fukuyama, Francis. (1992). *The End of History and the Last Man*. London: Penguin Books.

Gibson, William. (2004). *Pattern Recognition*. London: Penguin Books.

Glass, Julia. (2006). *The Whole World Over*. New York: Pantheon Books.

Glejzer, Richard. (2008). Witnessing 9/11: Art Spiegelman and the Persistence of Trauma. In: A. Keniston and J. Quinn, eds. *Literature after 9/11*. New York: Routledge, pp. 99–119.

Goldberger, Paul. (2012). Reflected Grief. *Vanity Fair*. Available at: www.vanityfair.com/news/politics/2012/04/maya-lin-vietnam-wall-memorial.

Graham, Stephen. (2008). Cities and the War on Terror. In: M. Sorkin, ed. *Indefensible Space*. New York: Routledge, pp. 1–28.

Grant, Barry Keith. (2004). Sensuous Elaboration: Reason and the Visible in the Science Fiction Film. In: S. Redmond, ed. *Liquid Metal: The Science Fiction Film Reader*. London: Wallflower Press, pp. 17–23.

Gray, Richard. (2011). *After the Fall: American Literature Since 9/11*. Chichester: John Wiley & Sons.

Grusin, Richard. (2009). YouTube at the End of New Media. Available at: https://socialmediaecologies.wikispaces.com/file/view/YouTubeReader-Grusin.pdf.

*The Guardian*. (2002). Hirst Apologises for Calling 9/11 'a work of art'. Available at: www.theguardian.com/world/2002/sep/19/september11.usa.

Gunning, Tom. (1986). The Cinema of Attractions: Early Film, Its Spectator and the Avant-Garde. *Wide Angle*. 8 (3/4), pp. 63–70.

Hamid, Mohsin. (2008). *The Reluctant Fundamentalist*. London: Penguin Books.

Haraway, Donna J. (2004). A Manifesto for Cyborgs: Science, Technology and Socialist Feminism in the 1980s. In: S. Redmond, ed. *Liquid Metal: The Science Fiction Film Reader*. London: Wallflower Press, pp. 182–190.

Harvey, David. (2011). Time-Space Compression and the Postmodern Condition. In: N. Marsh and L. Connell, eds. *Literature and Globalization*. London: Taylor and Francis, pp. 5–17.

Heineman, David S. (2014). Public Memory and Gamer Identity: Retrogaming as Nostalgia. *Journal of Games Criticism*. 1 (1). Available at: http://games-criticism.org/articles/heineman-1-1/.

Henthrone, Tom. (2003). Cyber-Utopias: The Politics and Ideology of Computer Games. *Studies in Popular Culture*. 25 (3), pp. 63–76.

Hirst, Damien. (1990). *A Thousand Years*. Available at: www.damienhirst.com/a-thousand-years.

Hirst, Damien. (1991). *The Physical Impossibility of Death in the Mind of Someone Living*. Available at: www.damienhirst.com/the-physical-impossibility-of.

Hirst, Damien. (1996). *Loving in a World of Desire*. Available at: www.damienhirst.com/loving-in-a-world-of-desire.

Hirst, Damien. (1999). *The History of Pain*. Available at: www.damienhirst.com/the-history-of-pain.

Hirst, Damien. (2006–2013). *Leviathan*. Available at: www.damienhirst.com/leviathan.

Hirst, Damien. (2007). *For the Love of God*. Available at: www.damienhirst.com/for-the-love-of-god.

Hirst, Damien. (2008). *For Heaven's Sake*. Available at: www.damienhirst.com/for-heavenas-sake.

Hoth, Stephanie. (2006). From Individual Experience to Historical Event and Back Again: 9/11 in Jonathan Safran Foer's *Extremely Loud and Incredibly Close*. In: M. Gymnich, B. Neumann and A. Nünning, eds. *Kulturelles Wissen und Intertextualität*. Trier: Wvt Wissenschaftlicher Verlag Trier, pp. 283–300.

Huehls, Mitchum. (2008). Foer, Spiegelman, and 9/11's Timely Traumas. In: A. Keniston and J. Quinn, eds. *Literature after 9/11*. New York: Routledge, pp. 42–59.

Huntington, Samuel P. (1993). The Clash of Civilizations? *Foreign Affairs*. Available at: www.foreignaffairs.com/articles/united-states/1993-06-01/clash-civilizations.

Jameson, Fredric. (1993). *Postmodernism: Or, the Cultural Logic of Late Capitalism*. London: Verso.

Jameson, Fredric. (2007). *Archaeologies of the Future: The Desire Called Utopia and Other Science Fictions*. London: Verso.

Jones, Jonathan. (2011). The Meaning of 9/11's Most Controversial Photo. *The Guardian*. Available at: www.theguardian.com/commentisfree/2011/sep/02/911-photo-thomas-hoepker-meaning.

Junod, Tom. (2003). The Falling Man. *Esquire*. Available at: http://classic.esquire.com/the-falling-man/.

Kalfus, Ken. (2007). *A Disorder Peculiar to the Country*. London: Pocket Books.

Kant, Immanuel. (2000). *Critique of the Power of Judgment*. New York: Cambridge University Press.

Keane, Stephen. (2001). *Disaster Movies: The Cinema of Catastrophe*. London: Wallflower Press.

Keane, Stephen. (2007). *CineTech: Film, Convergence and New Media*. New York: Palgrave Macmillan.

Klinger, Cornelia. (2009). The Sublime, A Discourse of Crisis and of Power, Or "A Gamble on Transcendence". In: L. White and C. Pajaczkowska, eds. *The Sublime Now*. Newcastle: Cambridge Scholars Publishing.

Kohlmann, Evan. (2011). The Antisocial Network: Countering the Use of Online Social Networking Technologies by Foreign Terrorist Organizations. Available at: https://homeland.house.gov/files/Testimony%20Kohlmann%5B1%5D.pdf.

Kristeva, Julia. (1982). *Powers of Horror: An Essay on Abjection*. New York: Columbia University Press.

Lane, Anthony. (2001). This Is Not a Movie. *The New Yorker*. Available at: www.newyorker.com/magazine/2001/09/24/this-is-not-a-movie.

Lang, Karen. (2011). Eric Fischl's Tumbling Woman, 9/11, and "Timeless Time". *Future Anterior: Journal of Historic Preservation, History, Theory, and Criticism*. 8 (2), pp. 21–35.

Leggatt, Matthew. (2013). Melancholic and Hungry Games: Post-9/11 Cinema and the Culture of Apocalypse. In: M. Pomerance and J. Sakeris, eds. *Popping Culture: Seventh Edition*. Boston, MA: Pearson, pp. 325–334.

Leggatt, Matthew. (2016). Deflecting Absence: 9/11 Fiction and the Memorialization of Change. *Interdisciplinary Literary Studies*. 18 (2), pp. 203–221.

Levi-Strauss, David. (2003). *Between the Eyes: Essays on Photography and Politics*. New York: Aperture.

Li, Stephanie. (2008). "Sometimes things disappear": Absence and Mutability in Colson Whitehead's *the Colossus of New York*. In: A. Keniston and J. Quinn, eds. *Literature after 9/11*. New York: Routledge, pp. 82–98.

Lisboa, Maria Manuel. (2011). *The End of the World: Apocalypse and Its Aftermath in Western Culture*. Cambridge: Open Book Publishers.

Lizardo, Omar. (2007). *Fight Club*, or the Cultural Contradictions of Late Capitalism. *Journal for Cultural Research*. 11 (3), pp. 221–243.

Longmuir, Anne. (2011) "This was the World Now": *Falling Man* and the Role of the Artist after 9/11. *Modern Language Studies*. 41 (1), pp. 42–57.

Lyotard, Jean-François. (1984). *The Postmodern Condition: A Report on Knowledge*. Minneapolis, MN: University of Minnesota Press.

MacDorman, Karl F. (2009). Too Real for Comfort? Uncanny Responses to Computer Generated Faces. *Computers in Human Behavior*. 25 (3), pp. 695–710.

Manghani, Sunil. (2008). *Image Critique & the Fall of the Berlin Wall*. Bristol: Intellect Books.

Martin, John. (1852). *The Destruction of Sodom and Gomorrah*. Available at: https://artuk.org/discover/artworks/the-destruction-of-sodom-and-gomorrah-37049.

Martin, John. (1853). *The Great Day of His Wrath*. Available at: www.tate.org.
uk/art/artworks/martin-the-great-day-of-his-wrath-n05613.

Martinson, Jane. (2015). Charlie Hebdo: A Week of Horror when Social Media
Came into Its Own. *The Guardian*. Available at: www.theguardian.com/
media/2015/jan/11/charlie-hebdo-social-media-news-readers.

McDermott, John. (2013). SimCity's Turn Toward a Dark Dystopic Vision of Our
Urban Future. *The Atlantic*. Available at: www.citylab.com/design/2013/11/
simcitys-turn-toward-dark-dystopic-vision-our-urban-future/7499/.

McEwan, Ian. (2006) *Saturday*. London: Vintage.

Merrin, William. (2005) Total Screen: 9/11 and the Gulf War Reloaded. *International Journal of Baudrillard Studies*. 2 (2). Available at: www2.ubishops.
ca/baudrillardstudies/vol2_2/merrin.htm.

Messud, Claire. (2006). *The Emperor's Children*. London: Picador.

Mitchell, William John Thomas (2011). *Cloning Terror: The War of Images,
9/11 to the Present*. London: The University of Chicago Press.

Morozov, Yevgeny. (2011). *The Net Delusion*. London: Penguin Books.

Morozov, Yevgeny. (2009). Foreign Policy: Brave New World of Slacktivism.
Available at: www.npr.org/templates/story/story.php?storyId=104302141.

Morton, Timothy. (2007). *Ecology without Nature*. Cambridge: Harvard
University Press.

Mosco, Vincent. (2004). *The Digital Sublime*. Cambridge: MIT Press.

Nissim, Mayer and Katie Goodacre. (2012). Stephen Spielberg: 'CGI is Artificial and Audiences Can Tell'. *Digital Spy*. Available at: www.digitalspy.
com/movies/war-horse/news/a359087/steven-spielberg-cgi-is-artificial-and-
audiences-can-tell/.

Nordstrom, Justin. (2016). A Pleasant Place for the World to Hide: Exploring
Themes of Utopian Play in *Ready Player One*. *Interdisciplinary Literary
Studies*. 18 (2), pp. 238–256.

Nye, David E. (1994). *American Technological Sublime*. New Baskerville, MA:
The MIT Press.

O'Neil, Joseph. (2009). *Netherland*. New York: Harper Perennial.

Page, Max. (2008). *The City's End: Two Centuries of Fantasies, Fears, and
Premonitions of New York's Destruction*. New Haven, CT: Yale University
Press.

Palahniuk, Chuck. (1997). *Fight Club*. London: Vintage.

Plato. (1925). *Plato in Twelve Volumes, Vol. 9*. London: William Heinemann
Ltd.

PNAC (Thomas Donnelley). (2000). Rebuilding America's Defenses: Strategy,
Forces and Resources for a New Century. Available at: www.information
clearinghouse.info/pdf/RebuildingAmericasDefenses.pdf.

Pomerance, Murray. (2004). The Shadow of the World Trade Center Is Climbing
My Memory of Civilization. In: W. W. Dixon, ed. *Film and Television after
9/11*. Carbondale: Southern Illinois University Press.

Pomerance, Murray. (2008). *The Horse Who Drank the Sky: Film Experience
Beyond Narrative and Theory*. New Brunswick, NJ: Rutgers University
Press.

Prensky, Marc. (2001). Digital Natives, Digital Immigrants. *On the Horizon*.
9 (5). Available at: www.marcprensky.com/writing/Prensky%20-%20Digital
%20Natives,%20Digital%20Immigrants%20-%20Part1.pdf.

Prince, Stephen. (2009). *Firestorm: American Film in the Age of Terrorism.* New York: Columbia University Press.

Randall, Eric. (2011). The 'Death of Irony', and Its Many Reincarnations. *The Wire.* Available at: www.thewire.com/national/2011/09/death-irony-and-its-many-reincarnations/42298/.

Randall, Martin. (2014). *9/11 and the Literature of Terror.* Edinburgh: Edinburgh University Press.

Ray, Gene. (2005). *Terror and the Sublime in Art and Critical Theory.* New York: Palgrave Macmillan.

Ray, Gene. (2009). History, Sublime, Terror: Notes on the Politics of Terror. In: L. White and C. Pajaczkowska, eds. *The Sublime Now.* Newcastle: Cambridge Scholars Publishing, pp. 133–154.

Richter, Gerhard. (2005). *September.* Available at: www.gerhard-richter.com/en/art/paintings/photo-paintings/death-9/september-13954.

Richter, Gerhard. (2006). *Stripes, WTC.* Available at: www.gerhard-richter.com/en/art/atlas/stripes-wtc-12306.

Robbins, Bruce. (2002). The Sweatshop Sublime. *Publications of the Modern Language Association.* 117 (1), pp. 84–97.

Rose, Steve. (2011). Tintin and the Uncanny Valley: When CGI Gets Too Real. *The Guardian.* Available at: www.theguardian.com/film/2011/oct/27/tintin-uncanny-valley-computer-graphics.

Rushkoff, Douglas. (2016). *Throwing Rocks at the Google Bus.* St Ives: Portfolio Penguin.

Schivelbusch, Wolfgang. (2004). *The Culture of Defeat.* London: Granta Books.

Schneider, Steven Jay. (2004). Architectural Nostalgia and the New York City Skyline on Film. In: W. W. Dixon, ed. *Film and Television after 9/11.* Carbondale: Southern Illinois University Press, pp. 29–41.

Schulman, Helen. (2008). *A Day at the Beach.* New York: Mariner Books.

Schulzke, Marcus. (2014). The Critical Power of Virtual Dystopias. *Games and Culture.* 9 (5), pp. 315–334.

Sebald, Winfried Georg (2003). *On the Natural History of Destruction.* London: Penguin Books Ltd.

Sebald, Winfried Georg (2011). *Austerlitz.* London: Penguin Books.

Self, Will. (2014). We Are Passive Consumers of the Pornography of Violence. *The Guardian.* Available at: www.theguardian.com/news/2014/dec/23/-sp-passive-consumers-pornography-violence.

Senie, Harriet F. (2016). Commemorating 9/11: From the Tribute in Light to Reflecting Absence. In: Harriet F. Senie, ed. *Memorials to Shattered Myths: Vietnam to 9/11.* Oxford Scholarship Online, pp. 1–86.

Shaw, Philip. (2006). *The Sublime: The New Critical Idiom.* London: Routledge.

Shelley, Percy Bysshe. (2012). Ozymandias. In: *The Complete Poetry of Percy Bysshe Shelley, Vol. 3.* Baltimore, MD: John Hopkins University Press.

Simpson, David. (2006). *9/11: The Culture of Commemoration.* Chicago, IL: the University of Chicago Press.

Simpson, David. (2008). Telling It Like It Isn't. In: A. Keniston and J. Quinn, eds. *Literature after 9/11.* New York: Routledge, pp. 209–223.

Sloan, Robin J. S. (2015). Videogames as Remediated Memories: Commodified Nostalgia and Hyperreality in Far Cry 3: Blood Dragon and Gone Home. *Games and Culture.* 10 (6), pp. 525–550.

Smith, Horace. (2012). Ozymandias. In: D. Wu, ed. *Romanticism: An Anthology, 4th Edition.* Hoboken, NJ: Wiley-Blackwell.

So, Jimmy. (2013). Reading the Best 9/11 Novels. *The Daily Beast.* Available at: www.thedailybeast.com/reading-the-best-911-novels.

Sobchack, Vivian. (2014). Sci-Why?: On the Decline of a Film Genre in an Age of Technological Wizardry. *Science Fiction Studies.* 41 (2), pp. 284–300.

Sorkin, Michael. (2008). Introduction: The Fear Factor. In: M. Sorkin, ed. *Indefensible Space.* New York: Routledge, pp. vii–xvii.

Spark, Alasdair. (2004). 9/11 Multiplied by 24/7. In: N. Campbell, J. Davies and G. McKay, eds. *Issues in Americanisation and Culture.* Edinburgh: Edinburgh University Press, pp. 226–244.

Spiegelman, Art. (2001). *The New Yorker* cover image, 09/24/2001. Available at: www.newyorker.com/news/news-desk/911-new-yorker-covers.

Spiegelman, Art. (2004). *In the Shadow of No Towers.* New York: Pantheon Books.

Spivak, Gayatri Chakravorty. (2013). Can the Subaltern Speak? In: P. Williams and L. Chrisman, eds. *Colonial Discourse and Post-Colonial Theory: A Reader.* New York: Routledge, pp. 66–111.

Sterritt, David. (2004). Representing Atrocity: From the Holocaust to September 11. In: W. W. Dixon, eds. *Film and Television after 9/11.* Carbondale: Southern Illinois University Press, pp. 63–78.

Sturken, Marita. (2007). *Tourists of History.* London: Duke University Press.

Taylor-Johnson, Sam. (2002). *Passion Cycle.* Available at: http://samtaylorjohnson.com/photography/art/passion-cycle-2002/attachment/passion-cycle-i-2002.

Taylor-Johnson, Sam. (2003). *Falling.* Available at: http://samtaylorjohnson.com/photography/art/falling-2003.

Taylor-Johnson, Sam. (2003). *Ivan (ladder).* Available at: http://samtaylorjohnson.com/photography/art/ivan-ladder-2003.

Taylor-Johnson, Sam. (2003). *Strings.* Available at: http://samtaylorjohnson.com/moving-image/art/strings-2003.

Taylor-Johnson, Sam. (2004). *Self-Portrait Suspended.* Available at: http://samtaylorjohnson.com/photography/art/self-portrait-suspended-2004.

Taylor-Johnson, Sam. (2008). *Escape Artist.* Available at: http://samtaylorjohnson.com/photography/art/escape-artist-2008.

Tommasini, Anthony. (2001). Music; The Devil Made Him Do It. *The New York Times.* Available at: www.nytimes.com/2001/09/30/arts/music-the-devil-made-him-do-it.html.

Tschumi, Bernard. (2000). Violence of Architecture. In: M. McQuillan, ed. *Deconstruction: A Reader.* Edinburgh: Edinburgh University Press, pp. 229–234.

Tsing, Anna. (2011). The Global Situation. In: N. Marsh and L. Connell, eds. *Literature and Globalization.* London: Taylor and Francis, pp. 49–60.

Turner, J. M. W. (1801). *Dutch Boats in a Gale.* Available at: www.nationalgallery.org.uk/paintings/joseph-mallord-william-turner-dutch-boats-in-a-gale-the-bridgewater-sea-piece.

Turnock, Julie. (2015). *Plastic Reality.* New York: Columbia University Press.

UNHCR. (2005). Against All Odds. Available at: www.playagainstallodds.ca/.

Usai, Paulo Cherchi. (2001). *The Death of Cinema.* London: British Film Institute.

Van Gogh, Vincent. (1889). *The Starry Night*. Available at: www.moma.org/learn/moma_learning/vincent-van-gogh-the-starry-night-1889.

Vint, Sherryl and Mark Bould. (2009). Manufacturing Landscapes: Disappearing Labour: From Production Lines to the Cities of the Future. In: L. White and C. Pajaczkowska, eds. *The Sublime Now*. Newcastle: Cambridge Scholars Publishing, pp. 269–285.

Walter, Jess. (2007). *The Zero*. New York: Harper Perennial.

Webb, Dan. (2009). 'If Adorno Isn't the Devil, It's because He's a Jew': Lyotard's Misreading of Adorno through Thomas Mann's Dr Faustus. *Philosophy and Social Criticism*. 35 (5), pp. 517–531.

White, Micah. (2010). Clicktivism Is Ruining Leftist Activism. *The Guardian*. Available at: www.theguardian.com/commentisfree/2010/aug/12/clicktivism-ruining-leftist-activism.

Wills, George. (2001). The End of Our Holiday from History. *The Washington Post*. Available at: www.washingtonpost.com/archive/opinions/2001/09/12/the-end-of-our-holiday-from-history/9da607fd-8fdc-4f33-b7c9-e6cda00453bb/?utm_term=.aefc14a5ee48.

Young, Robert. (1991). Poems That Read Themselves. *Tropismes*. 5 (1), pp. 223–261.

Žižek, Slavoj. (2002). *Welcome to the Desert of the Real*. London: Verso.

Žižek, Slavoj. (2011). *Living in the End Times*. London: Verso.

# Index